The Splendor of
IRIDESCENCE

The Splendor of
IRIDESCENCE

Structural Colors in the Animal World

BY HILDA SIMON

Illustrated by the Author

DODD, MEAD & COMPANY New York

ISBN 0-396-06208-3
Library of Congress Catalog Card Number: 72-126295
Printed in the United States of America

To my Father

who combined in his person the qualities of
the scientist, the artist, and the nature lover
and who encouraged my own interests in all
three fields

Acknowledgments

B Y ITS very nature a book of this kind becomes possible only through the contributions of many different people. The wealth of research and information from scientists and naturalists of the past and present available to me in this project becomes evident from the selected bibliography. I also wish to acknowledge gratefully the help and the frequent inspiration I received from a number of individuals during my work on this book.

Overseas, I want specifically to thank Professor Adolf Portmann of the University of Basel, Switzerland, and Professor Julius Grober of Bad Bodendorf, Germany, for the great interest they showed in this book and for the invaluable research material they provided; my late father's friends and associates at the Zeiss Optical Works in Germany for their help; and Mrs. Dorothea Richter of the Max Planck Institute of Biophysics in Frankfurt, Germany, for her untiring efforts to provide me

with even the most difficult-to-obtain material.

In this country, my thanks go especially to Mr. Charles H. Rogers, Curator of Ornithology, Princeton Museum of Zoology, for his patience in providing the countless bird specimens I required for study and sketching and for his conscientious checking of the ornithological accuracy of the manuscript. The same holds true for Alexander B. Klots, Professor Emeritus of Biology, The City University of New York, and Research Associate in Entomology, the American Museum of Natural History in New York, who checked the entomological contents of the book and to whom I owe special thanks for the encouraging enthusiasm he displayed for my technique of color illustration. I also sincerely appreciate the kindness of Mr. John Pallister, Research Associate of the Entomological Department of the American Museum of Natural History, for supplying specimens of all the tropical beetles I needed for my illustrations.

Text and illustrations are only the first step in producing a book. For the publisher the work begins at that point. I wish to thank Mr. Edward H. Dodd, Jr., and Mr. S. Phelps Platt, Jr., for the great interest they showed in this book and for their editorial help with the manuscript. To Helen Winfield go my warmest thanks for her enthusiasm, her meticulous devotion to detail, and her untiring efforts to insure superior quality in the production of the book.

Last, but not least by any means, I want my friends and family to know that I appreciate their forbearance in taking temporarily a back seat to the various dragonflies, beetles, wasps, and flies which I caught and studied during my work on this book and which, because I did not have the heart to kill them and turn them into mere specimens, turned my home into a veritable insect zoo.

HILDA SIMON

Contents

PART TWO
The Beauty of Iridescence

Illustrations

Preface

THIS BOOK, which intends to explore only one aspect of the vast and mysterious wonderland of color, was born out of delight in and admiration for certain exquisite colors found in the animal kingdom. Most specifically, this involved structural colors—iridescent and metallic hues —displayed by certain birds, insects, and other creatures. After studying the findings of modern electronic research, which for the first time revealed both the nature and the incredible number of minute precision structures that produce the glittering rainbow hues, the delight not only increased but was soon tinged with awe.

While an attempt has been made to capture the beauty of these animals in illustration—never perfect, because colors of this type, by their very nature, defy our best efforts at visual reproduction—the physical, scientific explanation of these rainbow hues has received the fullest possible attention. This was done from the conviction that such information would

prove far from boring, much less disillusioning. Knowledge of the manner in which the gorgeous colors of these living jewels are produced is bound to increase the sense of wonder in any sensitive person as he or she marvels at the energy expended by the unknown forces of life, forces which create beauty and splendor that exceed all functional need and purpose.

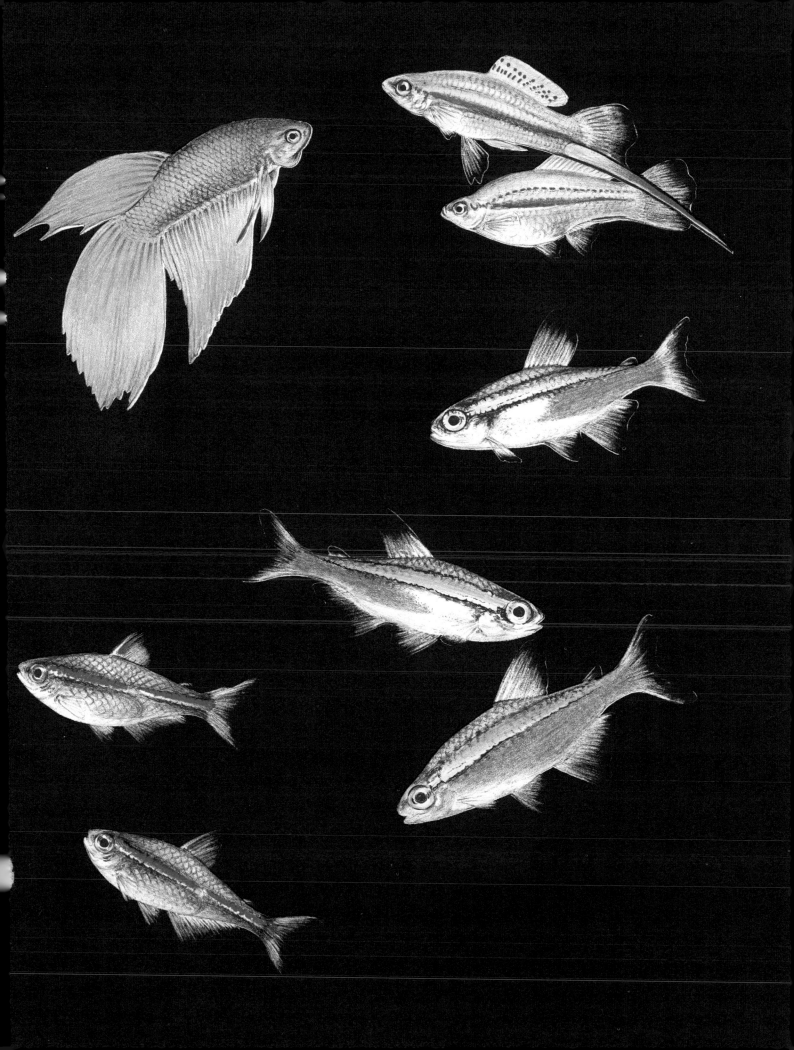

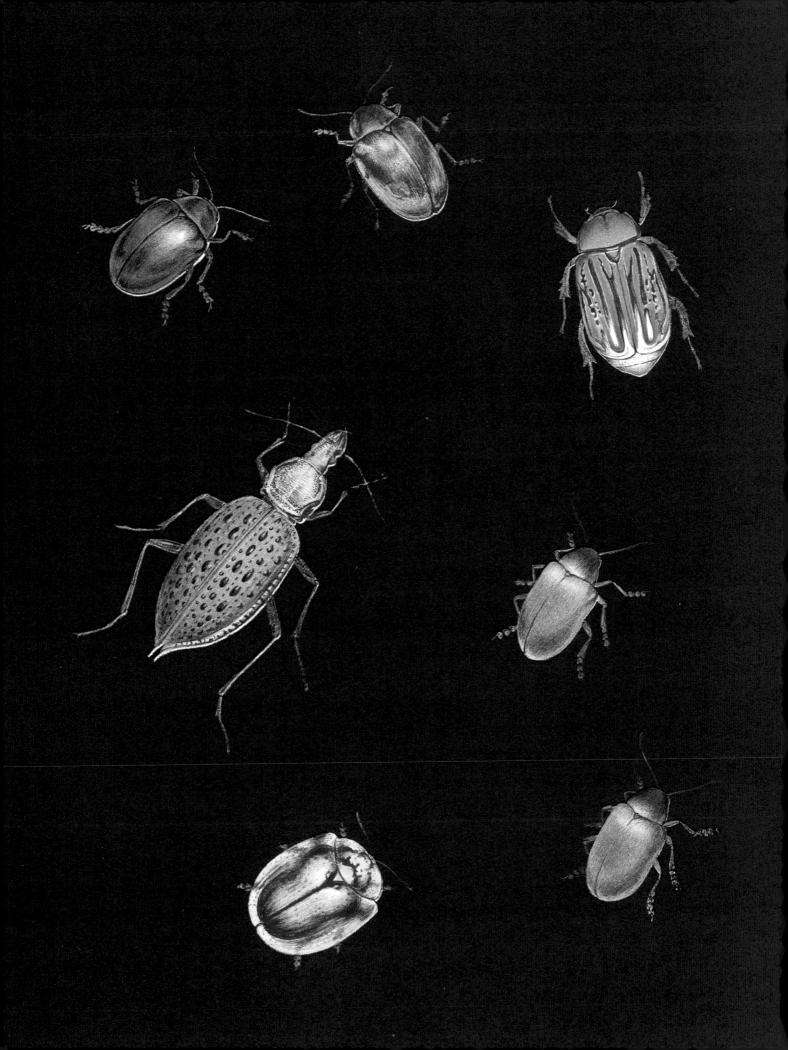

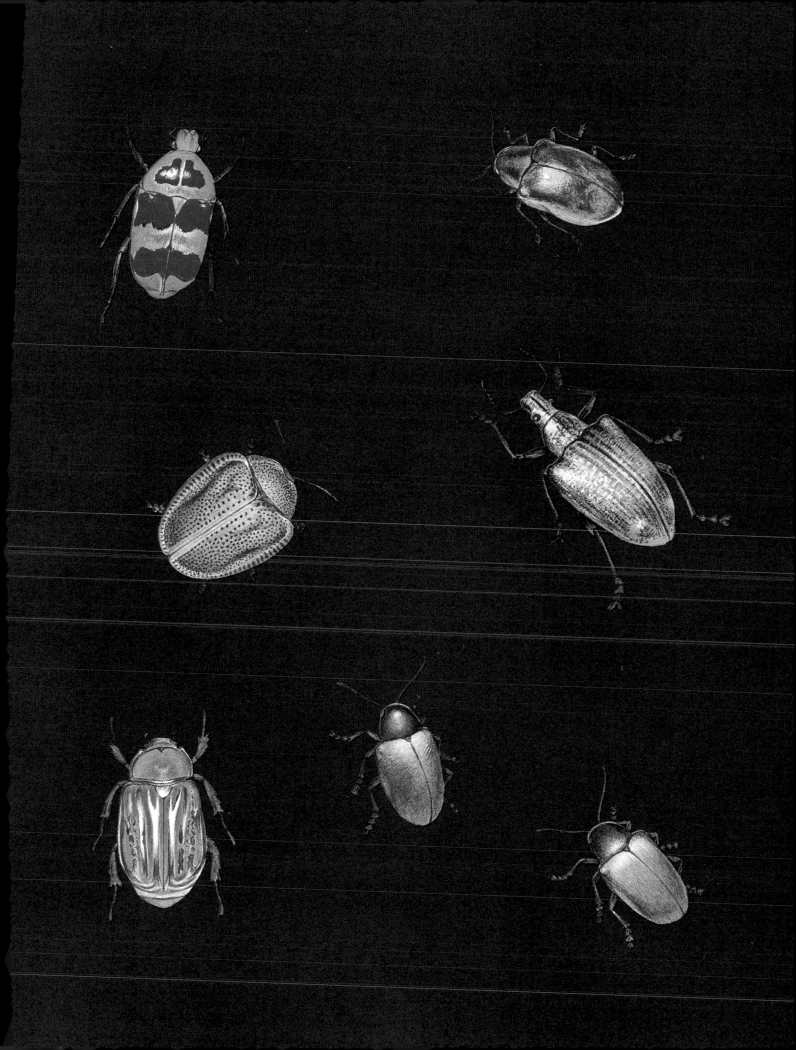

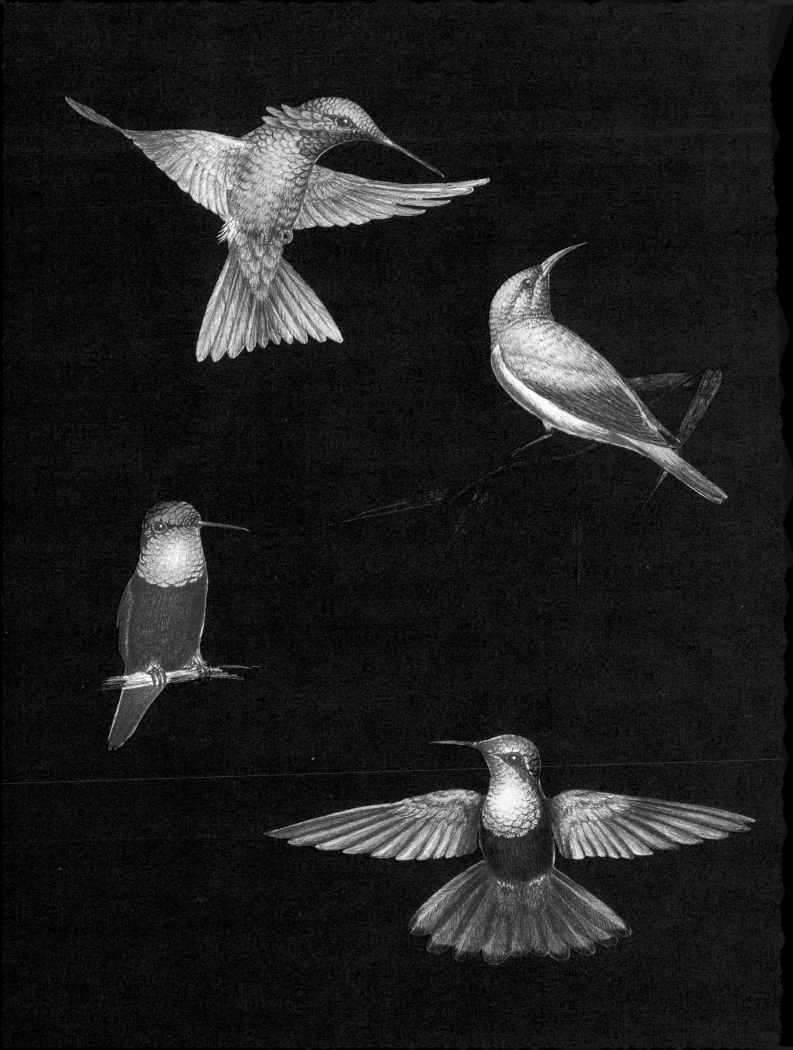

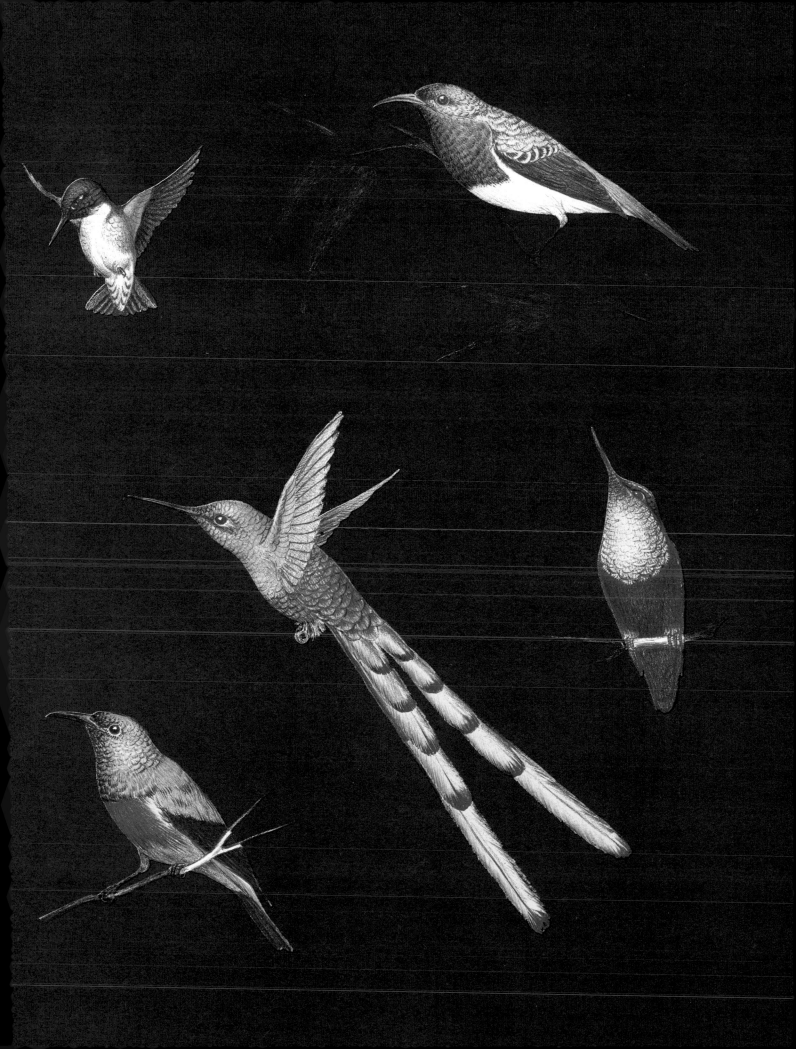

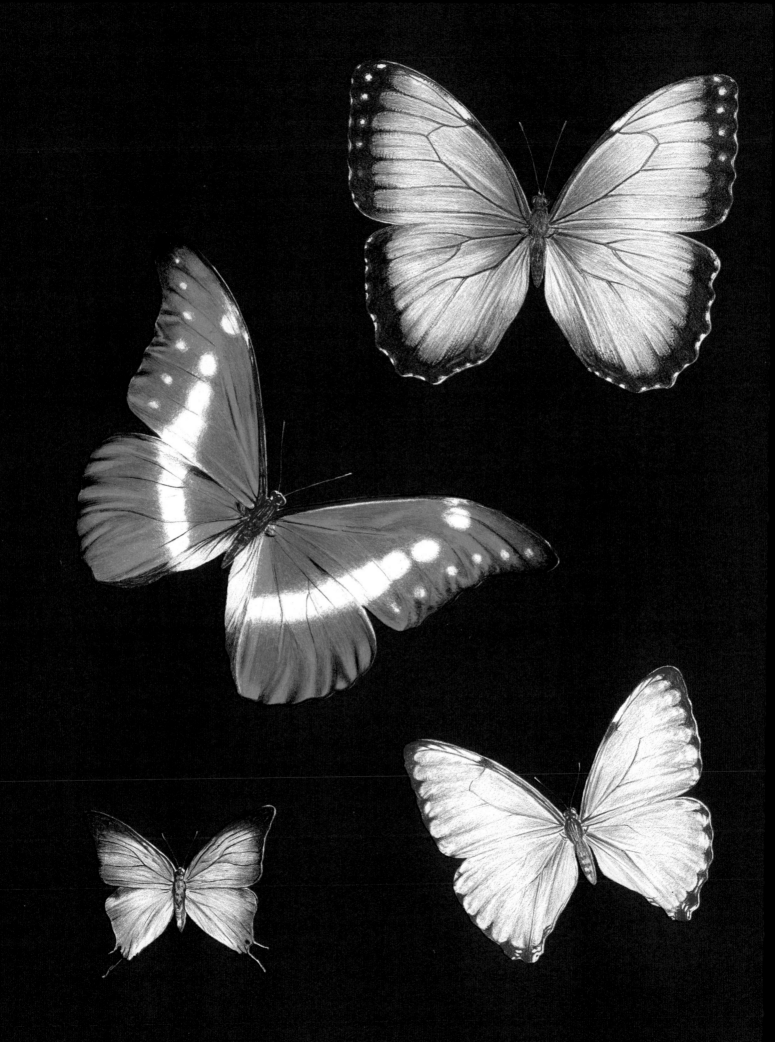

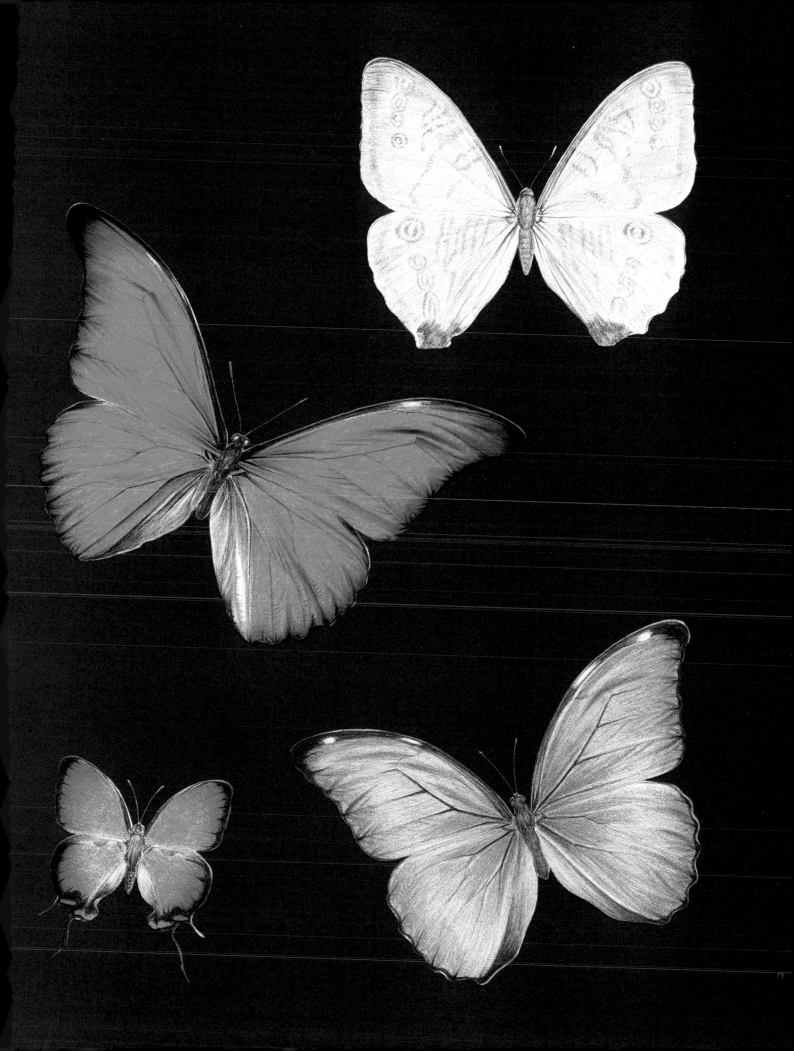

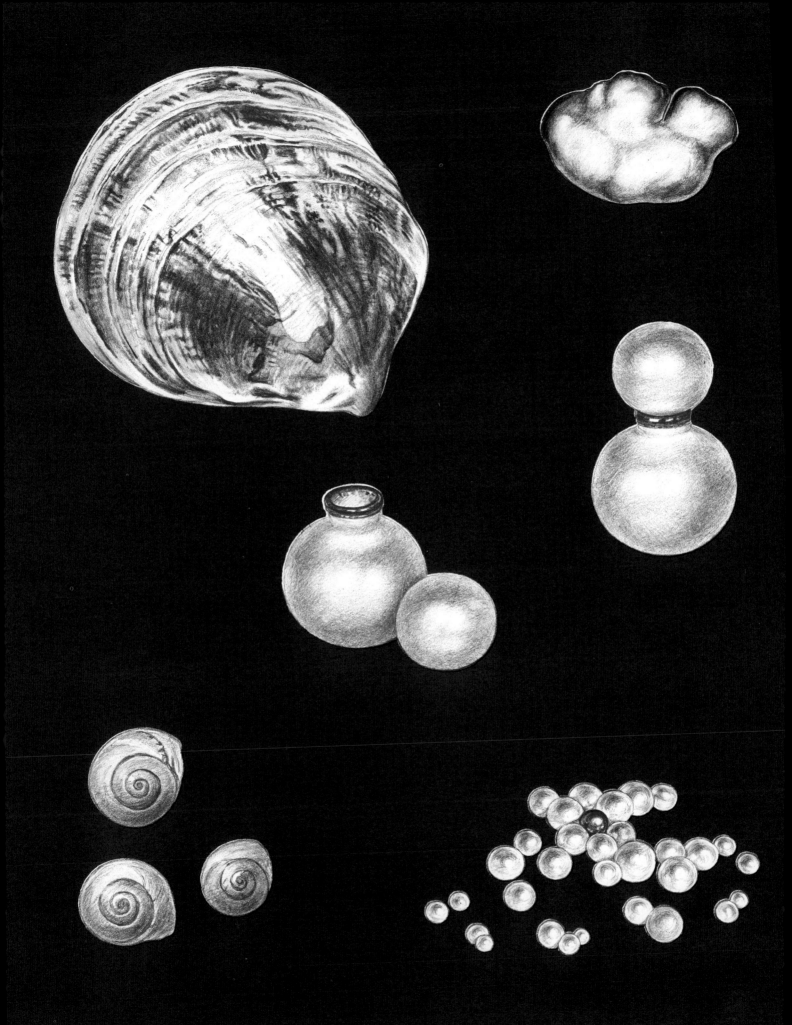

ALTHOUGH ANIMALS are prominently featured, this is not a book primarily about animals; their habitats, habits, and anatomy are here of secondary interest. Instead, the animals, from birds to insects, are interesting because they all have surface tissues that fulfill the requirements necessary for the appearance of certain optical phenomena.

Part One of this book is devoted to information concerning the physical laws governing these phenomena and to the very special conditions that must be present in order for the "colors of light" to appear. This explanation will greatly increase the understanding and appreciation of Part Two.

PART ONE
The Anatomy of Structural Colors

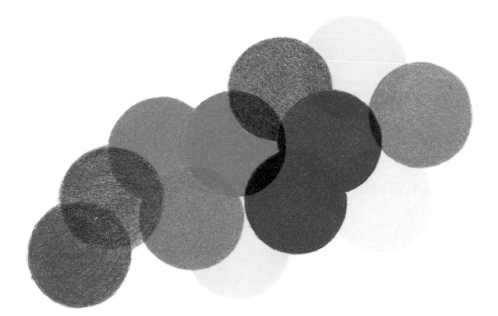

1. The ABC of Light and Color

DESPITE the fact that we have learned much about the nature of light, a satisfactory answer to the question, What *is* light? has not yet been found, and it remains the *enfant terrible* of science. During the past three hundred years, eminent scientists from many countries have advanced a number of often sharply differing theories on the nature of light. Color plays an important part in all these theories.

Prior to the seventeenth century, colors were assumed to be an integral part of the objects that display them. Sir Isaac Newton exploded that assumption. With the help of his epoch-making discovery that white light is composed of all the colors of the spectrum, he supplied proof that an object is colored only because it reflects certain component colors of white light. To account for the phenomenon of light itself, Newton suggested that it was made up of tiny particles, or "corpuscles," as he put it, which were emitted at a tremendous speed by a luminous body. Each individual

component color of white light, he thought, was produced by a different type of corpuscle. Newton's theory, which fitted in neatly with certain manifestations of light—reflection, to name only one—was accepted by many scientists and became widely known and famed as the Corpuscular Theory of light.

In 1690, the Dutch astronomer and mathematician Christian Huygens offered an entirely different concept of the nature of light. His theory, published in Leyden under the title "Traite de la Lumière," held that light was nothing but a wave motion, without any substance at all. This Wave Theory of light brought Huygens great fame, and many scientists preferred it to Newton's Corpuscular Theory.

For some time, physicists were divided in two camps, one of which favored Newton's corpuscular theory, and the other, Huygens' theory that light consisted of a wave motion only. As time went by, however, the wave theory gained general recognition, because it accounted perfectly for light phenomena such as refraction, reflection, and polarization, some of which could not be satisfactorily explained on any other basis. There was only one difficulty with the concept that light was nothing but a wave motion, and that was the fact that such a wave motion needs a transmitting medium. While it was clear that the earth's atmosphere provided such a medium, it remained unclear how light from the sun and the stars could reach us across the vast stretches of empty space. Huygens had supplied his own answer to that problem. He suggested that space, and indeed the entire universe, was filled with something he called *ether*: it was invisible, undetectable, and the ideal transmitting medium for light waves.

Physicists were so pleased with the wave theory that they were happy to accept the mysterious ether, and for some time the problem of light seemed to have been solved. But as science progresses new questions are raised because new problems appear, and old theories have to be reexamined because, regardless of how logical they seem or how probable they are, they remain theories. Toward the end of the nineteenth century many physicists began to question the nature of the mysterious and myth-

ical ether. After all, just what *was* ether? It could not be nothing, for then it could not be a transmitting medium. If it was something, though, what type of something was it? A number of experiments conducted by various physicists around the turn of the century seemed to point to a rather disturbing conclusion: ether, that convenient answer to the need of a transmitting medium, did not exist! This, of course, also knocked out the theory that light was nothing but a wave motion. What, then, was it? Back to Newton and his corpuscles—well, not quite. In 1900, the famed German physicist Max Planck advanced the theory that light is a form of energy. He believed that radiant energy such as light is composed of tiny irreducible units, or *quanta*, as he called them. He did not, however, discard the concept that light travels in undulatory vibrations, so that the wave theory was not discredited.

Planck's Quantum Theory of light brought him international fame. A few years later, a young physicist by the name of Albert Einstein formulated a more exact definition of the energy that produces light. He claimed that because light was electromagnetic energy, it must have mass, because without mass, there cannot be speed, or velocity. And the velocity of light, calculated to be 186,000 miles per second, and designated by a lower-case letter c, is a veritable sacred cow in physics, the one absolute in a world that has become increasingly relative. Einstein's famous equation $E = mc^2$, which ushered in the atomic age, is based on the assumption that the speed of light is the one and only thing in the universe that remains constant.

It seems amazing, in view of the tremendous progress made in science, and especially in physics, that the complete answer to the simple-sounding question, What is light? should continue to evade us. Sir William Bragg, Nobel Prize-winning English physicist, is reported to have said in jest that he and his coscientists were teaching the Quantum Theory on Mondays, Wednesdays, and Fridays, and the Wave Theory on the remaining days of the week. The problem child of physics has so far defied our best efforts to penetrate its mysteries. Because we do not know the exact nature of light, we also cannot know the exact nature of color. We have, however,

learned many things about color, and we are constantly adding to our knowledge. The fantastic laser beam, for instance, is nothing more than a beam of colored light that has been stimulated and amplified. Yet such beams will be used to cut through steel, or to operate on cancers inside the human body!

The most basic fact about color is, of course, that it is light. Without light, there is no color: "at night, all cats are gray." In bright light, colors become more intense, and when the light fades, they fade with it. We tend to accept these facts about color as commonplace. Actually, of course, even these facts are not simple. Certain kinds of light are "black" —they are invisible to us. Normally, however, the terms "light" and "color" are used to describe visual properties and their symbols.

With the help of a prism, a beam of white light can be refracted to display its component colors. A second prism is here used to regather the colors into a single white beam.

↑— invisible infrared invisible ultraviolet —↑

The visible spectrum extends from red to violet. It is bordered on one side by the invisible infrared, on the other side by the equally invisible ultraviolet rays.

We learn at school that so-called white light is composed of differing wavelengths which can be separated by passing a beam of such white light through a prism, thereby breaking it up into its component rays. This is easily confirmed by experiment, and what we see then is the spectrum, a continuous band of colors with red, the longest wavelength and the one with the least refraction, on one side, and violet, with the shortest wavelength and the greatest refraction, on the opposite side. Between these two extremes, we find yellow, green, and blue, as well as various mixed hues such as orange and blue-green. This band of colors, however, is only the visible spectrum: rays with wavelengths either too short or too long to be seen by the human eye extend on both sides of this spectrum. The visible spectrum is, in fact, only a very small part of the total electromagnetic spectrum, which includes radio waves several kilometers long on one side, and cosmic rays whose wavelength is less than a billionth of a centimeter on the other. Directly adjoining the visible red rays we find the infrared, or heat waves; next to the violet are the ultraviolet, or "black-light" waves, followed by the X rays.

We see a color when a substance—or a structure—reflects one or more of the spectrum's rays while absorbing the rest. Total reflection of all the combined rays results in the object appearing white; total absorption produces black. Because this is so thoroughly familiar, we hardly ever pause to think of why, for instance, our red jacket or green rug are red or green, respectively. They retain these colors only, of course, as long as there is enough light for the "color" in the material to reflect the red or green rays. If someone would awaken us in the dark of the night without turning on the light, and ask for the color of the rug, we still would automatically say "green," even though the rug in the dark would not be green but black or dark gray like everything else. What we mean, of

Pigments absorb, or "subtract," all except their own colors, which they reflect.

course, is that the rug is green in the light. Our eyes, delicately adjusted to seeing partially reflected light—in other words, color—are blinded by direct light sources, and even by total reflection, such as we get from sunlit snow or white sand.

Of all the colors, pure red fades most quickly when the light starts to fail. A red jacket will appear dark gray at dusk, when both blue and green can still be clearly distinguished. To look red to us, the jacket must be seen in fairly strong light. It must also contain a chemical substance, such as a dye, which, if pure, reflects only the red rays while absorbing all—or practically all—the others. But even if both dye and light are present, a third ingredient is needed for us to see the color red: this is, of course, the delicate mechanism of the human eye and its nervous system, which "translate" rays of a certain wavelength into something we call "red" and transmit the message to the brain. This has nothing to do with vision as such. There are people who can see very well but lack the specific capacity to distinguish color: they are color-blind. A person may be partially or totally color-blind; the latter happens rarely, but when it does, the afflicted person can see only the achromatic colors—black, white, gray— but none of the chromatic colors such as red, yellow, green, and blue. Partially color-blind people often are unable to distinguish red from other shades. Although color blindness is transmitted by women to their male offspring, they themselves rarely suffer from this deficiency.

Thus, the act of seeing and distinguishing a color is a complicated process requiring three different ingredients: (1) light; (2) the substance that reflects one or more of the white light's rays while absorbing the rest; and (3) the human eye's ability to distinguish each color and register the information with the brain.

In contrast to opaque substances, transparent matter lets light pass through unhindered. Partially transparent substances transmit only certain light rays while absorbing others. Thus, red glass transmits only the red, and green glass only the green rays, as everybody knows from traffic lights. The fact that certain rays can be filtered out is the basis of color photography and color printing, where specific color plates are made with the help of the appropriate filters that are added to the camera lens.

The chemical substances which reflect light rays and which we commonly refer to as "colors" are more accurately known as pigments, from the Latin word, *pingere*, to paint. Pigments are found widely throughout nature in inorganic as well as in organic matter. With the help of these pigments, we produce colors—dyes, stains, paints, inks—for scores of commercial uses. Many pigments have the tendency to fade and lose their color when exposed to light over any length of time, as we know to our chagrin especially from textiles. Pigments occurring in the tissues of living beings are no exception: natural-history museums find that many of their mounted birds have colors that fade quickly; others, whose feathers

Colored transparent substances act as filters, absorbing all except their own colors, which they transmit.

contain different pigments, are remarkably constant. The problem of fading pigments has plagued artists for centuries; Leonardo da Vinci is known to have worked long to find pigment mixtures which would keep their true colors after long exposure to light.

Pigments are sensitive to many chemicals. When we bleach the color out of a material, what we actually do is to alter or destroy the pigment's capacity to reflect specific light rays; a pigment's color cannot be destroyed by immersing it in any medium that does not attack the pigment itself, and a pigment's reaction to light outside of tissues remains the same as within. It is possible, for instance, to withdraw the pigment from a red feather by a chemical process; the pigment crystals thus isolated will retain their former color properties.

Among the most widespread animal pigments are the melanins, which are responsible for all blacks, browns, and grays found in the animal world. Black and brown hair, fur, feathers, skin, and eyes are due to melanin deposits in the respective tissues. This applies also to humans regardless of race; the only exception being certain members of the Caucasian race who have blue eyes and red or reddish-blonde hair.

Even if melanin does not appear as black or brown color in animal tissues, it is often present in the lower layers, and enhances the tissue's characteristic color by absorbing the rest of the light.

A complete lack of the body's capacity to produce melanin results in albinism. Albinos occur among human beings, including Negroes, and can be found in many animals. Perhaps the most familiar albinos are the well-known white rabbits, mice, and rats with their pink or reddish eyes.

A white mouse: example of albinism, easily recognized by the red eyes, pink nose, ears, and tail.

A weasel: example of leukemism. Dark eyes, nose, and tail-tip distinguish it from the albino, which lacks all pigmentation.

A slight biological "error" is responsible for all cases of albinism: the individual is born without the enzyme that produces melanin. The resulting lack of pigmentation lets hair appear white; the skin and eyes, actually colorless, appear pink or reddish owing to the blood vessels which show through the tissues.

Albinism should not be confused with leukemism, which simply means white coloring. By far the majority of white-furred or white-feathered animals belong to the latter group; albinos can be bred as a strain, but in the natural state they are usually quickly eliminated because of their greater vulnerability, and therefore remain the exception. Many creatures living in the arctic are white, and some exchange their dark summer fur or plumage for a white one when winter comes, thus assuring themselves of better camouflage against the white snow. All these animals are not albinos and have normal dark eyes and often dark-colored ear- or tail-tips and noses.

The combination of white fur or feathers, pink skin, and reddish eyes is usually, but not always, a reliable indication of an albino. Some albinos have pale blue eyes, for blue is a product of tissue structure and not of pigment. Blue and brown eyes are thus the two different kinds of color found in the animal world; the brown, a result of pigmentation, is a chemical color, the blue, a result of structure, is a physical color.

Structural colors in animals are rarer than pigment colors. The great majority of colors found in both plants and animals are chemical in origin and are produced by the organism, often through the food that is consumed. For many years zoological gardens were confronted with the problem of color fading, especially among birds such as the roseate spoonbill, the scarlet ibis, and the deep pink, salmon-colored species of flamingos. In captivity, these bright colors often faded to a pale, washed-out, light pink. Dr. William Conway, formerly curator of birds and now director of the Bronx Zoological Park in New York City, experimented with numerous kinds of food for his birds. He finally solved the problem of fading by adding large doses of chopped shrimp to the flamingos' diet; ever since, these birds have maintained their deep pink color.

Physical, or structural, colors are never affected in this way. Caused by the extremely fine structures of the surface tissues, which reflect certain light rays and eliminate others, these colors remain stable until the tissue itself is altered, damaged, or destroyed. They are not affected by chemical action that does not attack the tissues, nor can they be separated from the tissue: it is always possible to extract pigment from a feather, but structural colors are an integral part of the feather which displays them.

Among the several different types of structural color, diffusion and interference colors are the most widespread. The difference between the structural and the chemical colors is easiest to recognize in a kind of structural color which occurs frequently in the inorganic world: prismatic color, which is achieved by refraction, or bending, of white light in such a manner that the different wave lengths become visible. The most familiar example is the glass prism which separates white light into its component rays, allowing us to observe the spectrum. The "fire" of the

diamond is based upon the same principle. Probably the most striking instance of prismatic color in nature is the rainbow. To create this phenomenon, tiny drops of moisture have to form a prismatic curtain of "water beads" in the air, which glitters in all the spectral colors as the sunlight that strikes the droplets is bent. The classic example of diffusion color—our blue sky—results from the refraction and scattering of the blue rays only. The iridescent hues of a soap bubble are interference colors, which will be discussed in subsequent chapters.

The fact that structural colors are produced by structure and not by a chemical substance makes it easier to associate them with inanimate matter than with living, growing, changing beings, because the prerequisite for the constancy of such colors would seem to be certain rigid, inflexible, and unchangeable qualities difficult to imagine in animal tissues. Thus, it is not surprising to find that these brilliant colors occur most often in already "dead" tissues—ones that are fully formed and no longer subject to change, such as feathers and insect scales.

Because we take color in our environment so much for granted, we rarely think about the fact that the complex color patterns found in plants and animals must have been an important part of evolution.

2. A History of Color

How DID colors begin in living organisms? This question is as shrouded in mystery as the origin of life itself. Did the shadowy, soft-bodied creatures of the primeval oceans a billion years ago develop patterns and colors? Or were they as colorless as the most primitive living animals, the amoebas? We do not know. The evidence of much of today's low forms of animal life seems to indicate that the mysterious forces working toward what Dr. Portmann, of the University of Basel, calls "self-expression" of organisms were busy developing distinctive color patterns at a time when there were still no eyes to see them—before sensory organs, including eyes, had evolved. Almost certainly, they could do no more than distinguish between light and dark.

While fossils have told us much about the shape of the animals of millions of years ago, their *coloring* must remain in the realm of speculation.

It can be assumed, however, that many of the animals, including the reptiles among which were the ancestors of both birds and mammals, had varied color patterns. This probably did not apply to the large reptiles such as dinosaurs. If we can judge from the large living representatives of ancient orders—crocodiles or the giant tortoises—the "monsters" that walked the earth or waded in the swamps so many millions of years ago were spectacular because of size and shape, but not because of color, having probably mostly dull greenish- or grayish-brown coloring.

While color in *animals* of ages past thus remains unknown, no such problem exists with respect to plants. Fossil impressions of plants that grew hundreds of millions of years ago have shown us much about the shape of that ancient vegetation, and their color also is no secret: it was green. We are sure about this because the coloring of plants is intimately tied to their function of providing food for themselves. Plants that are not green, such as fungi, for example, have to depend on others for food; green plants can manufacture most of their own food only with the help of chlorophyll, the substance that gives them their green color. Chlorophyll is well known to us in its chemical composition. One molecule of chlorophyll contains 55 atoms of carbon, 72 atoms of hydrogen, 5 atoms of oxygen, 4 atoms of nitrogen, and 1 atom of magnesium. In this composition, the molecule reflects mainly the green portion of the spectrum, while absorbing especially the red rays. It is interesting to note in this connection that the reverse is true for hemoglobin, the pigment in the blood corpuscles of higher animals, which has the same chemical composition, with the exception of the magnesium atom, which is replaced by iron.

With the help of light—chiefly the red rays—the chloroplasts, the plant cells containing chlorophyll, manufacture carbohydrates in the process of photosynthesis. Carbon dioxide, which the plant gets from the air, and water are the other necessary ingredients. Owing to the magical properties of the chlorophyll-containing cells, light, water, and carbon dioxide suffice to produce starch, sugar, fats, proteins, and vitamins in the plant, which thus becomes the supporting basis for all life on the dry land.

This would be impossible without chlorophyll, and the color green is therefore frequently used as the symbol of life itself. What also becomes clear is the fact that the red light has a very special importance in stimulating growth, a fact that has been proven by various experiments not only with plants but also with animals.

About 150 million years ago, a sizable portion of the dry land was covered by green vegetation, and this land was inhabited chiefly by reptiles of all sizes and shapes and probably—at least among the smaller species—many different colors. Primitive insects, including giant dragonflies with a wingspread of two feet, flourished. But absent was everything which to us is color in nature at its most striking and beautiful: flowers, advanced insects such as butterflies, and birds. All the ancient plants were nonflowering. There were no blossoms, no birds, and no butterflies—a rather bleak picture. Then, during the Jurassic period, about 130 million years ago, a peculiar creature, half lizard, half bird, appeared on the scene. From excellently preserved fossils, we have been able to get a very good idea of the shape of the Archaeopteryx, the oldest known bird. Color, however, again remains a question mark. The lizard-bird could fly, although it surely was neither a strong nor a graceful flier. Its tail and wing feathers were fully developed, but its head with the toothed bill, as well as the long, bony tail, were purely reptilian. How much of the body was covered by feathers is unknown.

Nothing is known about the origin of feathers. The often-repeated theory that feathers are nothing more than modified scales may seem plausible at first but has been more or less discarded by modern zoologists. Feathers are such marvelously complex structures, light and flexible but extremely strong, that, scientifically speaking, to have to picture "modification" of reptile scales into feathers is scarcely less difficult than to imagine that feathers evolved independently. Today, most experts lean to the latter theory. They believe that scales and feathers were found side by side on the bodies of the earliest ancestors of our birds. The mystery of the origin of feathers, however, remains unsolved.

As for the coloring of Archaeopteryx, no one knows. Artists have pic-

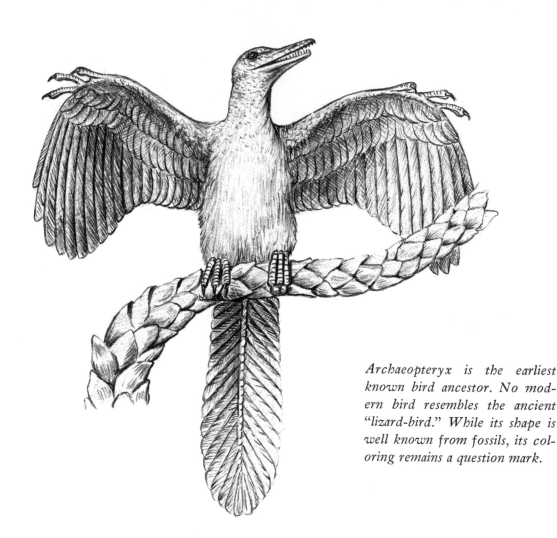

Archaeopteryx is the earliest known bird ancestor. No modern bird resembles the ancient "lizard-bird." While its shape is well known from fossils, its coloring remains a question mark.

tured the lizard-bird as reddish or brownish; others as greenish or grayish; and still others have shown it to display different colors on different parts of its body. The ancient bird may have been streaked or spotted. What we do know is that all the thousands of birds living today, with their tremendous variations in size, shape, color, and pattern, evolved from such ancestral stock.

In the Cretaceous period, which followed the Jurassic, and which is assumed to have lasted from about 120 to 60 million years ago, developments occurred which were of decisive importance. Flowering plants such as sassafras, magnolias, and many others appeared. With these plants came advanced, nectar-seeking insects to pollinate the blossoms and thus assure the plants' survival. And along with both came color: many-hued flowers

that developed in many types of plants from grasses to trees and colorful insects such as butterflies and beetles whose ever increasing variety of wing patterns gleamed in all the hues of the rainbow. The nectar-feeding insects were attracted by the smell as well as by the colors of the blossoms they visited. This does not mean, however, that the incredible variety of individual shapes, hues, and patterns of flowers which we know today were needed to attract these pollinators: as with animals, the wealth of variety among flowers seems to far exceed the demands of necessity.

Man, a late product of evolution, appeared on earth a mere two million years ago. While mentally superior, man's senses—smell and hearing, for instance—were inferior to those of most other higher animals. Rather surprisingly, though, man did possess the ability to distinguish a full range of chromatic colors, while most other mammals seem to have little or no color perception, and many are thought to be color-blind. Man, the highest mammal, thus shares his ability to see color, not so much with his closer relatives, but rather with his humbler fellow brethren of the long evolutionary journey: birds, reptiles, fishes, and insects.

What would it be like to live in a world without color, a continuous monochrome with only varying shades of gray between the extremes of black and white? It is a bleak and depressing thought, and one which normally would not occur to us, so much is color an integral and ordinary part of our life. The color-blind person is an exception, as of course is the fully blind person. By and large, all races share as their natural heritage the ability, not only to distinguish, but also to appreciate and enjoy, the various colors that adorn our natural as well as our man-made environments. Although culture and civilization have employed and refined color, its appreciation is not a product of culture and civilization. Rather, it was a strong trait which must have been inherent in our early ancestors, and one which found active expression long before even the most rudimentary forms of civilization were established. The often remarkable sense of color and design found in primitive cultures proves that this is a much more universal and "natural" ability than is the ability to do the abstract mathematical thinking upon which the development and progress of science is based.

Unlike science, art cannot be measured in rigid terms of "progress"—the cave drawings of 15,000 years ago, created by anonymous artists with primitive tools and colors, can be evaluated independently of any but esthetic standards.

Early civilizations attached great importance to color, and many colors had religious significance. The connection between light and color was well appreciated: colors disappeared with darkness and reappeared with light. Since light and color both came from heaven, they were endowed with supernatural and divine qualities. Although these ideas have survived in Western civilization only as dim racial memories in some of our legends and fairy tales, we still use colors as symbols or as expressions of our moods, traits, and qualities. Such symbols vary, but many have similar meanings among different races and nationalities. White and black, standing for light and darkness, can be called the basic colors, for all creatures, even those without organs of sight, can distinguish between light and dark. Because darkness was always feared by man, black is widely equated with evil, fear, gloom, doom, wickedness, horror, and death: black heart, black tidings, black mood, black sheep, black art or magic. White usually stands for purity, chastity, innocence, truth, peace, and goodness; white soul, white lily, white dove, white lie, white magic. Of the other colors, red, the color of blood, signifies courage, excitement, anger, strength. Blue stands for fidelity, serenity, but also for depression and melancholy: having the "blues." Green, the neutral color between the "hot" and "cold" hues represents the new, young, fresh, hopeful, and inexperienced: green memories, greenhorn. It is the color probably most universally accepted and used as the color of hope and symbol of life.

> Gray, my good friend, is every theory,
> And green alone Life's golden tree.

Thus Goethe in his great dramatic poem, *Faust*, defines the difference between dusty theory and pulsating life.

Blue and red seem to be the favorite official colors of many countries, with preference about equally divided, and closely followed by green.

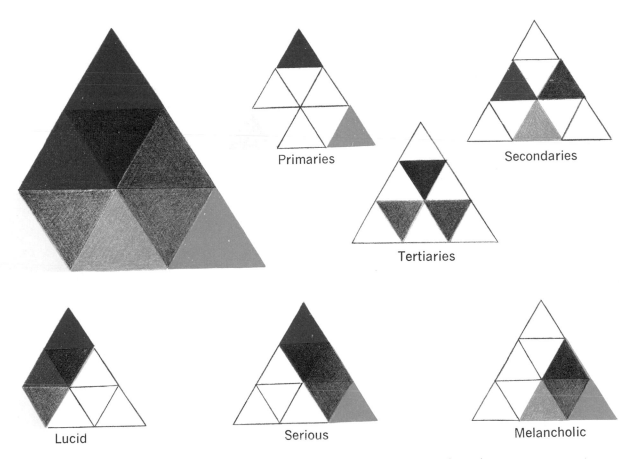

Primaries

Secondaries

Tertiaries

Lucid

Serious

Melancholic

The poet Johann Wolfgang von Goethe, in his book on color, sets up a color triangle, sections of which lend themselves to psychological interpretations.

It is interesting to note that the great majority of national flags show one or both of these colors, usually in a combination with white and sometimes black. Tests with red and blue light have shown that these rays influence certain bodily functions. Guinea pigs grow faster when exposed to red light, and hormonal activity in birds is accelerated by such exposure. It should be remembered that plants need red light to accomplish photosynthesis. The growth of plants exposed to blue light, scientists have discovered, was slowed down, and they showed signs of malnutrition.

There is much evidence that color acts in various ways on the nervous system, with red producing excitement, while blue has a calming, depressing effect. Tests with mentally ill people seem to indicate that red makes depressed people more cheerful, while violet light tends to calm the agitation of excited and excitable patients.

In view of the important part played by color in our lives—one historian went so far as to say that the history of civilization is in one way a history of color—it would be understandable if we were to conclude that, although we share color *vision* with other, much lower animals, the appreciation, use, and enjoyment of color is something reserved exclusively for human beings. However, even that may be too hasty an assertion. The great importance of color to certain animals in selecting their mates is apparent from the brilliant plumage donned by many male birds at mating time. This also holds true for certain reptiles and many fish, who show special bright colors when the mating season arrives. The females are clearly attracted by these colors. Far beyond such attraction, however, go the activities of certain birds which seem to indicate that they derive pleasure—a heightened sense of life and well-being—from the selection and use of colors for ornamental purposes. So unusual are the artistic habits and talents of these Australian bowerbirds that they have been the subject of intensive studies by zoologists. At mating time, the male bird builds complex structures, or bowers, which are not nests but playgrounds and showplaces, painstakingly constructing them of sticks and twigs. Up to three thousand sticks may be used for a single bower! The most startling fact about these playgrounds, however, is the amount of time and effort the bird spends in decorating them with a variety of colored objects. Depending on the species of bowerbird, the ornaments may consist of flowers—wilted blossoms are promptly replaced with fresh ones—stones, shells, berries, bits of colored glass, feathers, and other objects. A few species actually paint the walls of their bowers! One species, for instance, crushes berries, then uses the juice as paint and a wad of fibers as a brush. Another species ordinarily paints its bower walls with a mixture of charcoal and saliva, but if one leaves a package of wash blue in the vicinity, the bird is apt to improve on its original work by coating the walls a bright blue!

True, these little artists lack all freedom of choice in their activities: a certain species will always decorate its bower in a certain way and always paint the walls with certain colors, bound as it is by instinctive, inherited

urges. There can be little doubt, however, that the care with which the colored ornaments are selected, and the patience with which the bower is tended by the male long after the mating—he mates only once and remains faithful to the female—are evidence of an appreciation of his creation which goes beyond the need to attract the female. Uncanny, and also still unexplained, is certain bowerbirds' instinct for building their structures in a way which allows them to take full advantage of the sunlight: the bower walls are arranged so that light will fall all day long on the bird's "parade ground" with its different colored objects.

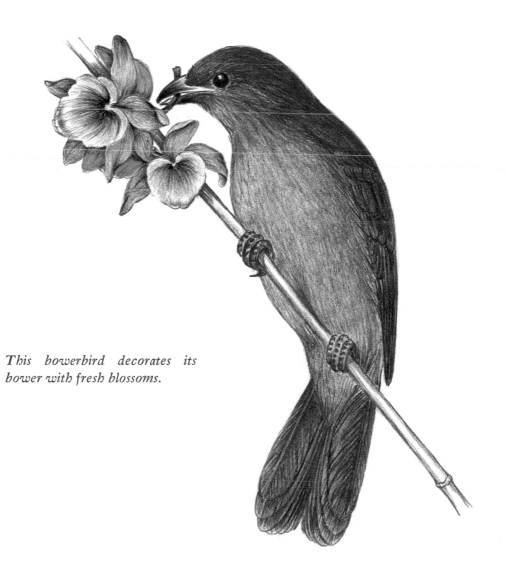

This bowerbird decorates its bower with fresh blossoms.

Never has color been more widely used in everyday life than today, and consequently, chromatology, the study of color in general, is a constantly expanding branch of science. Quite naturally, research into the field of animal pigmentation and coloration, as well as the color vision, perception, and reaction of animals continues on an increased scale. This research has yielded some fascinating insights into the part played by color in the lower levels of the animal kingdom.

In the past few decades, much has been learned about the color vision of certain insects through the exhaustive studies by Dr. Carl von Frisch, famed German authority on honeybees. After hundreds of painstaking experiments with these insects, Dr. Frisch and his collaborators had collected proof of some fascinating facts about, among other things, the color perception of bees. According to these findings, the flowers we admire in our gardens, meadows, and fields look quite different to the industrious little nectar seekers.

The range of human color perception, which seems to coincide more or less with that of birds, reptiles, and fish, does not hold true for many insects. Bees, for example, have a different spectrum. They cannot see red at all, but they can see a color which, for human beings, lies beyond the

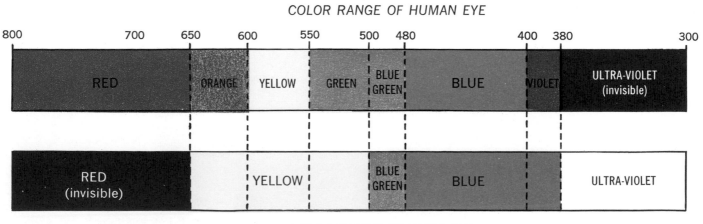

A bee's vision, including its color vision, differs markedly from that of a human being. The insect's inability to distinguish red is compensated for by its ability to see ultraviolet, which to us is invisible.

range of the visible: ultraviolet. Although we know the existence of ultraviolet from the effect of its rays, it is "invisible light" to us. The bees' spectrum, beginning with yellow on one side, ranges over blue-green and blue to ultraviolet on the other side. The quality of the color they see will most likely remain a mystery forever.

All hues that contain yellow, from orange to light green seem to appear to the bee simply as different shades of yellow. Blue-green, however, is a separate color. All the colors from blue to mauve and bluish-red are seen as different shades of blue. This color perception with its accent on blue and yellow is interesting in view of the predominance of yellow and blue or bluish-red wildflowers in those regions where honeybees are the main pollinators, and a conspicuous lack of flowers that are bright red. White flowers and blossoms, which also abound, are a special case, for they appear quite different to the eye of a bee: most white flowers look blue-green to honeybees. In order to understand why this is so, we have to make a short detour into the field of physical optics.

We know that a beam of white light separated into its component colors by a prism can be joined together again with the help of another prism. If, however, one of the colors is filtered out, the remaining light will no longer look white, but will instead assume the *complementary* color of the one that has been filtered out. This is rather easily explained by the theory that the visible spectrum is made up of three main color sensations: red, green, and violet. Yellow appears where red and green overlap; blue, where green and violet are joined. Yellow is therefore assumed to be a combination of red and green; blue, a combination of green and violet light. This appears to be borne out by the fact that we get yellow light if we project red on top of green light on a white screen. In the same way, blue results from projecting violet light on top of green light.

The three fundamental colors—red, green, and violet—are called the *primaries* of light. Together, they produce white light. This makes light the exact opposite of pigment, for the three primary pigment colors—pink, yellow, and blue—produce black when mixed together.

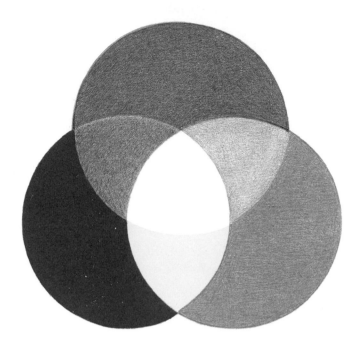

The primaries of light are violet, green, and red. Together, these colors produce white light.

Any two light primaries produce another color. It follows that of any two colors that produce white light, one must be complementary to the other; it provides the ingredient necessary for the production of white light. Red and blue light make white light; blue is complementary to red because it consists of green and violet light. In the same way, yellow, a combination of red and green, is complementary to violet, and pink, containing red and violet, is complementary to green.

Pigment primaries—pink, yellow, and blue—are the exact opposite of light primaries in that they, when mixed, produce black.

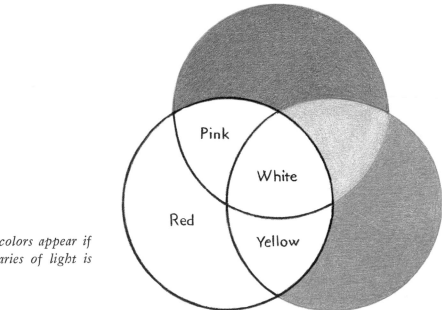

Complementary colors appear if one of the primaries of light is removed.

On the basis of these facts, it is easy to see why, if one removes one of the fundamental colors, the remaining light will assume the hue of the complementary, that is, the mixed, color. Filter out the red, and the remaining light will appear blue. Filter out the green, and what is left will look pink.

Returning to the white flowers and the way they appear to the honeybees, we find that the rule of complementary colors applies in this case also. Most of our white flowers, it has been found, filter out ultraviolet light, which, we must always remember, is a real color in the bees' spectrum. It follows that the bee will not see white when looking at such a flower. Instead, it will see the complementary color of ultraviolet, which happens to be blue-green. This means that where we see white apple blossoms among green leaves, or daisies in the grass, a bee sees brilliant blue-green shapes set against a background of pale yellow.

The bees' different color perception may be one reason why true scarlet wildflowers are so rare in those regions where bees are the chief pollinators, while being predominant in localities where small birds such as hummingbirds pollinate many blossoms. To birds, which see red as a brilliant color, these flowers are naturally especially attractive. Thus, it

To us, daisies are white flowers with yellow cen-
ters growing in green grass.

A honeybee, on the other hand, apparently sees
blue-green stars with yellow centers against a
background of pale yellow grass.

seems likely that there is a close connection between the predominant colors of the blossoms found in any one region and the color perception of their local pollinators.

For some time, one of the main obstacles to this theory was the scarlet-red poppy which is widely found in Europe's fields and meadows. The color of this flower greatly puzzled entomologists, for it seemed to contradict their findings about the honeybees' color vision: there can hardly be a more brilliant, fiery red than that of the poppy, and yet these flowers are always busily visited by bees. In an effort to find a solution to the problem, scientists examined the poppy closely. The result was a surprise: it was discovered that the poppy reflects not only the red wavelengths which we can see, but also the ultraviolet rays that are invisible to us but are an important color to the bee!

Research into the part played by ultraviolet as a color sensation for insects is continuing and may eventually explain much that is still puzzling to us, besides providing insights that may prove valuable in other fields of science. Some butterfly wings show traces of ultraviolet on sensitive photographic plates, and it must be assumed that, to insect eyes, these wings gleam in color combinations and patterns only partly visible to us. Further studies will most likely yield more information about this and other secrets of animal coloration.

3. The Blue Birds

ACCORDING to that great spinner of tales, Maurice Maeterlinck, the Blue Bird which brings happiness can be found at the third turning after you pass the Land of Memory. Who among us has not reserved a special place in his childhood memories, along with such other classics as Peter Pan and Alice in Wonderland, for that charming fairy tale by the great Belgian poet, writer, and naturalist? We recall the children Mytyl and Tyltyl and their long search for the Blue Bird of Happiness. Again and again they thought they had captured it, but when they looked at their catch in the light, they discovered that the bird they had was not blue. Finally, when they returned, they found that the Blue Bird had been in their home all the time without their realizing it!

This charming fable about the intangible quality of the thing called happiness could not help but establish blue birds as something special in the minds of its young readers, a feeling which lingers beyond childhood

years. The choice of the color blue for the bird in Maeterlinck's fairy tale was a happy one and was probably not accidental: blue birds are a symbol of good luck in many countries. But as the Belgian poet was also a naturalist, he may have had another reason for his choice. For unlike most other colors—red, yellow, brown, and black, for example—blue in birds is not the product of a chemical substance but is a physical, or structural, color, caused by the structure of the feather.

The difference between feathers with pigment colors, and those whose colors are structural is most strikingly demonstrated by a chemical test. If a red feather is dipped into a glass containing a suitable solvent, it begins to fade; at the same time, the liquid in which it is immersed acquires a reddish tint. The pigment drawn from the feather is now contained in the solvent. While the color has thus been separated from the feather, the pigment responsible for the color has retained its ability to reflect red light rays even when dissolved in a liquid. The same experiment with a blue feather would be negative, for no structural color can be separated from the structure which produces it, and, except for a few species, all blue in feathers from the lightest greenish-blue to the deepest violet is a structural color.

Although the color cannot be extracted from the ordinary blue feather, the blue can be made to disappear by immersing it in certain liquids. The blue feather will turn blackish or brownish, but this color change is only temporary. As soon as the feather dries, it again assumes its natural blue hue.

How does the feather produce blue? To understand it, we have to understand the general principle of the phenomenon first described by John Tyndall, a nineteenth-century English physicist. He was well known even in his day—he once showed Queen Victoria how to produce "lightning" in test tubes—and his explanation of why the sky is blue earned him worldwide fame. Ever since, all blue found to be based upon the principle first outlined by him is described as *Tyndall blue*. This includes the blue in various animal tissues, including the eyes of human beings, that is caused by light scattering, or *diffusion*.

On clear days, our atmosphere contains myriads of tiny dust particles and water droplets, most of which are smaller than the wavelength of visible light. Although sunlight can easily pass through the ordinary atmospheric layers, part of the light is refracted and scattered by submicroscopic particles. (Anything smaller than a wavelength of light is submicroscopic; it cannot be seen with the help of an optical microscope.) The amount of scattering varies with the wavelength. Violet light, with a wavelength of less than 400 millimicrons—a millimicron is one millionth of a millimeter and a standard unit in measuring light—scatters light about nine times as effectively as does red light, whose wavelength is about twice as long.

A light ray striking a particle smaller than its wavelength is refracted. The smaller the particle, the greater the refraction. The reasons for this are complex and have mainly to do with the fact that small particles are good conductors of electricity. Light has been found to have electromagnetic qualities. When a light beam strikes small particles whose absorption

Submicroscopic particles refract and reflect especially the shortwave, blue and violet rays.

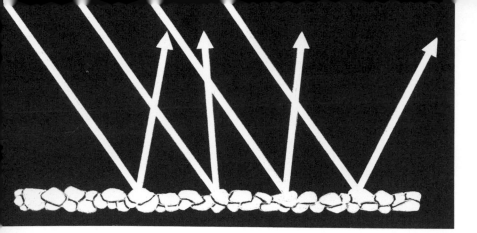

and reflection properties differ from those of the medium in which they are embedded, the particles react to especially the shortest wavelengths. In other words, the greater density of the particles causes the blue wavelengths to be most strongly refracted. The plane-polarized blue rays, in fact, are emitted at right angles.

Polarization, which is often misunderstood, means that the vibrations of the light waves are affected in such a way that they take on one definite form. In ordinary light, vibrations are assumed to be in all directions; in polarized light, only in one plane, which is perpendicular to the ray. If these vibrations are in ellipses, or circles, we talk about elliptically or circularly polarized light, respectively; if they are all in straight lines up and down, we call it plane-polarized. With the help of certain crystals that shut out light vibrating in all directions, we have learned to polarize ordinary light. Polarized light is employed in a number of ways from photography to making complicated chemical analyses.

Sunlight contains both ordinary and polarized light. Although we cannot distinguish one from the other without instruments, certain insects, crabs, and a number of other creatures have this ability.

When the plane-polarized blue light is emitted at right angles from the particles suspended in our atmosphere, it strikes other particles and is again refracted; in this way it is widely scattered and reflected, giving us the beautiful blue of our sky on a sunny day. The intensity and the vibrations of polarized sunlight vary with the height and the position of the sun in the sky. This may mean nothing to us, but it is of vital importance to other creatures, honeybees, for example. This is the mysterious compass which they use to find their way to the hive, even if their search for nectar has taken them miles away. Bees can distinguish polarized light, and the blue

of the sky therefore looks different to them than it does to us. All a bee has to see in order to get a bearing is a small patch of blue sky: because polarized light changes as the day progresses, the bee will know exactly where the sun is even if it is hidden behind a bank of clouds or a mountain.

It may at first be a bit disappointing to realize that we owe the "heavenly blue" color of the sky to the various impurities of our atmosphere. However, we must remember that any color can be seen only if some substance reflects part of the light. This explains why space, which has no atmosphere, and therefore nothing that refracts and reflects light, is completely dark and, of course, colorless.

An inferior kind of Tyndall blue can be produced at home with the help of a simple experiment. If, in an otherwise darkened room, the beam of a flashlight is focused on a glass of water to which a few drops of milk have been added, the water will appear bluish. This means that the blue rays striking the water are bent and reflected by the small particles of milk suspended in the water, while most of the other colors pass through and are absorbed by the dark background. If this blue appears rather weak, it is mainly because the particles are comparatively large and coarse, and some light other than the blue is reflected.

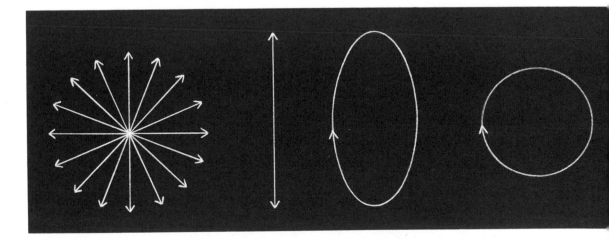

Ordinary light (left) is assumed to vibrate in all directions. Polarized light is believed to vibrate on one plane perpendicular to the ray. Physicists distinguish between plane polarized, circularly polarized, and elliptically polarized light.

Tyndall blue can be found in many different kinds of animal tissues. The blue color of eyes and the blue color of bare-skin patches displayed by some mammals are produced in the same way. In both cases, tissue structures bend, scatter, and reflect the blue rays, while underlying layers of melanin absorb the other colors.

Blue feathers are by far the most common as well as the most striking and attractive example of Tyndall blue in animals. If a small piece of a white, a red, and a blue feather is placed under a powerful microscope, the difference in the tissue structures becomes immediately visible. The horny matter of the white feather looks like cut glass or snow crystals, and its color is based upon very much the same principle—total diffuse reflection. A great number of tiny air spaces enclosed in the feather branches reflect the incoming light in all directions, and the feather looks white.

The horny matter of the red feather, on the other hand, is quite clear and transparent. The hollows of the small branches are filled with red

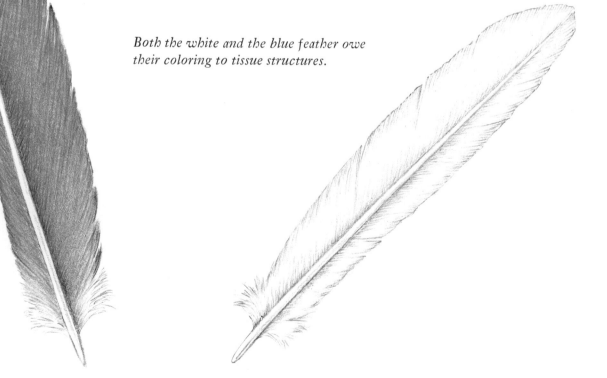

Both the white and the blue feather owe their coloring to tissue structures.

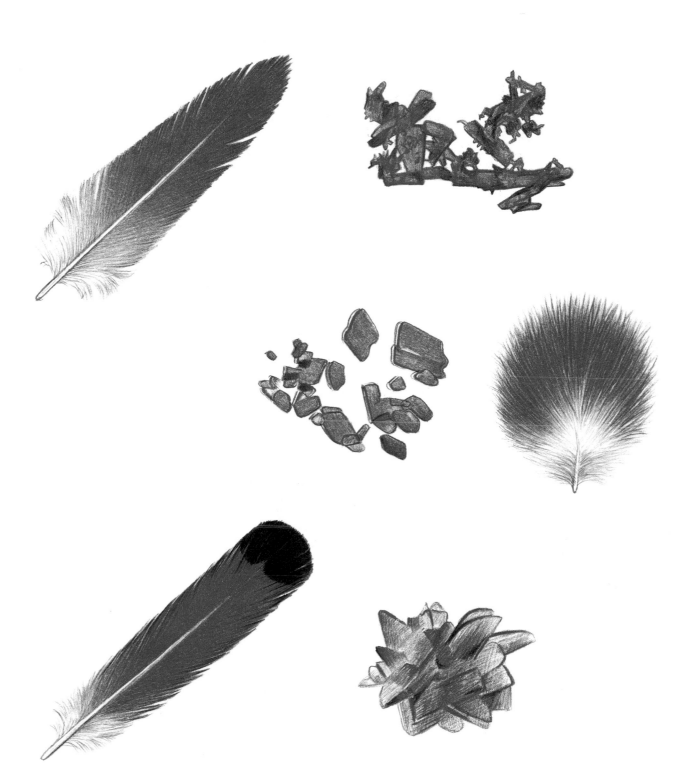

The three feathers on this page have similar shades of red, but their pigments are chemically very different.

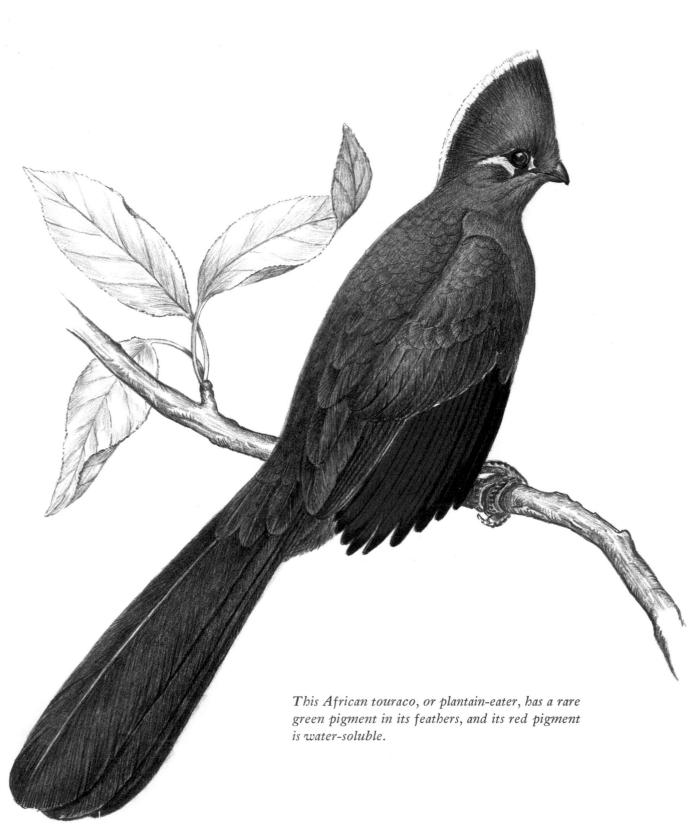

This African touraco, or plantain-eater, has a rare green pigment in its feathers, and its red pigment is water-soluble.

pigment, coloring matter which absorbs all the light except the red rays. Pigmentation of feathers, incidentally, is an interesting subject, and one that by no means has been fully explored. It will suffice here to say that the carotinoids, the yellow and red pigments found widely in feathers, can be produced only by plants, and can therefore reach the bird's system only by way of the food it consumes. Many birds have the biochemical ability to change certain yellow carotinoids into red coloring matter; others have to consume the actual red pigments in order to show red in their feathers. Occasionally, yellow variants of birds with normally red-feather areas may appear. These variants do not possess the ability to transform yellow into red pigment matter.

Very interesting because of their unusual pigmentation are the touracos, a group of African birds related to our cuckoos. Their plumage contains two pigments, one red, one green, called turacin and turacoverdin, respectively. The fact that these pigments have been named after the bird is suggestive of their special qualities. Green pigment in feathers is extremely rare. The red turacin also is unusual in that it is a copper salt

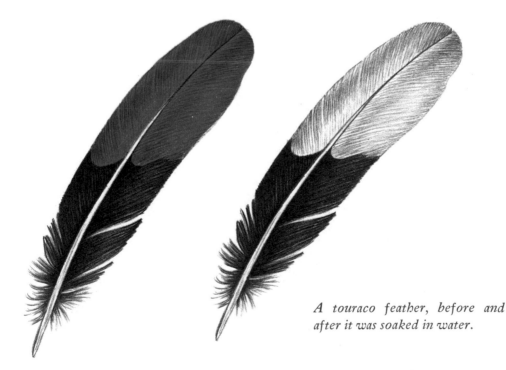

A touraco feather, before and after it was soaked in water.

Bluebird

Indigo Bunting

Honeycreeper

soluble in water. This means that the pigment can be extracted by the simple means of washing it out in water. How the touraco manages to survive heavy rains without dripping red color all over the place in its native habitat remains to be explained.

To return to our feather samples: looking at the blue feather, we immediately realize, even without being able to distinguish all details, that the structure is different from that of both the red and the white feathers.

Blue Vanga

Swallow Tanager

Blue Jay

All six birds on these pages, although not related, are similar in one respect: the blue hues of their feathers are structural colors.

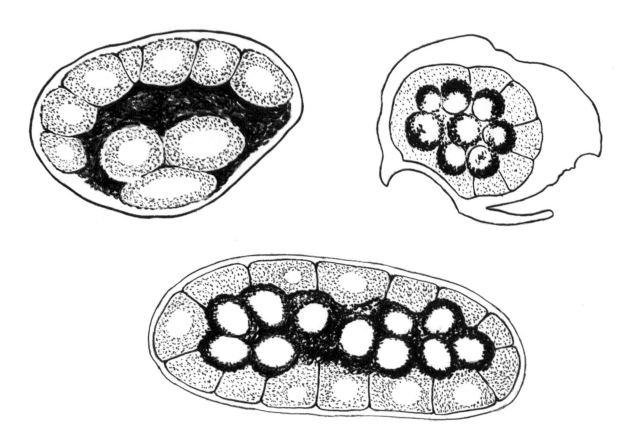

On this page, we see greatly magnified blue-producing feather structures from three different birds. The dark melanin "filling" assures better absorption of the other wavelengths, and thus helps intensify the blue.

The keratin, the horny feather matter, appears cloudy or milky. With a very strong magnification, it is barely possible to distinguish small particles suspended near the surface of the feather branches. However, only a transverse cut through a feather branch photographed by an electron microscope will provide a clear picture of this structure. Such a micrograph, greatly enlarged, shows something looking roughly like a piece of pastry stuffed with a dark filling. The latter is the melanin in the center of the branch hollow. Cells with what appear to be spongy walls and air spaces in the center are suspended in the horny layer which surrounds the melanin "filling." These cells are the tiny particles that refract and reflect blue light while the dark melanin absorbs all the other colors.

Like all other structural colors, the blue of feathers can be destroyed only if the structure that produces it is altered. That the color does indeed depend entirely on the structure and disappears when the structure is damaged can be demonstrated by a simple experiment: crush a blue feather, and it will promptly turn dark. All that is left after the blue-producing structure is destroyed is the melanin backing, which now becomes visible. A red or yellow feather, on the other hand, will retain its original color even if it is ground up, because the pigment is not affected by damage done to the feather tissue.

As mentioned earlier, the color of a blue feather may be temporarily eliminated by soaking it in a liquid of a certain optical density which fills the tiny air spaces in the feather substance. The feather then appears dark while it is wet but returns to its original blue color as soon as it dries.

Why is blue coloring in animals predominantly due to structure, while red and yellow hues are almost invariably the result of pigmentation? We do not know the answer to this question, but it is not because blue pigment cannot be produced in and by living organisms. The blue of flowers, for example, is a pigment, even though the intensity and brilliance of the color is frequently enhanced by the minute structure of the petals. Some crabs, marine snails, and other animals also have genuine blue pigment in their tissues, but the majority of blue found in animals is of spectrochromatic—structural, origin.

Most interesting is the fact that structural blue also accounts for virtually all the green coloring in birds, although there are also exceptions to this. A few birds, notably the touracos, have green pigment in their feathers. Ninety-nine percent of the green birds, however, are actually blue birds with a dash of yellow pigment, or yellow birds with blue structure. In other words, their green color is a combination of yellow pigmentation and blue feather structure. This combination accounts for all the shades of green we see in birds, from the lightest chartreuse to the deepest forest green. Variations in the blue structure, the melanin backing, and the amount of yellow pigment present allow for an almost unlimited range of hues.

The fact that green in birds is the product of this combination of two different types of color explains why both blue and yellow birds can be bred from the original green prototype. The most familiar and best-loved example of this phenomenon is the shell parakeet, which during the past one hundred years has become a favorite pet in Europe, the United States, and in other parts of the world as well. It was, in fact, almost exactly a century ago when the first parakeets were brought from Australia to Europe, where they quickly won over the people who made them pets. The demand for the little birds increased, and soon they were successfully bred in captivity. The early parakeets were all bright green with yellow heads and black-barred backs. About fifty years ago, the first blue parakeets turned up. Breeders concentrated on getting more of these beautiful color variants, and a few decades ago, not only blue, but also yellow, white, and very pale blue parakeets became a familiar sight in petshops all over the world.

How was it possible to get all these different colors from green birds without crossing them with any other breed? The answer lies in the fact that the green is a combination color and that each variant represents a color loss. Such a loss is another one of those "biological errors," such as albinism, that do happen occasionally, and occur during formation of the egg. In the case of the yellow variant, the blue structure was lost; in the blue bird, the yellow pigment. If a blue bird suffers loss of the melanin filling in its feathers, the result is a light blue shade. The next step—loss of blue structure—would produce a white parakeet.

Such color variants also occur occasionally among birds living in the wild state, but there individuals who are more conspicuous than the rest—as a white or yellow bird would be among green birds in green foliage—are more quickly eliminated by their natural enemies; thus, they do not get much of a chance to pass on their peculiarities to their offspring. Only in the safety of captivity, and by careful selection of birds with specific hues, was it possible to breed entire strains of different color variants.

Structural blue caused by light scattering is only one of two different types of spectrochromatic colors occurring in animals. Tyndall blue ac-

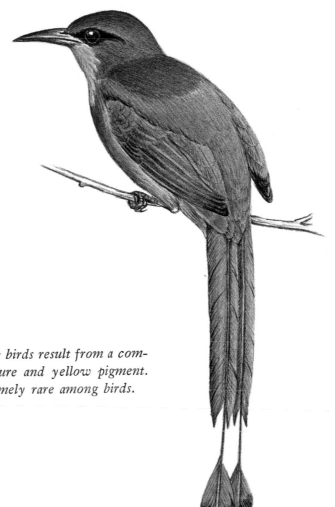

The green hues of these birds result from a combination of blue structure and yellow pigment. Green pigment is extremely rare among birds.

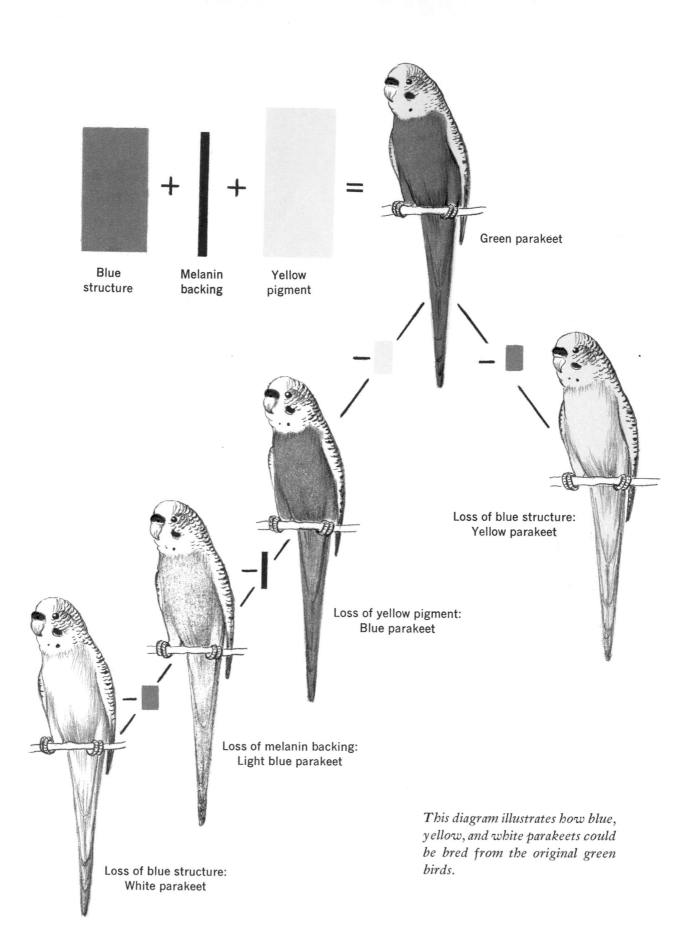

Blue structure + Melanin backing + Yellow pigment = Green parakeet

Loss of blue structure: Yellow parakeet

Loss of yellow pigment: Blue parakeet

Loss of melanin backing: Light blue parakeet

Loss of blue structure: White parakeet

This diagram illustrates how blue, yellow, and white parakeets could be bred from the original green birds.

counts for all the "flat" blue hues found in birds; these colors look the same when seen from different angles. Although beautiful in their own right, they do not compare in brilliance to those structural colors which are produced by submicroscopic structures much more minute and complex than those of blue feathers—colors whose iridescent hues range over everything from red, orange, copper, gold, and bronze to green, blue, and violet, and which are the result of a physical phenomenon known as *interference*.

4. The Mechanics of Iridescence

In'ter-fer'ence, n. (From INTERFERE.)
Physics. The mutual effect, on meeting, of two beams of light or of two series of pulsations of sound or, generally, of two waves or vibrations of any kind. When two beams of monochromatic light from the same source meet, especially if their waves have equal amplitudes, the neutralization of waves at some points and their reinforcement at others produces alternate light and dark lines, bands, or fringes. If the beams are composite, as in white light, the neutralization of certain wave lengths causes the lines, bands, or fringes to show colors (*see* INTERFERENCE COLORS). Cf. IRIDESCENCE, 1. This is satisfactorily explained by the undulatory theory of light. In the case of sounds, interference produces silence, increased intensity, or beats.

<div align="right">

— *Webster's New International Dictionary*
Unabridged Edition

</div>

THROUGH our increased knowledge of light in general we have also gained additional insights into interference since this phenomenon was discovered three hundred years ago. The credit for formulating the

principle of iridescence, or the "colors of thin films," as he called them, goes to Robert Boyle, contemporary and compatriot of Sir Isaac Newton. More than a century later, interference was explained in detail by the English physicist Thomas Young. According to Young's definition, very thin plates or films, such as a coat of oil on water, or the "skin" of a soap bubble, reflect some of the incoming light from their mirrorlike top surface. The rest of the light travels through the film and is then reflected by the lower surface. The light that enters the film is bent and deflected from its path by the film's greater density, or *refractive index*. The refractive index of air, which in physics is considered the norm, has been assigned the numeral 1, and anything denser than air therefore has a higher numeral. Assuming the oil of an oil slick were twice as dense as air, it would then have a refractive index of 2; light traveling through the oil is bent, and slowed down, twice as much as the same light traveling through air.

What actually happens when light enters a medium with a greater refractive index? The movement of the light is slowed down, the waves become smaller, and the traveling distance within the film is increased. In other words, the light cannot go straight through. After the light reaches the lower surface and is reflected, it has to make the return trip through the film, still at the same slowed-down pace. When this light finally rejoins the light that is reflected at the upper surface, it is out of phase. How

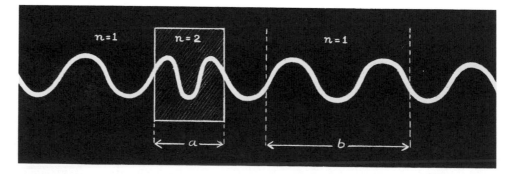

Light waves are slowed down in a medium with a refractive index greater than that of air. A refractive index (represented by the letter n) *of 2 indicates that wavelengths inside this medium are only half the size of light waves in air.*

Wave crest meets wave trough. All light is eliminated, and darkness results.

Wave crests of one ray do not meet the troughs of the other. Neither do crests and troughs coincide. The resulting light is weakened.

Wave crests and troughs coincide. Light is in phase, and the resulting color pure and strong.

Anatomy of interference.

much out of phase it is depends on the distance it has had to travel within the film, which in turn depends on two factors: the thickness of the film, and the angle at which the light strikes the surface.

If the phase difference between the beams reflected at the upper and lower surfaces happens to equal one full wavelength, or a multiple thereof, that particular wavelength—or color, in other words—will be reinforced when the light that went through the film rejoins the upper-surface reflected light. Reinforcement will be strongest—and the color purest—if the waves happen to have the same amplitudes, that is, if their crests and troughs are of equal height. All the other wavelengths are either weakened considerably or, where crest meets trough, eliminated. This, of course, results in only one color becoming visible. For instance, assume that a green ray, after having traveled through the film and back, has a phase difference of two full wavelengths when it rejoins the green light reflected at the upper surface. It is now in phase with this green light: wave crests and wave troughs of both lower- and upper-surface reflected green light coincide. The green color is thus reinforced. Because the

wavelengths of the other colors are different, they are by necessity out of phase and are therefore either eliminated or very much weakened. However, if the phase difference between the two green light rays were one and a half wavelengths, they would neutralize each other and become invisible. In that case, some other color whose wavelengths coincide would appear.

These facts hold true only for composite light. If the light is mono-chromatic—if it consists of only one color—the result of interference would be the dark lines, bands, and fringes mentioned in the dictionary definition. Darkness results when waves of the same amplitude are out of phase in such a way that wave crest meets wave trough. We thus have the apparently paradoxical situation that light plus light may equal darkness.

We have seen that the color of light reflected by a thin film can be changed simply by increasing or decreasing the distance the light has to travel within the film. Every change of this "traveling distance" causes a different wavelength to be in phase. This can be achieved in a number of different ways. One of them is to alter the thickness of the film. This, however, has its limitations, because films that are too thin reflect all the light, and those that are too thick eliminate only a few colors, with the result that the remaining mixture again appears colorless.

Shifting the angle of light incidence is another way of changing the traveling distance, and with it the phase difference, of that part of the light that has to go through the film and back to the upper surface. With every change of the optical distance a different color appears, and this is the phenomenon known as iridescence. Common occurrences of irides-cence in our daily lives are soap bubbles, with their rapidly changing, gleaming, pure colors, and the familiar oil slick on a wet street. Both are classic examples of the "colors of thin films."

Diagrams can provide a clearer picture of what happens when light beams interfere. Fig. 1 shows two beams of light striking the surface of a film, whose density, and therefore whose refractive index, is greater than that of air. While beam No. 1 is reflected at the upper surface, beam No. 2 enters the film, is refracted, and is slowed down by the denser

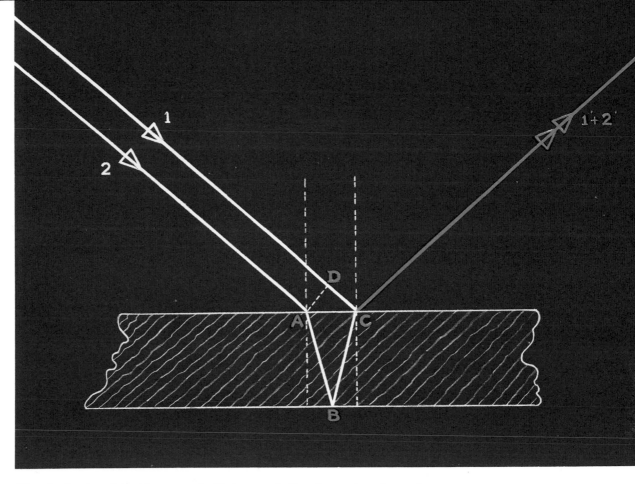

Fig. 1. Angle of incidence and thickness of film determine the color—or wave-length—which is in phase.

medium. Traveling to the lower surface, beam No. 2 is reflected there and returns to the upper surface, where it rejoins beam No. 1 at the point of greatest optical density, here marked with the letter C. The distance ABC minus CD is the phase difference between the two beams. Let us assume that this distance equals one full wavelength of green light. This would mean that the green light waves of beam No. 1 are in phase with the green light waves of beam No. 2 when they meet at point C. Because their wave crests and troughs coincide, what we now see is a pure green color, especially if the waves have the same amplitudes. All other colors, being out of phase, have been more or less eliminated.

In Figs. 2 and 3, the angle of incident light has been changed. This changes the traveling distance for beam No. 2 within the film in each case. It follows that the phase difference is also changed, and that, in turn, means that different colors appear.

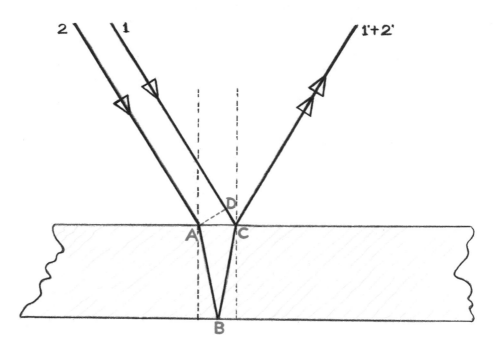

Figs. 2 and 3. By changing the angle of incidence, the phase difference also is changed. A different color appears.

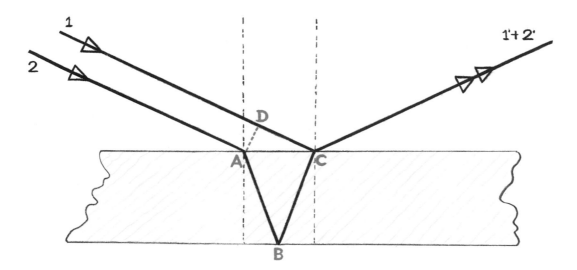

Fig. 4 shows that the optical distance can also be changed by substituting a thinner film. In this case, it is shortened, with the result that still another color appears even if the angle of light remains constant. This explains why different colors appear and disappear in rapid succession as air is pumped into a soap bubble and the "skin" becomes thinner.

All iridescence, regardless of whether it is found in organic or in inorganic matter, is based on the principle of interference, which causes light waves of composite light to reinforce, weaken, or eliminate each other alternately, depending on the phase differences and the amplitudes of the light waves involved.

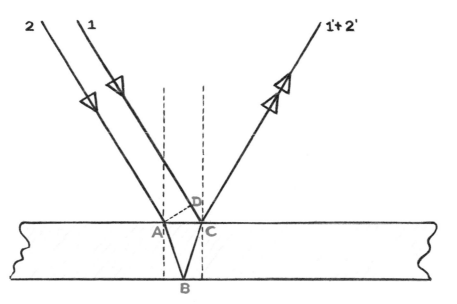

Fig. 4. A thinner film also changes the phase difference, even if the angle of incidence is constant, and thus also lets a different color appear.

Thin films, however, are only one of a number of ways in which light may be brought to interfere and produce colors; physicists have found certain structures that affect light in a way which causes interference.

When light strikes very thin slits, it is diffracted, or deflected from its path. Fig. 5 shows what happens in that case. Depending on the phase difference *AB*, one color is reinforced and the others are weakened. If such slits are arranged at equal distances from each other, we get what physicists call a *diffraction grating*. The German physicist Joseph von Fraunhofer produced artificial diffraction gratings for measuring the component colors of white light. Fine parallel lines were scratched into a sheet of glass with the help of a diamond, and then a beam of white light was directed onto this glass at angles ranging from 0 to 90 degrees. As interference colors appeared, the wavelength of each color was determined by mathematical calculations which took into consideration the phase difference and the amount of diffraction.

We now have examples of interference colors produced by thin films and thin slits. There is at least one additional way to get the same results, and this possibility—for a long time nothing more than an optical theory—is especially important to us here, because some of the most beautiful iridescent animal colors are based on this particular structure.

Research on how the blue color of the sky is produced had already established that very minute particles, suspended in a medium with a different refractive index, cause light refraction. If these particles are suspended diffusely throughout the other medium, they can produce color, as in the sky and in blue feathers. They cannot, however, produce interference.

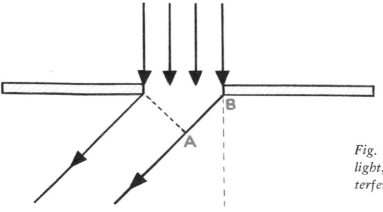

Fig. 5. Thin slits refract light, and can cause interference.

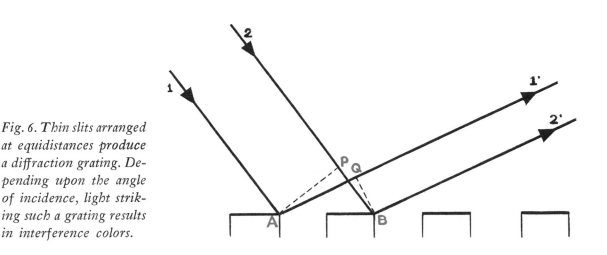

Fig. 6. Thin slits arranged at equidistances produce a diffraction grating. Depending upon the angle of incidence, light striking such a grating results in interference colors.

The situation changes if such particles are arranged on levels, or planes, which are spaced at equal distances from each other. Now interference becomes possible in certain circumstances. A structure called a *space lattice* in optics has all the particles distributed in a cubic arrangement on planes that are stacked one on top of the other like layers in a layer cake. Interference by means of a space lattice is caused by arranging several of these planes in a way that will produce the right phase difference for whatever color is to appear. Changes in the angles of incident light as well as variations in the distance between layers can cause different colors to appear. The normal color is considered to be that which is produced when light enters the film at an approximately vertical angle.

When light strikes a space lattice, one portion is reflected immediately from the top. Another portion is refracted into the underlying layers of the space lattice, where it is again refracted and reflected. A third portion enters directly between the particles into the lower regions of the space lattice and is reflected there. The more levels are stacked one on top of the other, the purer and more monochromatic the light reflected by the space lattice becomes, for physicists have proved that even neighboring wavelengths eliminate each other through interference.

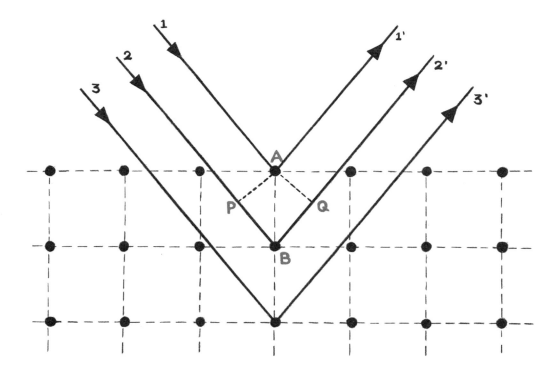

Fig. 7. A space lattice produces interference through the refraction properties of minute particles arranged in equidistant layers.

Sir William Bragg, the English physicist mentioned earlier, did much work on the problems of the space lattice. He found that the most important factor for production of interference was the maintenance of equal distances between levels. The position of the particles in each level was relatively unimportant.

Because a space lattice calls for submicroscopic precision structures, it long remained simply a theory, although physicists did find evidence of a natural space lattice while examining crystals with ultraviolet rays. No present-day machine can produce a structure that would come close to fulfilling the conditions necessary for creating a space lattice. With the development of the electron microscope came the possibility of examining submicroscopic structures in organic as well as in inorganic matter. It did not take long for scientists to find that, while creation of a space lattice

may be beyond the capability of man even today despite all the advances in science, these, as well as other structures that produce interference colors, are a common occurrence in living organisms. In fact, they are being produced by the billion daily in various animal tissues ranging from scales to feathers!

Interference colors are the purest and most brilliant colors known to man. They cannot be matched by even the brightest pigment colors in depth and intensity. In addition, the glittering play and change of hue that accompanies any change of light angle or observer position lends these colors a magic and beauty unparalleled by any others. It is, therefore, quite understandable that animals displaying such colors were objects of admiration and wonder long before people knew and realized that the infinitesimal structures necessary to create these colors—unmatched by anything human beings can create—are, in their precision and minuteness, a miracle in themselves.

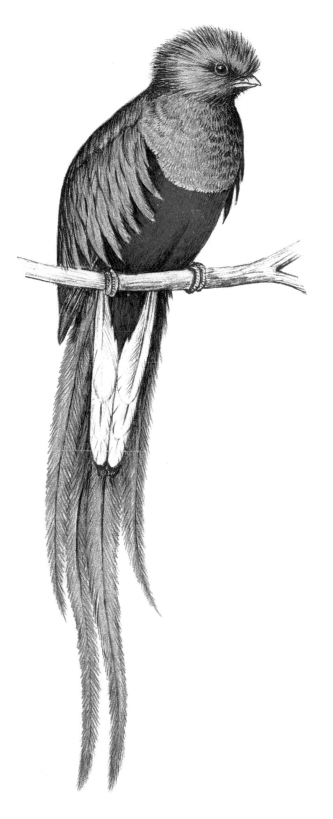

PART TWO

The Beauty of Iridescence

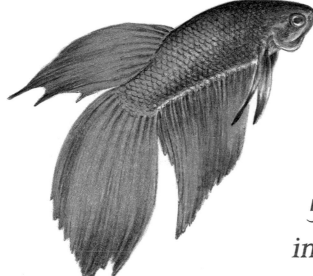

5. Iridescent Colors in the Animal World

O F ALL the colors found in the animal kingdom, the gleaming, glittering "rainbow hues" are without a doubt the most eye-catching and attractive. Animals, especially birds, with pronounced and brilliant iridescence have been favorites of man throughout the ages, some even figuring in ancient religions.

When we look at the distribution of color in the animal world, we are struck by the fact that one large class of animals—the one that ranks highest on the evolutionary ladder—is conspicuously lacking in bright, chromatic hues. This applies to both pigment and structure colors. There are no mammals with bright red, green, or blue coloring, and pink elephants are seen only in special circumstances. Except for some small skin patches displayed by a few mammals such as baboons, the coloring found in mammals is mostly limited to the brown-black-gray-white range, and all these colors except white are caused by a single group of

pigments, the melanins. Although combinations and patterns of these muted hues can be very attractive, and some of the reddish- and yellow-browns are relatively bright, the beauty of mammals is generally due more to their shape, strength, grace, and agility than to their coloring: horses, cats, dogs, and deer come readily to mind.

It is interesting to note that experiments have shown most mammals to possess only limited color vision. Many of them cannot see the bright, chromatic colors. They are more or less color-blind. The old, familiar tale that the red color of the matador's cape infuriates the bull has been discarded; it seems to be the movement, not the color, that enrages him.

Undoubtedly, some kind of connection exists between this deficiency in color vision and the muted, largely achromatic colors found among mammals. Man is an exception in that his color vision enables him to see and appreciate the full range of the visible spectrum from red to violet.

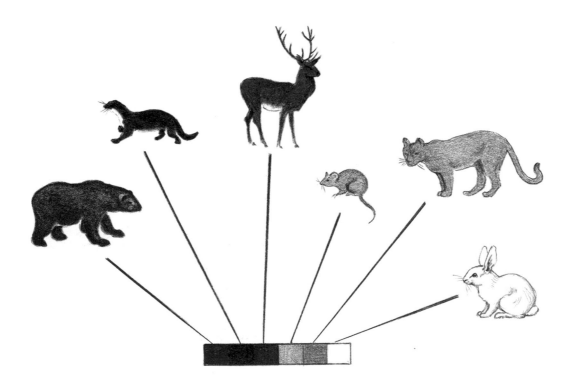

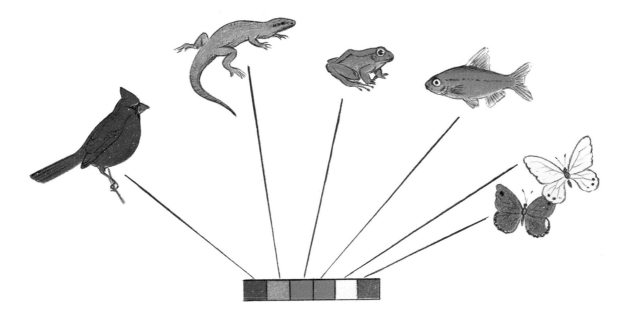

Although his body and hair coloring also lacks any bright colors—the red and golden-yellow hair coloring of certain members of the Caucasian race are the only exceptions—he compensates for this lack by wearing clothing and ornaments which make full use of available colors. He also uses makeup, dyes, and various cosmetics to supplement, enhance, or change physical features.

Research has shown that many lower animals share man's color vision, although there is some variation. Among the groups that do have a good color vision, we find many species with colorful body patterns, including birds, fish, and insects, as well as some reptile groups. Among birds and insects, structural colors are most frequently found. There is an excellent reason for this: both birds and adult insects have body coverings such as feathers and scales consisting of "dead," that is, fully developed and formed tissues that do not change once the initial growth period is completed. This, of course, is most important for the production of permanent iridescent colors, which are completely dependent upon the precision structures. Even the most infinitesimal alteration in these structures can

lead to the colors' winking out as though a switch had been turned off. In a manner of speaking, the structure *is* the color.

Among all animal tissues, the fully formed and stable horny matter such as that of feathers and scales is therefore the best vehicle for the production of permanent iridescent colors. Soft and "living," that is, changing, tissues are obviously less well suited to this purpose because the color will necessarily have less permanency. There are quite a few animals whose soft skin tissues display iridescent colors, but such colors are usually not lasting, and almost always disappear quickly when the animal dies, sometimes fading to a dull brown or gray within minutes after death.

A few outstanding examples of iridescent coloring in the animal world, whose color-producing tissues have been examined with the help of modern research equipment, will be discussed in detail in later chapters. They include the peacocks, hummingbirds, sunbirds, and Trogons, as well as some iridescent butterflies and beetles. In all these instances, electronic photographs have revealed many fascinating facts about the submicroscopic tissue structures that create the glittering colors. Iridescence is much more widespread in the animal kingdom, however, and a quick glance through the various groups will give us an idea just how it is distributed.

Anyone familiar with pictures of living birds of the world cannot help being impressed by the wealth of color and variety of pattern displayed by these feathered descendants of some ancient reptilian ancestors. From the brightest reds, blues, yellows, and greens to the most muted shades of brown and gray; from pure white to pitch-black, every color, shade, hue, and tint is featured by some species of birds. A number look as though they had served as a trial palette for the color experiments of an artist; in a few species, all the hues of the spectrum seem to have been combined. Others are a variation of only one color theme. Some are uniformly colored from beak to tail; still others display the most complex and intricate patterns on various parts of their bodies. Whereas the majority of birds get their coloring from pigments, there are many species that display the glittering "rainbow" hues that always assure their owners of an extra measure of

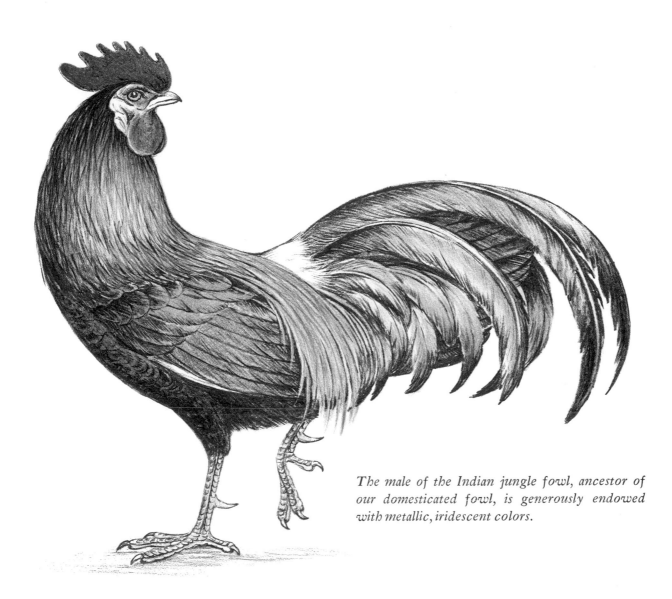

The male of the Indian jungle fowl, ancestor of our domesticated fowl, is generously endowed with metallic, iridescent colors.

attention. The limitations of space do not permit us to discuss more than a handful of the more brilliantly iridescent birds.

The group that includes the peacock is generously endowed not only with a variety of handsome feather forms and patterns but also with considerable iridescence. Among these birds of the pheasant family are many species which display areas of frequently brilliant structural colors. The familiar and widely known ring-necked pheasant, for instance, has shimmering green, bronze, and copper-toned feathers on its head, neck, and back. The rare and beautiful Congo peacock has gleaming green and bronze feathers.

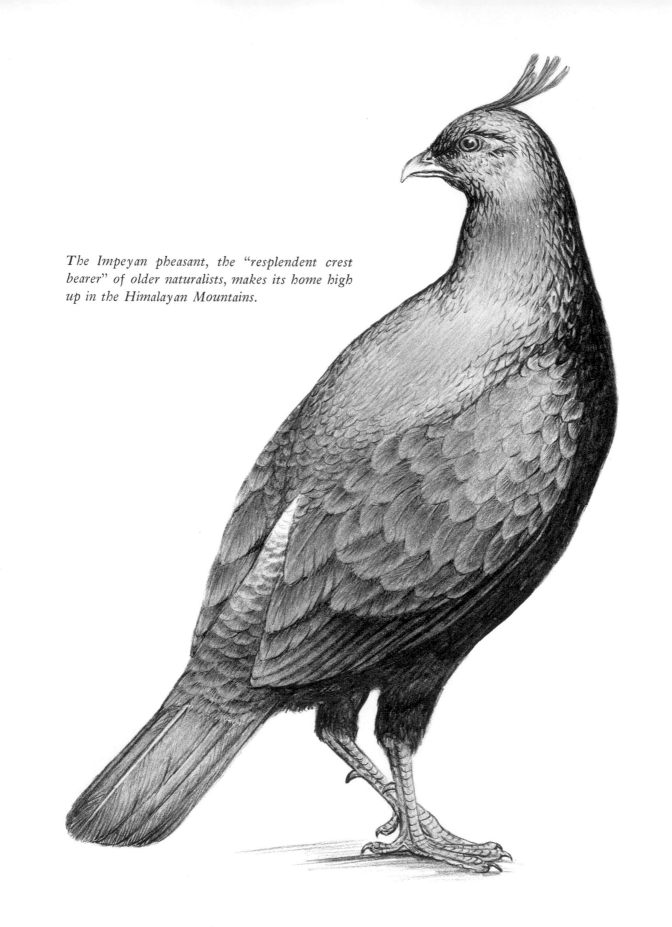

The Impeyan pheasant, the "resplendent crest bearer" of older naturalists, makes its home high up in the Himalayan Mountains.

Most pheasants have long, ornate tail or train feathers, of varied and often of intricate designs and patterns. Many males of our common barnyard fowl, which belong in the same family, are extremely handsome birds displaying large areas of metallic iridescence on various parts of their plumage.

Conspicuously lacking in any kind of train is the Himalayan pheasant, which has a short and very ordinary tail. However, this bird is compensated for its lack of ornate plumes by coloring of such breathtaking brilliance that older zoologists felt moved to give it the name *Lophophorus resplendens*, the "resplendent crest bearer." In more recent times, the bird, which wears a small crest of dark feathers on its head, has been renamed *Lophophorus impeyanus*, and its common name is now Impeyan pheasant. The change of name came about through Lady Impey, the wife of a highly placed British official in India in the nineteenth century. She was so impressed by the beauty of the Himalayan pheasant that she had a number of them taken back to England, where unsuccessful attempts at domesticating them were made.

The Impeyan pheasant lives almost exclusively in the Himalayan Mountains. It is found at very high altitudes, often close to the snow line. A large bird, somewhat heavier than the ring-necked pheasant, it appears even chunkier because of its short tail. No description can do justice to the colorful brilliance of the bird's plumage. Seen from the right angles, fiery copper blends into gold and bronze, bronze into green and blue, and blue into deepest violet. The head, neck, breast, back, and wings of the male bird gleam with this brilliant "molten-metal" iridescence merging into midnight blue and black. The entire bird looks as though some master craftsman of old had fashioned it from precious metals and then burnished it to a high gloss.

It would take too long to list all the other members of the pheasant family with iridescent feathers. Even some pheasant relatives, such as our turkeys, are very handsomely colored birds, with much copper and bronze iridescence over their backs, wings, and tails. It is unfortunate that most people consider the turkey mainly as something to be eaten at

Thanksgiving instead of as a handsome North American bird with beautiful colors and patterns.

So far, we have dealt only with birds whose plumage shows large areas of iridescence, which naturally creates an eye-catching effect. There are many cases, however, where relatively small patches of brilliant iridescence—such as the head, throat, or breast—can produce just as striking an effect, especially if these patches are set off by surrounding or adjoining areas of dark or dull-colored feathers. Many hummingbirds are excellent examples of such "selective" iridescence, but there are any number of other birds which display a similar arrangement. We find quite a few among a group which sixteenth-century Spaniards named birds of paradise. The first Europeans to see a few prepared skins, they believed these birds to be visitors from heaven, and named them accordingly.

When we look at these birds, it is easy to understand that their beautiful coloring, and their often exquisite, sometimes fantastic plumage, would have impressed anyone seeing them for the first time, and without any previous knowledge that such birds existed. The idea that they were creatures of another world, however, was due to those early Spaniards' misinterpretation of the prepared skins they saw, and their lack of zoological knowledge. The natives who prepared the skins always cut off their legs, closing the resulting holes in the skin so skillfully that the birds appeared to have had no feet. Together with their unusual plumage, this fact led to the story that the birds had no feet because they were constantly on the wing in paradise.

Among the more than forty species of birds of paradise, all of them native to New Guinea and the adjoining small islands, we find an amazing variety of shape—especially of the modified plumes sported by the male at breeding time—and coloring. No other group can match the many varying ways feathers are modified to serve solely for display. The males can erect, spread, arch, and otherwise arrange these elegant plumes in numerous patterns and shapes. Combined with the beauty of the colors, the effect is striking. It seems all the more amazing when we remember that the birds of paradise in all likelihood evolved from a common crow-

like ancestor undistinguished by either colors or plumes. The females have retained the ancestral characteristics and are generally dull-colored, ordinary birds.

In selecting those that display iridescent feathers, let us start with some of the smaller species. The superb bird of paradise is less than ten inches long but it nevertheless puts on quite a spectacular performance for its prospective mate. It has a sort of cape consisting of dozens of velvety

One of the smallest of all the pheasants, the peacock pheasant is also one of the loveliest.

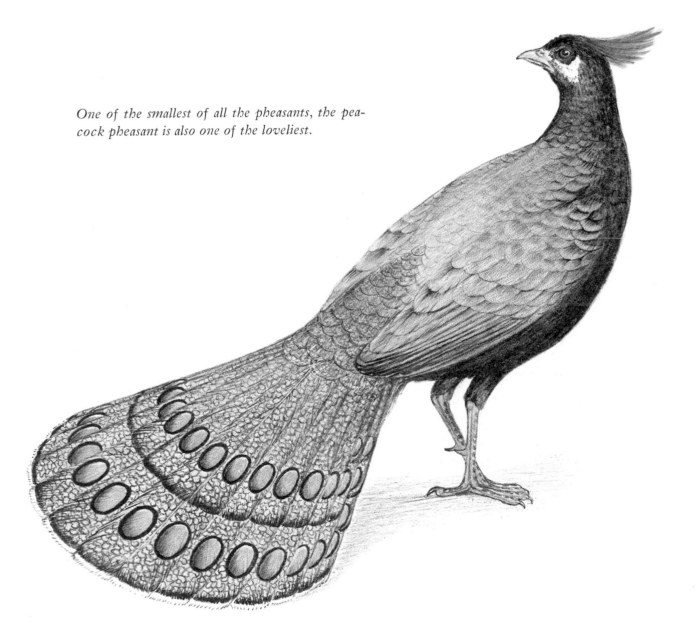

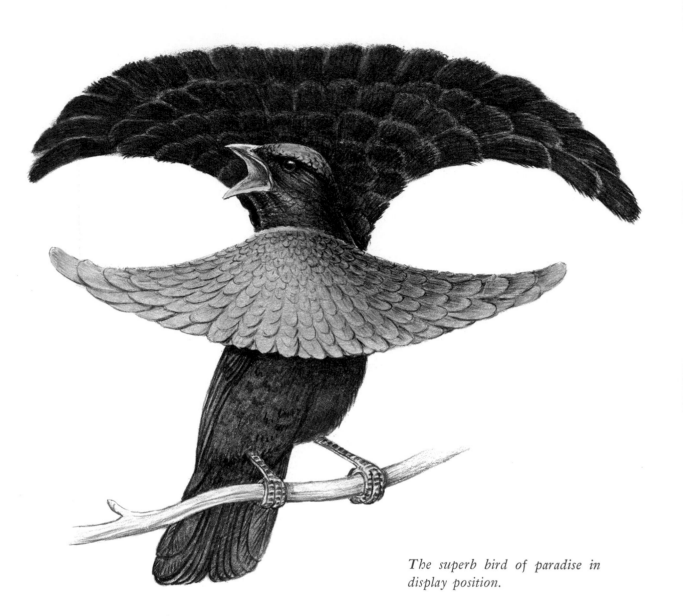

The superb bird of paradise in display position.

black feathers, graded in size, growing out of the back of the neck. These feathers can be erected and spread to form a large black fan behind the bird's head. At the same time, a large breast patch of brilliantly iridescent feathers, ranging in hue from blue-green to the deepest violet, is spread out until it resembles a second, upside-down fan whose tips almost meet with those of the extended neck plumes. By turning its head from side to side, the bird manages to show off the full range of its iridescent blue

hues. For good measure, it also at the same time opens its mouth wide to display the brightly colored greenish-yellow lining of its mouth.

Another dark-colored but slightly larger bird of paradise is the superb riflebird. The queer name is thought to stem from the bird's call, which sounds somewhat like the whine of a bullet. Seen under ordinary conditions, even the male riflebird does look rather crowlike except for its somewhat elongated flank plumes. On display, however, it is anything but drab. Spreading its wings wide, the bird throws its head all the way back, and then twists it from side to side. Thereby, it catches the light on a large throat patch of brilliant, glittering violet-blue, which appears even more intense because of the contrast with the dark brown and black of the other feathers.

Probably the most gorgeous iridescence found in the group is displayed by certain long-tailed members which are often called paradise magpies. The splendid bird of paradise, which fully deserves its name, measures about two feet, half of which consists of its long tail. The feathers of the back, tail, and wings are velvety black, and the entire underside has a beautiful malachite-green color. Head, throat, and nape, however, are brilliantly iridescent, gleaming mostly in emerald green with golden undertones. A "necklace" of fiery red gold-tipped feathers begins behind the eyes and forms a half-moon on the bird's breast. These red feathers glow like live coals when the light is right, with a luminosity that seems to come from beneath the surface. Seen from certain angles, though, the color disappears and the bird then looks almost all black. This winking-out of the color is typical of certain kinds of iridescence and, as we shall see, is the result of special tissue structures. Most of the examples of iridescence among birds mentioned so far belong to groups that live in the tropical regions of the world. Such colors are also found among birds of the temperate zones, but they are not as brilliant as those of the tropical species. This is consistent with the fact that animal colors in general are brighter and more vivid in the latitudes near the equator. Various theories have been advanced to explain the fact that certain very brilliant colors are found in the tropics only. Some biologists believe that the accelerated rate

of metabolism in the hot climates may play a part, but so far no really satisfactory answer has been found.

One of the most familiar northern birds with iridescent coloring is the ever-present, and often obnoxious, starling. Its black plumage is glossed with purple and green. Its tropical relatives, especially the glossy starlings, have brilliantly iridescent coloring.

Another northern bird with rainbow hues on a black background is the grackle. Among the several species, the purple grackle is endowed with the strongest iridescence. From a short distance, this blackbird has a neck and back which shimmers in hues ranging from green to purplish and bronze. The females are much less iridescent than the males.

Iridescence should not be confused with gloss. Many birds have pigment-colored feathers that have a glossy, silky sheen. A bird which is

Tropical relatives of our starling, both the splendid glossy starling and the amethyst starling (opposite page) are found in Africa. At certain angles, the feathers of the amethyst starling turn from violet to a reddish purple rarely seen in birds.

glossy black, and one whose black feathers show different colors as the light angle changes, are literally birds of a different feather, though gloss and iridescence may sometimes be found in the same bird.

Moving on to the group just below the birds, we find that reptiles cannot begin to match the variety of pattern and color that distinguishes the winged, feathered descendants of some ancient reptilian ancestor.

Although many snakes and quite a few lizards have bright, attractive color patterns, the majority are rather dull-colored creatures displaying mainly brownish, greenish, and grayish shades. Entire groups, such as the crocodiles and alligators, have no brilliant chromatic colors, and turtles and tortoises have very little.

As mentioned earlier, iridescent colors can be permanent only if the tissue structures that produce them remain unchanged. Because they constantly change their skins, shedding the old one and growing new layers underneath the old, reptiles cannot have any permanent iridescent colors. Some species do, however, display iridescence shortly after shedding their old skin. This phenomenon is especially pronounced in the boas and pythons, a group of primitive snakes. The most famous of these "iridescent"

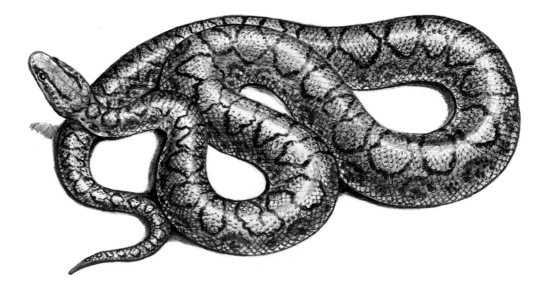

A rainbow boa shortly after molting temporarily displays iridescent colors.

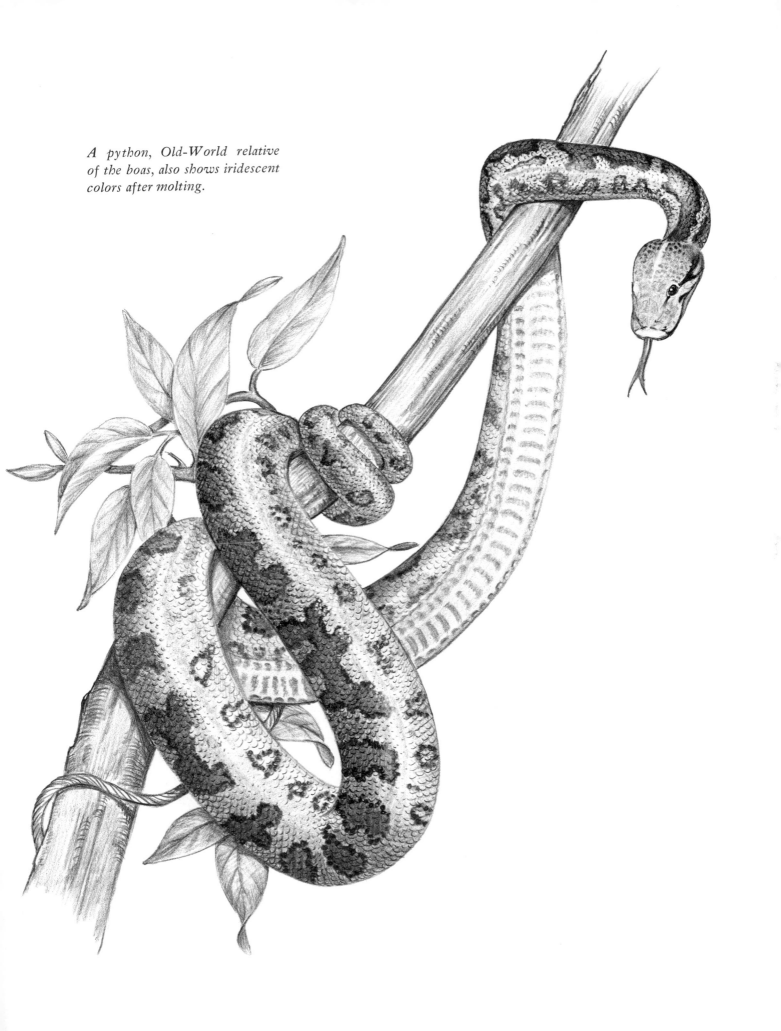

A python, Old-World relative of the boas, also shows iridescent colors after molting.

snakes is a South American species appropriately named rainbow boa, which gleams with a kind of opalescent play of colors after each molt. Several other boas as well as pythons—the Old World relatives of the boas—display the same phenomenon. Vergil must have seen one of these pythons just after it had shed its old skin, for in the *Aeneid* he gave a vivid and picturesque description of a giant snake that had coiled itself about the tomb of Anchises, father of the Trojan hero Aeneas:

> Scarce had he said, when from the shrined base a slippery snake trailed seven huge coils, in each seven folds; and circling tranquilly the tomb, slid o'er the altar; dark blue streaks its back lit up, its scales a sheen of spotted gold as (when the sun shines opposite) the bow darts from the clouds a thousand varied hues.

Poetic as it is, it is also a very accurate depiction of a python after a molt.

Although these colors are attractive, they do not last. The new skin grows old and another one begins to form underneath; as this happens, the colors disappear, because the skin structure is altered enough to eliminate the physical basis for interference.

The same thing holds true for certain lizards, which have beautiful, gleaming metallic colors for a short time after shedding the old skin.

Continuing our descent of the evolutionary ladder, we find that iridescent colors in skin tissues of amphibians are virtually nonexistent. However, among the fish, classed just below the amphibians, we find not only a great range and variety of bright and vivid colors but also many instances of beautiful structural colors, quite a few of which are iridescent. These colors are much more permanent than those exhibited by snakes after shedding, and will remain throughout the life of the fish. They disappear almost invariably when the fish dies, and there is no way of preserving them, for the slight change in the tissues that comes with death is enough to destroy the precision arrangement necessary to create the rainbow colors.

All the same, the oceans and streams of the warm zones yield a tremendous variety of fish with almost every kind of color combination that

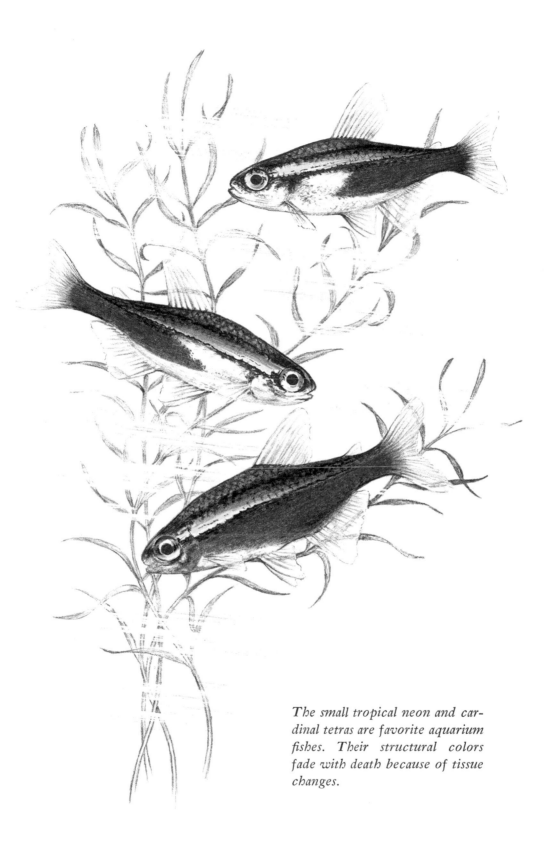

The small tropical neon and cardinal tetras are favorite aquarium fishes. Their structural colors fade with death because of tissue changes.

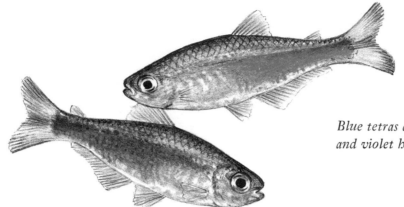

Blue tetras display iridescent blue and violet hues.

can be imagined. While many of them are pigment colors, others glitter in the shifting, changing rainbow hues that reveal their structural origin. Colors in fish may be located beneath or in the scales, or even in the thin outer skin that covers the scales.

Probably the most beautiful of all colors and patterns displayed by fish are those found among the smaller species that inhabit the streams of tropical America, Africa, and the Indo-Australian region. Many of these are favorites of the aquarium enthusiasts. There are, for example, the characins, which are usually called tetras by aquarists. The famous neon

The glowlight tetras have structural colors which seem to come from beneath the surface, leading to the popular misconception that they are luminescent.

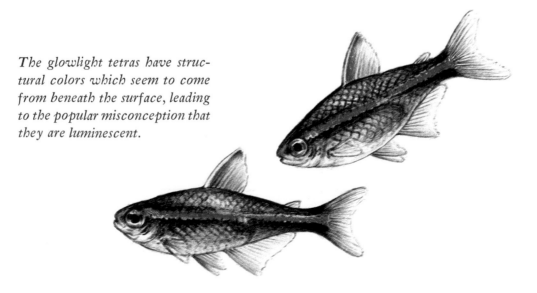

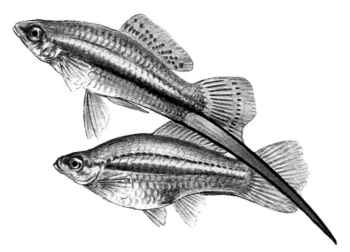

The colorful swordtails show almost every hue of the rainbow.

tetra is a very small fish, but is valued for its brilliant blue or blue-green and red coloration. The cardinal tetra has more red, and the glowlight is salmon pink, with a brilliant pink stripe running from tail to nose. These fish all look as though they are lit up from inside, and some people seem to think they are a kind of glowworm among fishes. This, of course, is not so; the glowing hues are structural colors.

Another group that has many beautifully colored members is the family of Anabantids, which includes both the gouramis and the bettas, also known as the Siamese fighting fish. The male dwarf gourami, with his bright blue breast, and blue-and-red-striped body, is one of the handsomest of all aquarium fishes. The moonlight gourami is an exquisite, ethereal fish, displaying soft, mother-of-pearl-tinted hues.

The Siamese fighting fish, with their enlarged veil-like fins, are probably the most spectacular of all the aquarium fishes. Bettas come in a variety of colors. The blue bettas have a breathtaking blue color that shades into violet and purple, and gleams in a rare purity and depth of hue.

Although we know that all the metallic and iridescent colors are based upon interference, the exact nature of the structures that produce these colors in fish has not been examined. Obviously, this presents formidable difficulties because of the type of tissues involved.

It is a different story with another class of animals which, next to birds, has the most beautiful structural colors in the animal kingdom. Moreover, most of these colors are permanent and last long after death. Insects are a huge group, and a great many of its more than 700,000 members have bright and attractive wing and body patterns. Even though many of the colors are pigmental in origin, a fairly large percentage are based on structure only. Excluding for the moment the iridescent butterflies and beetles, which will be discussed in later chapters, there remain many other insects with varying degrees of iridescence. Some of them are very small, but under a magnifying glass or microscope dazzling colors leap at the eye. The eyes of the green lacewing fly, for example, gleam in a green-golden iridescence that makes this delicate and beneficial insect—lacewings, and especially their larvae, the aphid lions, destroy aphids in great numbers— a thing of pure beauty. The eyes of many ordinary flies also show a magnificent iridescence, and some, including a number of filth-loving species, have nevertheless beautiful steel-blue or golden-green bodies. A number of small, dainty flies are endowed with bright metallic hues.

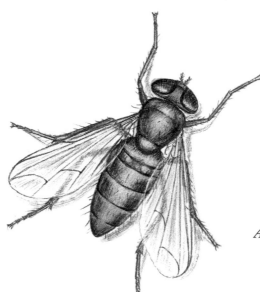

A small, strongly iridescent flower fly.

A section of a fly's eye, enlarged about 80 times. The multicolored iridescence disappears with death.

And then there is that long-bodied, swift, and terrible nemesis of all flies and other flying insects: the dragonfly. Many of these insect hunters have wings, and especially bodies, that glitter in iridescent hues. In flight, dragonflies are little more than a flash of a jeweled needle and diamond-studded wings in the sunlight; only when they are at rest, typically with their wings spread horizontally, is it possible to see details.

Dragonflies and their smaller cousins, the damselflies, form a single order. They belong to an ancient insect group that has existed for some two hundred million years. Dragonflies with a wingspread of two feet, probably the largest insects that ever existed on earth, flew and hunted in the dinosaur-ruled primeval swamps many millions of years before Archaeopteryx, the reptile-bird, appeared.

Today's dragonflies are also found near the water, for that is where their peculiar-looking larvae live and hunt until the time comes for the adult insect to emerge from the last nymphal skin.

Dragonflies have frequently been described in the folklore and poetry of many lands. They were favorites of ancient Oriental artists, who painted delicately tinted watercolors of them or cast them in precious metals. To realists unimpressed by their wraithlike appearance, their swift and agile flight, and their often beautiful colors, the fact that they are beneficial insects which destroy a great number of pest insects such as mosquitoes, flies, and midges will seem more important. However, there

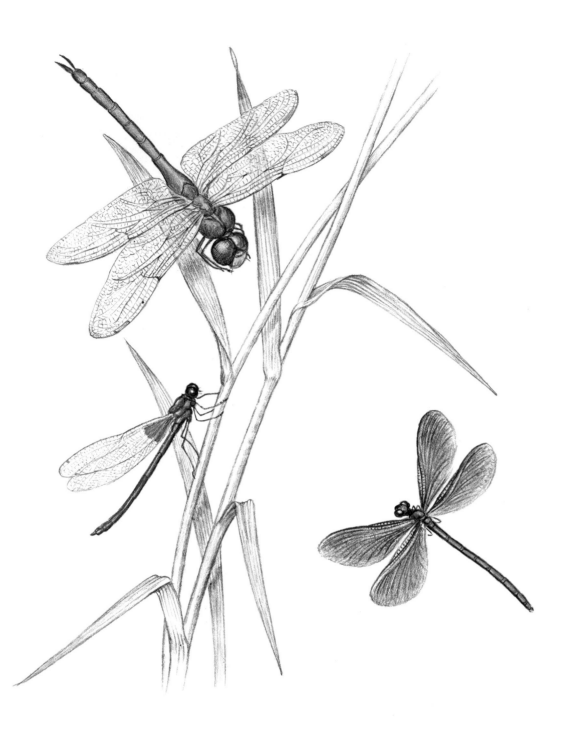

Although many of its members have dull coloring, dragonflies as a group are richly endowed with structural, metallic hues. The dainty damselflies are distinguished from their larger relatives by their habit of resting with their wings closed instead of spread.

are probably few people who will fail to admire the glittering colors displayed by some of the most attractive species. The color is generally concentrated on the long, slender body, and the wings are usually more or less transparent and glassy. A few species, and especially some tropical kinds, also have colorful wings. Both the body and the wings of certain damselflies are a deep blue or violet, and some Oriental species have patches of iridescence on their wings that catch the light and make them gleam. Bright gold, green, or ruby-red bodies are typical of many other kinds. This rainbowlike coloring also is often found in the huge compound eyes of dragonflies—eyes which enable them to spot their insect prey in midair.

Possibly the most solidly iridescent insects, with the exception of certain butterflies and beetles, are a group of small Hymenoptera called cuckoo wasps. Their popular name refers to their habit of laying their eggs in the nests of others; their scientific name, *Chrysididae* (*chrysis* means "golden"), is a tribute to their attractive coloring.

These wasps frequently display an iridescent emerald green which may shade into a shining ruby red with golden overtones, or a deep, intense blue. Changes of light angle create a dazzling play of color.

Cuckoo wasps have a very hard exoskeleton, which not only helps protect them against attacks by the owners of the nests they parasitize, but

Cuckoo, or gold, wasps display a variety of structural colors.

which also has the incidental advantage of stabilizing the structures that produce the colors, so that they are fairly permanent and remain after the death of the insect. Under the microscope, the integument of the cuckoo wasps shows a closely pitted surface on all iridescent parts. This structure permits production of interference colors.

Under a microscope, a small portion of a cuckoo wasp's exoskeleton reveals its pitted, multicolored surface.

Leaving the insect class and looking over the lower strata of the animal kingdom, we find that a number of aquatic creatures have iridescent colors. There are, for instance, marine worms with attractive opalescent hues. Other primitive animals, which often have no eyes, are nevertheless endowed with beautiful rainbow colors. Because all these creatures are soft-bodied, their color disappears soon after the animal's death. This does not, however, hold true for what is the most famous, most sought-after, and most precious of all opalescent organic substances: the hardened secretions of oysters and other shellfish known commercially as mother-of-pearl and as pearls.

Mother-of-pearl is found as a lining of the inside of the shell in various types of shellfish. Some of the most beautifully iridescent mother-of-pearl

is produced by the large abalone. The entire inside of this mollusk's ten-inch-long shell is covered with the rainbow-hued nacre, as the secretion is called. Abalone shells are used for ornaments and jewelry. Several differ-

Portion of abalone shell, slightly enlarged, showing the multi-colored mosaic of this shell's nacre.

An abalone pearl, enlarged 4 times.

Abalone shell is often used in jewelry and ornamental designs, such as this silver pillbox.

A fine pearl oyster shell, polished to show the strong iridescence. These shells are a main source for mother-of-pearl.

ent color variants of abalone are known; the nacre of the so-called red abalone shades more into pink tones, while the blue abalone has a predominantly blue-green opalescence.

Before the discovery of various suitable artificially produced substances, mother-of-pearl was used exclusively for fine buttons. In those days there was a great demand for pearl shells, and populations of entire regions, especially on the island of Polynesia, lived on the proceeds of the pearl and mother-of-pearl trade. Today the demand has fallen off sharply, but mother-of-pearl still is being used for a number of purposes, and a rich haul of fine pearl shells is still a cause for celebration in those regions.

Pearls, abnormal growths found usually in oysters and certain other mollusks, are composed of very thin layers of nacre deposited concentrically around foreign particles. Pearls are the only gems produced by

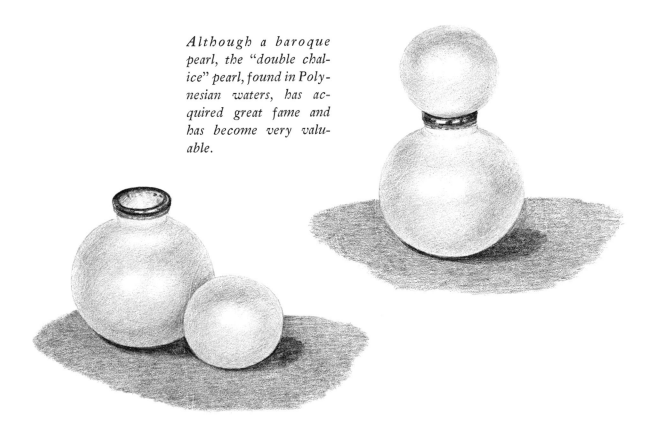

Baroque pearls are not very valuable. However, the black pearl in this lot is quite rare.

the ocean. They need neither cutting nor polishing, and their fame and appeal is as old as man's civilizations. Even today, the word is often employed to describe something rare and costly. Although there are colored pearls, including black, pink, and yellow ones, the typical fine pearl is

Although a baroque pearl, the "double chalice" pearl, found in Polynesian waters, has acquired great fame and has become very valuable.

Many familiar shells display the typical "mother-of-pearl" colors in a soft play of rainbow hues.

grayish-white, and has a weak opalescent shimmer. The "colors of thin films" which layers of nacre can produce are much more clearly visible in the common types of mother-of-pearl.

The truly fine, valuable pearl must be completely round and even. Such pearls are not found very often; most pearls are somewhat irregular. Called "baroque" in the trade jargon, these pearls are comparatively worthless, but are used in inexpensive jewelry. Cultured pearls, produced by artificially induced growths in oysters, have become very popular and are not expensive. Japan is a leading exporter of cultured pearls.

Portion of an opalescent shell shows the mosaic of different colors ranging from pink and yellow to blue and violet.

Instead of an iridescent lining, many shells of varying size have opalescent exteriors, displaying a handsome, soft play of rainbow hues that makes such shells favorites with many collectors.

In the chapters that follow, we shall see what the most modern research has revealed about the miraculously fine structures in organic tissues that give us the beautiful rainbow colors we admire in so many animals.

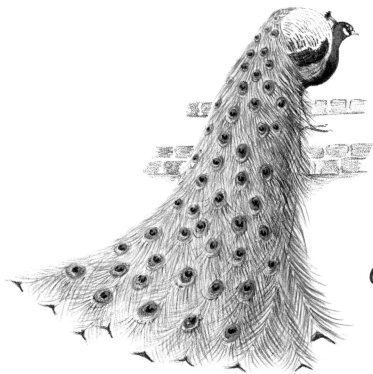

6. The Bird of Juno: the Peacock

THE PEACOCK has long been a symbol of vanity. "He struts like a peacock" is popularly said of a man who is overly conscious of his good looks or appearance, dresses flashily, and betrays this weakness by his mannerisms. The peacock is thus quite unfairly accused of a human trait, for whatever the bird may feel about its appearance, it hardly would be conscious vanity in our sense of the word. If, however, the peacock were found to be proud of its looks, any objective observer would have to admit that there is good reason for such pride, for the bird indeed does have a magnificent plumage. Darwin once said that the eyespot of the peacock's train feathers is probably the most beautiful object in the world. One does not have to go far to admit that it is an unusually beautiful arrangement of glittering colors.

The peacock walks with what looks like a proud, pronouncedly slow gait, but this is mainly due to the long, cumbersome train, composed of

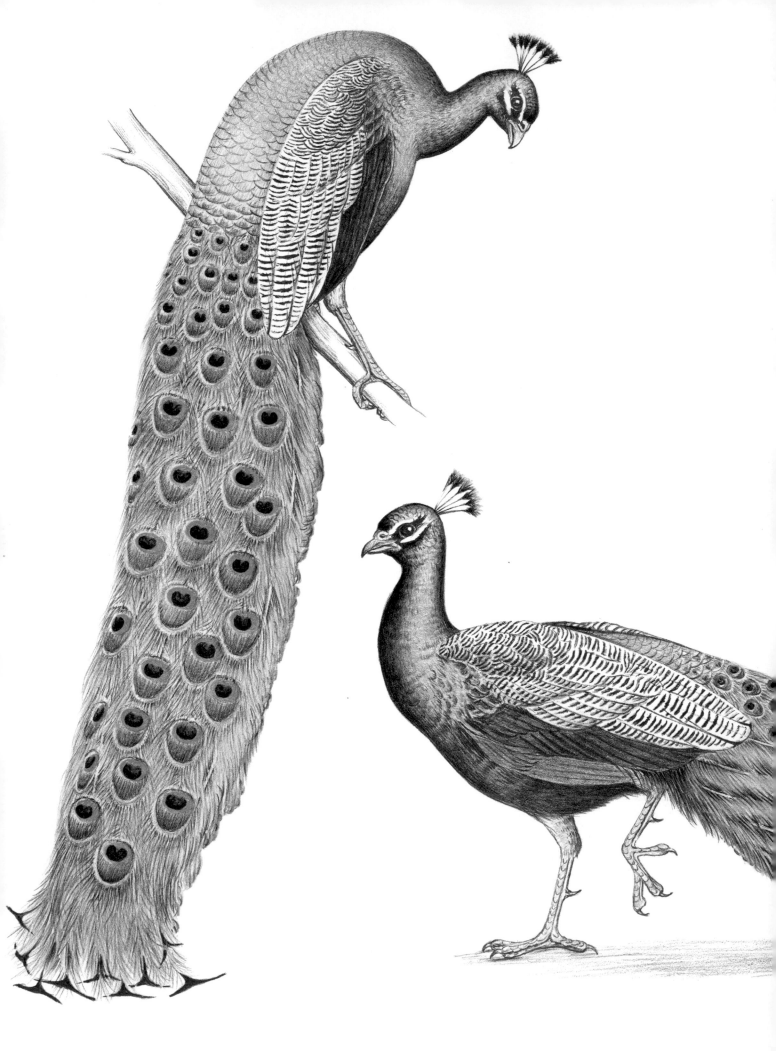

dozens of two- and three-foot-long feathers. And then the peacock lifts those glittering feathers, forming the well-known fan, and prances and moves from side to side so that the light gets a chance to strike the feathers from different angles, reflecting colors that range from bronze to deep blue-green and violet. At this point, not only the peahen, for whose benefit the show is put on, is impressed: any human observer would readily concede that there are few sights in birddom that can compare to this spectacle.

Because it is such a large bird—from six to seven feet, of which about two-thirds are taken up by the train—the peacock is the most impressive of birds with iridescent plumage, even though its iridescence is not of the intense metallic kind displayed by certain other birds. It is also a prime example of a bird whose feathers have been modified extensively to serve, not as a protection against cold, or as an aid in flight, but for appearance only. Beautiful as it is, the long train is a nuisance in many ways, a hindrance to the bird in flight as well as to quick, unhampered movement on the ground. But if functional usefulness here has been sacrificed "for appearance' sake," it has been done with remarkable results. From the

Light striking the feathers from different angles brings out hues ranging from bronze to blue-green in the peacock's train.

deep violet-blue of the neck, the blue and bronze-green of the back, to the exquisitely patterned feathers of the train with their play of hues from copper, gold, and bronze to green and blue, the big bird is one of the most striking examples of iridescence in its entire group.

The beauty and stateliness of the peacock caused its fame to spread far and wide even in ancient times. Peafowl are native to India and Ceylon and are considered sacred birds by the Hindus. Large flocks are often found in the vicinity of Hindu temples, where they are fed and cared for by priests. Although wild, these birds quickly learn to appreciate the sanctuary afforded them, and become as tame as any domesticated fowl.

Ancient cultures around the Mediterranean valued the peacock highly for its stately appearance and glittering colors. Legend has it that King Solomon's fleet brought back peafowl from the mythical land Ophir, the mysterious region where Solomon's gold was supposed to come from. If, as some experts believe, Ophir was located somewhere in Africa, the peacock of the legend probably was not the Indian kind, but the handsome blue-green Congo peacock.

At the time of Pericles, peafowl still were rare in Greece, and people came from all over to admire the wonderful birds. The Greek historian Aelianus reports that fabulous prices—a thousand drachmas and more—were paid for a single male bird.

During his Indian campaign Alexander the Great saw and admired the peacock, and he is said to have brought back with him a number of these birds. That is supposed to have been the beginning of domesticated peafowl in Greece, although Aristotle, Alexander's teacher, already knew the peacock as a fairly common sight in Greece. Its train feathers were widely used as ornaments in ancient times, and the bird was generally looked on as a symbol of opulence and royalty, and even as an attribute of divinity. On the Greek island of Samos, peafowl were kept near the temple of Hera—or Juno, as the goddess was known in Roman mythology—and peacocks appeared on silver coins minted on the island. They remained the "birds of Juno" even in Roman times, and the goddess was frequently pictured with a light chariot drawn by peacocks.

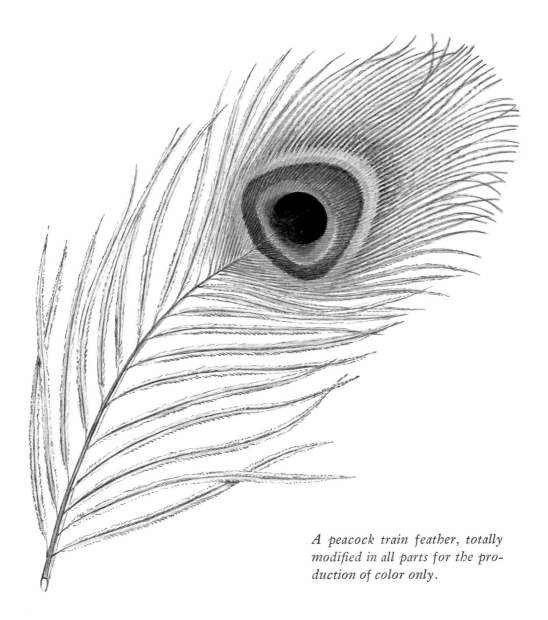

A peacock train feather, totally modified in all parts for the production of color only.

Peacocks were rarely seen in Europe until a few hundred years ago. Since then, increasing numbers of them have been raised in captivity. Zoos almost always feature peafowl, and many private estates keep a few of these ornamental birds on their grounds.

It is interesting to note that the special qualities of iridescent animal colors in general, including the peacock's, were first mentioned and discussed, not by naturalists, but by physicists. It was, in fact, Sir Isaac Newton who drew attention to the special colors of the "peacock tails." In his

famous work, *Treatise on Optics*, which was published in 1704, Newton mentions this phenomenon:

> The finely coloured feathers of some birds, and especially those of pea-cock tails, do in the very same part of the feather appear of several colours in several positions of the eye, after the very same manner that thin plates were found to do.

Despite Newton's remarks, biologists were surprisingly slow in taking up this field of research and interesting themselves in what caused certain types of feathers to show the beautifully pure and changing hues. It was, in fact, only little more than a century ago—and exactly 150 years after Newton had published his remarks on the "peacock tails"—that the German biologist Altum for the first time discussed the origin of these beautiful colors, and mentioned that they were caused by light interference. Explanations of how this purely optical phenomenon is produced in feather tissue structure was difficult because the structures are submicroscopic and therefore beyond the range of the optical microscope. All the same, some fairly accurate theories on how at least some types of these colors are produced were advanced long before the advent of the electron microscope finally made possible actual, greatly enlarged photographs, or micrographs, of these structures.

The electron microscope is an optical instrument which utilizes electrons, the minute constituents of atoms. Using a beam of electrons, which are emitted by hot bodies, and focusing this beam with the help of an

Cross section through a train feather barbule, showing dark outer zone. (From an electron micrograph, magnification 2,650 : 1)

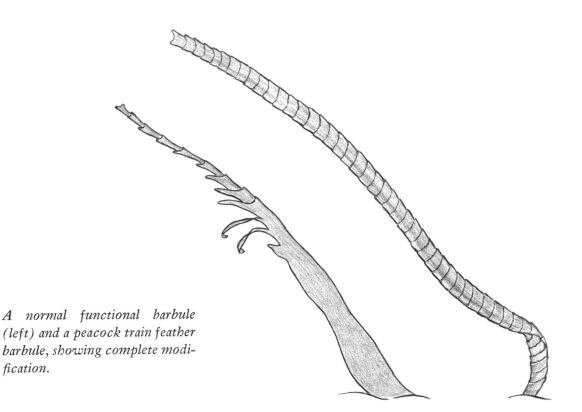

A normal functional barbule (left) and a peacock train feather barbule, showing complete modification.

electron lens, an enlarged image of a submicroscopic object may be projected onto a photographic plate.

The method with which material such as feather or scale tissues is prepared for photography by electron beam calls for some deft handling. In order to expose the structure of the iridescent peacock train feather, transverse cuts of the barbules—the tiny branches of the barbs—have to be made, and these cuts are then embedded in plastic.

At a magnification of about 2,600 times, the transverse cut through one of the barbules—which are totally modified, flattened, and turned at an angle of 90 degrees—shows up as something looking rather like a banana sliced lengthwise, and speckled with fine black dots. Upon closer inspection, the outer zone—the skin of the "banana"—proves to consist of rows of these fine dark dots set close together. The light-colored inner zone has only a sprinkling of dots. It is interesting to note that a photograph of about the same magnification taken with an ordinary optical microscope also distinguishes a darker and a lighter inner zone. However, additional details are not visible because of the limitations of the microscope.

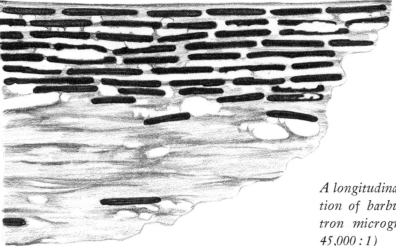

A longitudinal cut through a portion of barbule. (From an electron micrograph, magnification 45,000 : 1)

At a magnification of 12,000 times, the electron micrograph shows a small portion of the transverse cut through the barbule. All the details of the structure can be clearly distinguished. Six to seven rows of dark dots make up the outer layer. These rows, set at certain distances from each other, are separated by lighter spaces. Toward the center, there is a large area of keratin, the horny feather matter, which is interspersed, at irregular intervals, with black dots and light air spaces. The precise and orderly arrangement of the outer zone contrasts sharply with the completely irregular distribution of the particles and air spaces in the center portion of the barbule.

Longitudinal cuts through the barbule show the "dots" to be, in fact, long, thin rods of melanin, which are arranged in rows that run parallel to the axis of the barbule, and stacked one upon the other with layers of keratin spaced between. Seen from the side, this arrangement looks somewhat like a brick wall with long, narrow, dark bricks and lighter mortar spaces between them. The minuteness of these rods defies the imagination, for there are 6,000 rows of them, tightly packed, side by side, into each millimeter of feather tissue, or 18,000 into one-eighth of an inch.

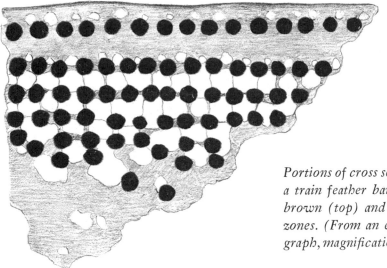

Portions of cross sections through a train feather barbule. Reddish-brown (top) and turquoise blue zones. (From an electron micrograph, magnification 40,000 : 1)

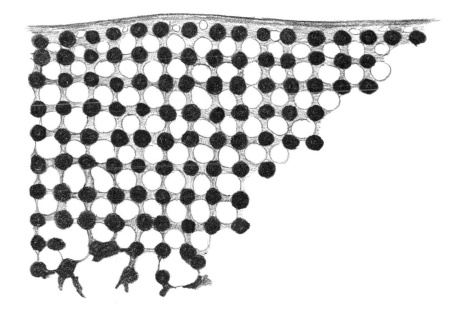

Here, then, in organic matter, is the space lattice that had figured so long in the theories of physicists.

Only the adult peacock's feathers have the precision arrangement of melanin rods set in regular rows and spaced to form definite layers. The

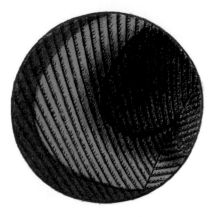

Small portion of a peacock feather eyespot, enlarged about 3 times.

barbule of the immature peacock, which has plain brown feathers, shows only particles of melanin scattered irregularly through the entire keratin area, with air spaces also placed at irregular intervals, and without any definite outer and inner zones.

One of the most interesting features of the adult peacock's train feathers, as compared to other types of iridescent feathers, is that several different color zones are found within one small part of the feather. If a single barb is plucked from the train feather's "eye" region, and we look at it under an ordinary microscope, we can see the barbules sprouting from both sides of the center like some strange multicolored plant stems. A

Enlarged portion of center color zone of peacock eye feather. Brown color normally seen proves to be mixture of violet and gold.

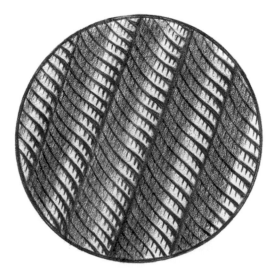

single barbule, segmented like the antenna of an insect, may show multi-colored segments, and the various parts of the barb glitter in blue-green, violet, copper, and bright green hues. If a longitudinal cut is made through a barbule with differently colored segments, an electron micrograph clearly reveals a break at the segment borders, and a difference in spacing and number of the melanin layers. Turquoise, which is a very strong, pure color, has as many as nine or ten closely spaced levels. The brown zone, on the other hand, which the microscope reveals to be a mixed red-golden hue, has only six levels. Because black—meaning nonreflected light —has to be added to this red-yellow mixture to get brown, this area should reveal indications of much light absorption. This is indeed proven by the low brilliance of the brown zone.

The outer zones of the feather also reflect mixed hues. The basic tone of the train feather is a green which has a bluish cast in oblique light, but becomes bronze colored when the light is more vertical. This means that, in vertical light, red light is reflected along with the green, and the eye

Magnified about 60 times, barbules from a train feather show the multicolored, segmented structure.

*A train feather of a juvenile peacock. No irides-
cence exists, because the submicroscopic struc-
ture is missing in this feather.*

mixes the two hues to get the bronze color. The same thing happens with
the violet-colored outer zone, a mixture of red, blue, and green interfer-
ence colors. In each case, the distance at which the levels are spaced from
each other determines which color will be reflected at a given angle,
while the number of levels tends to make the reflected light purer and
more monochromatic.

When we look at the schematic diagram of the space lattice, it becomes
clear that the angle at which light can reach the lower levels is very limited
by the short horizontal distance between the melanin rods. Because the
angle of light incidence—and equally, of course, the angle of reflection
is thus limited, a relative constancy of color is produced in the peacock
feather. We can see from Fig. 8 that very oblique light can never reach

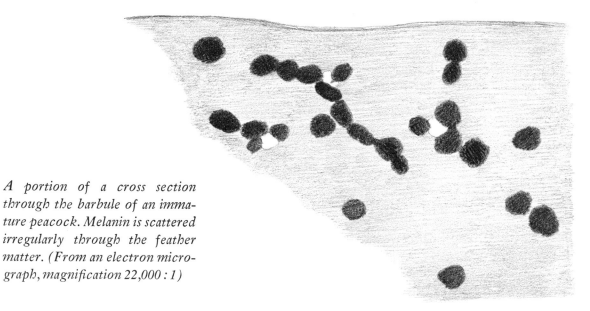

A portion of a cross section through the barbule of an immature peacock. Melanin is scattered irregularly through the feather matter. (From an electron micrograph, magnification 22,000 : 1)

the lower levels at that angle. Instead, it is refracted by the top layer of melanin rods, and is then reflected in the same way as the more vertical beams by the lower levels of the space lattice. The color can thus never go beyond a certain range of hues, and it also cannot, as it does in certain other kinds of iridescent feathers, disappear.

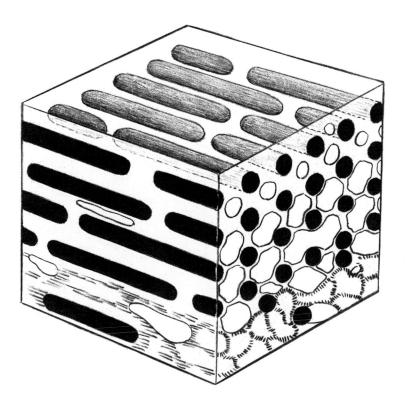

Diagram of a small portion of a cross section through a peacock barbule. The evenly spaced layers of melanin rods form the classical space lattice.

We know that the purity of the reflected color depends on the equidistance of the individual levels as well as on their number. The intensity of the color, on the other hand, is determined by the density of the rays that are reflected. This optical density is insured by the huge number of melanin rods present in each level of the space lattice.

The electron micrographs of the peacock feather structure, taken at the Institute of Electronic Microscopy associated with the University of Basel, under the direction of Prof. Adolf Portmann, were the first instance where a space lattice had actually been photographed. Although the theory of the space lattice had been explored earlier, especially by the English physicist Sir William Bragg, proof of this theory was made difficult by man's inability to manufacture an artificial space lattice. Much less, of course, could scientists attempt to match a structure such as that

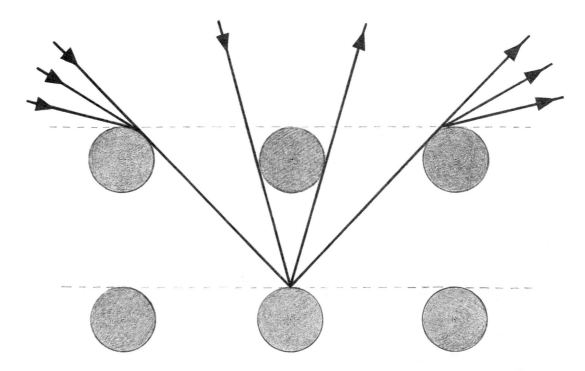

Fig. 8. Diagram of structure in a peacock barbule proves to be the typical space lattice, which limits incident light to a narrow range and keeps it constant.

of the peacock feather, where different colors are produced within a small area by varying the distance between, and the number of, the various reflective levels.

It is interesting to note that albinotic peacocks not only have no melanin in their feathers, but also have no vestige of any structure that would indicate that *only* the melanin rods were missing from it. The feathers of the white peacock are simply keratin with irregular air spaces scattered throughout, creating the classic total diffuse reflection necessary to produce white.

It takes quite some time for the young peacock to outgrow its plain brown juvenile plumage, and the entire process has to be repeated every year after the molt, in which the male loses its resplendent train feathers. Seven months are needed each year to regrow the train. Thus, billions of minute precision structures have to be produced, without change or variation or error, many times during the life of each peacock. This seems indeed a tremendous expenditure of growth energy for the sake of good looks only!

As we shall see in the chapters that follow, other iridescent feathers that have been examined with the help of the electron microscope in recent years have different physical structures for producing the glittering interference colors. So far as we know today, the stately peacock's train feathers are not only beautiful, they are also unique among feathers in their special type of interference-producing tissue structures.

7. The Bird of Quetzalcoatl:
the Quetzal

IN GUATEMALA, *quetzal* is a household word. The country's second largest city is named Quetzal; Guatemalans use quetzals, not dollars or pesos, as their standard monetary unit. The most important quetzal, however, is a very beautiful bird. It was the bird that gave its name to the city and the money; it is the bird that is pictured on Guatemala's state seal, its postage stamps, and its coins, for the quetzal is the national symbol of Guatemala.

A little more than a foot in length from the bill to the tip of its tail, the quetzal is not a very large bird, even though the male in full breeding

Fully grown male quetzal.

plumage adds another foot or so to the over-all length with the long upper tail coverts that stream out behind him. In pure splendor of coloring, the quetzal has few equals. Anyone who sees a male quetzal during the mating season—before the magnificent plumes have become tattered and worn through the parental duties of sitting on the eggs—will readily understand the intense pride with which modern Guatemalans look upon "their"

Seen from two different angles, the quetzal's feathers show iridescent colors ranging from gold-green to blue-green. Red breast is a pigment color.

bird. He will also understand the awe and reverence with which the ancient Indians of those regions regarded the quetzal, whom they thought to be symbol and embodiment of one of their gods.

A bright, intense gold- or bronze-green is the predominant color of the male's plumage above. Head, throat, back, and train display this gleaming

green color. The underparts contrast sharply by being red and white, and only the wings are dark. The female is a much less striking-looking bird, lacking not only the crest and the train but also much of the iridescent green coloring.

Softness is the distinguishing quality of the quetzal's plumage. Despite their brilliant iridescence, which causes the green to shade into gold, and then again into blue and even violet tones with every shift of the light angle, the feathers of this bird do not have the hard, solid, metallic look that is so typical of many other feathers with iridescent colors. The quetzal's soft, loose plumage is due to a lack of the interlocking vane structure typical of most contour feathers. Combined with the glittering hues of the upper parts, and the contrasting bright flat tones of the underparts, these soft feathers lend the bird a unique appearance that is not matched by any other member of its class. It is, therefore, not astonishing to find the quetzal a leading candidate, in the eyes of many naturalists, for the title of "most beautiful bird in the world." Beauty is, of course, partly a matter of individual taste and opinion, and many birds deserve to be ranked among the very beautiful. No one, however, would want to quarrel with the contention that the quetzal belongs among the front runners.

As mentioned earlier, the splendor of the bird was well appreciated by the ancient Indian tribes of Central America. The word "quetzal" comes from the Nahuatl Indian word *quetzali*, which means tail feathers. Both the Mayans and the Aztecs worshiped the bird, which they associated with Quetzalcoatl, the famed "feathered serpent," the Aztec god of the air. Quetzalcoatl is reputed to have originally been a hero of the Toltecs, and then later became the Aztec and Mayan patron of the arts and crafts. Indian artists of those times often represented Quetzalcoatl as a stylized, formalized quetzal. Essentially, he was a god of peace and peaceful endeavors and was also one of the few Aztec deities to whom human beings were rarely sacrificed.

Although the long plumes of the quetzal's train were used by the Indians in their religious ceremonies, and as an ornamental headdress of their kings, the sacred bird was never killed; instead, the tail plumes were

plucked, and the quetzal was then set free to grow new feathers.

Today's citizens of Guatemala, who are proud of their beautiful national symbol and its long and distinguished history, insist that the quetzal is the personification of freedom and that to deprive it of its liberty is to break its heart and kill it. It is a fact that the bird does not seem to thrive in captivity, and up to this time, quetzals have not done well in zoological gardens. It is to be hoped that further study of their natural environment and way of life will afford more insights into what they require and so increase the chances of successfully maintaining these beautiful birds in captivity.

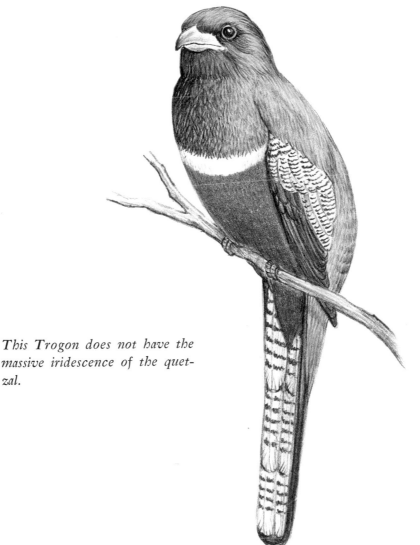

This Trogon does not have the massive iridescence of the quetzal.

A native of Ecuador, this Trogon is distinguished by the deep blue and violet hues of its head and breast.

The quetzal is a member of the Trogonidae, a rather peculiar family of birds which also form an order, because they could not be fitted into any larger group of related birds. The thirty-four species are all tropical, and about two-thirds are found in South and Central America. The rest are distributed over Africa, which has three kinds, and the Indo-Australian region.

Trogons are medium-sized birds of between ten and fourteen inches in length, and all of them are brightly colored. Frequently, their coloring consists of a combination of iridescent hues on the upper parts and sharply contrasting pigment colors on the underside of the body. The most resplendent as well as one of the largest is the quetzal, which inhabits the tropical rain forests from southern Mexico to Costa Rica, usually at elevations of 6,000 feet; it has also been reported living at altitudes of up to 9,000 feet.

Trogons have a number of anatomical peculiarities which set them apart from other birds. One of these is the arrangement of their toes, the first two of which point backward, the second two forward. Their bill is short, broad, and rather weak. The upper mandible is strongly curved and has a serrated edge. The most unusual anatomical feature, however, is their skin, which is thinner than the skin of any other bird. It has been described, by despairing ornithologists attempting to prepare specimens for mounting, as having the consistency of wet tissue paper. If not handled with the greatest of care, the skin tears, and even if the skin is not damaged, the feathers will fall out at the slightest touch. Naturalists collecting specimens reported that a bird shot out of a tree and hitting a branch in its fall was so badly damaged it became unfit for mounting.

The habits of the Trogons, and especially those of the handsome quetzal, have been fairly extensively studied by naturalists. This was made easier by the fact that the birds are not very active or fast-moving. In fact, they often remain sitting in the same position for long periods. When they see an insect flying by, they will dart from their perch, catch it, and then return to the same spot. Or they will nibble on a fruit, for they eat both insects and fruit. A nineteenth-century English naturalist wrote that, if the quetzal were not so beautiful to look at, studying this bird and its habits would be downright boring because of its inactivity. Trogons are not migratory, and how the various species of this isolated family became established in separate parts of the world is something of a puzzle.

Trogons are hole nesters. Many species lay their eggs in hollow trees or similar natural cavities. Others will hollow out a nest for their eggs, but

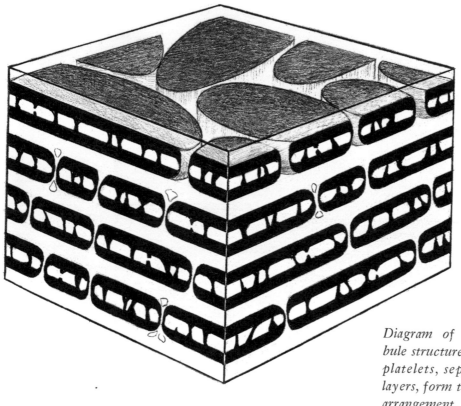

Diagram of the quetzal's bar-bule structure. Air-filled melanin platelets, separated by keratin layers, form the color-producing arrangement.

because their bills are so weak, they prefer soft materials which can be easily managed. Thus, some Trogons use termites' nests or the paper nests of certain tropical wasps for their own purposes after dislodging—and usually eating—the rightful owners. The male quetzal shares the duty of brooding the eggs with the female. This means that he often has to double up his train plumes to fit them in the nesting hole, which leaves the train a poor sight after the family has been raised.

With the advent of the electron microscope, and the feasibility of examining, among other things, submicroscopic feather structures, it was only a matter of time before naturalists turned their attention to the iridescent Trogon feathers. By that time, iridescence in other birds, such as

the hummingbirds and the peacock, had already been examined. From such examples as hummingbirds, the natural and logical conclusion was that, while interference structures may differ in different groups of birds, they will be the same among the various species of any one group. However, a surprise awaited the scientists who were doing the research on the Trogon feathers, for although this family is quite isolated, and has no close relatives among other birds, various species were found to have different types of interference-producing structures in their feathers! What is more, some of these structures proved to be similar to those found in the feathers of entirely unrelated birds, and quite different from those of their nearest relatives!

Selected for this examination were seven different species from various parts of the world. Foremost was the quetzal; also chosen were the so-

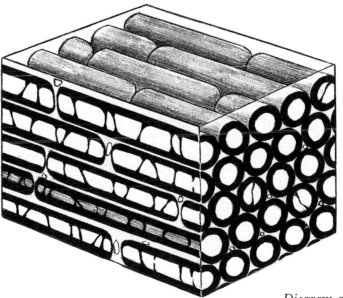

Diagram of a different Trogon's barbule structure. Here the color-producing arrangement consists of tightly packed hollow melanin tubes.

called Peacock Trogon of Ecuador; two other species from the same region; a Trogon from Cuba; one from Sumatra; and one from West Africa.

The most interesting and outstanding of all these species is the quetzal, not only because it is the best known and most beautiful of them all, but also because it displays the most intensive iridescence, and has, more than any of its relatives, feathers totally modified to provide the basic requirements for the color-producing structures. This means that the normal feather structure is largely absent; the barbicels, which ordinarily end in tiny hooks which hook onto the next barbule, and so unite the feather branches in a vane, are missing. The feathers of the peacock train show a similar phenomenon, while iridescent feathers of many other birds are only partially modified.

Under the microscope, a quetzal barbule gleams in a beautiful golden-green, which changes to a bluish-green as the light angle is shifted. If the light is very oblique, the barbule shows violet, but the color is not very intense, because a lot of black components are visible, so that much of the light is absorbed. The barbule does not have the multicolored segments of the peacock barbule and is much more uniform in coloring, shifting merely between gold-green and blue-green.

In the electron micrograph, transverse cuts through iridescent barbules of quetzal feathers at magnifications ranging from 10,000 : 1 to 40,000 : 1 show layers of melanin platelets filled with tiny air spaces. The platelets, which are elliptical, are packed tight and touch on all sides, with just a little space showing between the narrow ends. The number of the layers varies from five to eight. The air spaces in each platelet are broken up by a cell structure.

The rows of platelets are most numerous in the upper, dorsal part of the barbule; toward the lower, ventral surface, melanin particles are often scattered irregularly through the keratin.

Every layer of melanin platelets is separated from the next one by a layer of keratin whose thickness varies with the wavelength—or color—that is being reflected. The thinnest layer measured 0.1 μ, the thickest 0.14 μ. The thickness of the platelets was also found to vary, being

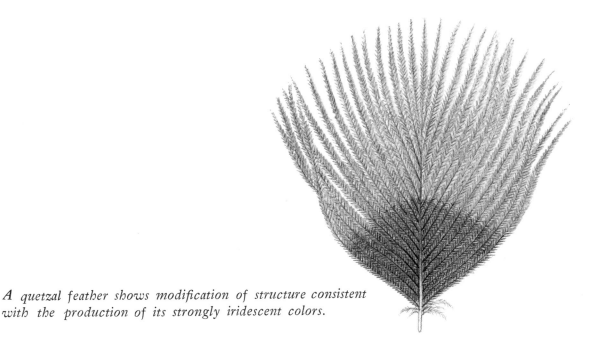

A quetzal feather shows modification of structure consistent with the production of its strongly iridescent colors.

roughly twice that of the keratin layer. In the transverse cut, we can see that the platelets consist of a melanin "sandwich" with air spaces in between.

In the quetzal feather, therefore, three layers are stacked, and each has a different refractive index. Melanin, air, and keratin, which are repeated at regular distances from each other, form an inhomogenous medium. Theoretically, differences in color could be achieved by altering the thickness of any or all of these media. In practice, it was found that the feathers of the quetzal reflect certain wavelengths from each of the three media, and that the thicknesses of these various layers are so delicately adjusted that each of them reflects about the same wavelength, so that primarily one color is reinforced. This produces the intense and brilliant green which we admire in this bird. What seems most amazing is the incredible precision which such interference demands, and which the structure provides: "errors," where they occur, are limited to less than 1/100,000 of a millimeter!

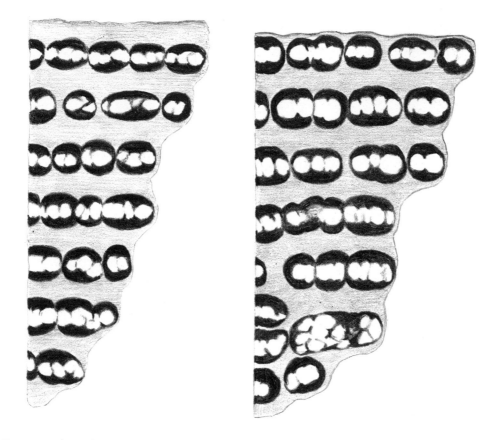

Cross section through sections of different Trogon barbules. Blue-green color zone. (From an electron micrograph, magnification 30,000 : 1)

In the Ecuadorian Peacock Trogon, the iridescent feathers were found to have a different structure. The melanin here consisted of air-filled hollow rods, or tubes, packed tightly together in a kind of honeycomb ar-

Transverse cut through a single melanin platelet of a Trogon barbule. (From an electron micrograph, magnification 60,000 : 1)

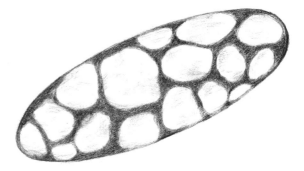

rangement that left no keratin between the melanin particles. Because only light with a 30-degree angle of incidence entering the tubes exactly through the center can produce interference, the color of this Trogon is much less brilliant, and its iridescence is much weaker, than that of the quetzal.

Variations in the reflected colors in these species are produced by differing tube diameters: those with the largest diameter reflect the longer wavelengths; those with the smallest, the shorter wavelengths. Thus, feathers with wide tubes look coppery, and those with very narrow tubes produce the blue hues.

In the iridescent feathers of the other three species that were examined, a third type of structure was found, which is basically a variant of the

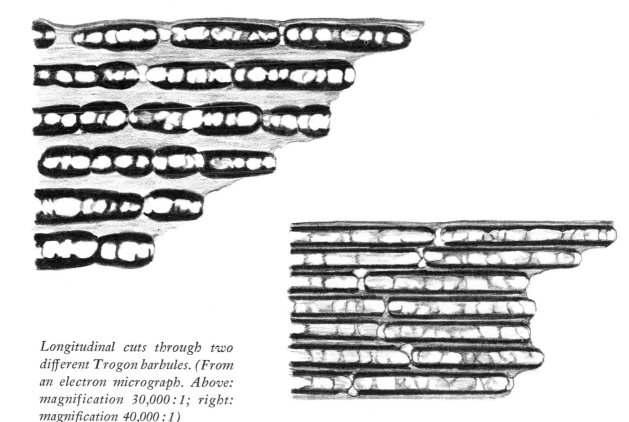

Longitudinal cuts through two different Trogon barbules. (From an electron micrograph. Above: magnification 30,000:1; right: magnification 40,000:1)

Cross sections through portions of Trogon barbules showing two different color zones, violet-blue (left) and copper-yellow. (From an electron micrograph, magnification 50,000:1)

last-described tube arrangement. Here, however, the tubes are not only larger in diameter but are also set in definite layers, with keratin spaced in between. Furthermore, the tubes are not quite round, but somewhat flattened. All this influences the intensity and iridescence of the color. One species, with very few layers, has only a rather weak color; another, with a greater number of layers, displays much stronger and more brilliant hues.

It is interesting to note that, while the air-filled platelets of the quetzal are similar to those found in hummingbird feathers, the air-filled-tube arrangement is found, among others, in the iridescent feathers of the Impeyan pheasant. The space lattice of the peacock, on the other hand, seems to be in a class by itself. Sunbirds, which will be discussed in a

later chapter, have been found to have still a different interference-producing structure. The logical assumption that iridescence in feathers is produced by one identical "thin-film" structure in all cases has been proven wrong; the fascinating complexity and variety of these structures goes far beyond anything naturalists expected to find.

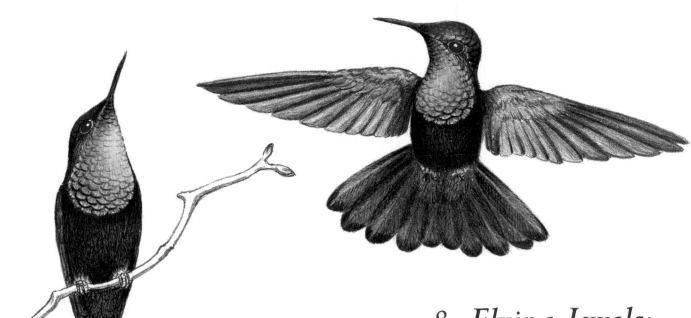

8. Flying Jewels: Hummingbirds

THE ONE-SIDED love affair between naturalists and hummingbirds is one of long standing. Even today's most severely factual zoologists show signs of possessing a talent for the fanciful when it comes to describing these little birds. Naturalists of past ages, who were not constrained to appear at all times strictly objective and scientific, vied with each other in praising the "feathered jewels," often using extravagant terms.

The famous American naturalist and artist John James Audubon called hummingbirds "lovely fragments of the rainbow." Even before Audubon's time, the Frenchman Comte de Buffon had given rapturous descriptions of the little birds, claiming, with characteristic Gallic flair, that "among all living beings they are the most beautifully formed and most gorgeously colored." Buffon dismisses precious stones and metals,

which human craftsmanship polishes and fashions into jewels, as unfit to be mentioned in the same breath with the living, winged gems of nature. Not to be outdone, the English naturalist Charles Waterton stated that the hummingbird is the "true bird of paradise." "One moment," he exults, "it resembles a ruby, the next, a topaz, then an emerald, and then again gleaming gold." Darwin did not go quite so far as Waterton, but he did write that hummingbirds "almost vie with the birds of paradise in beauty." A German zoologist added that no other family of birds in the world can match the exquisite beauty of the hummingbirds.

Such total international agreement may seem astonishing, given the natural differences of opinion on what constitutes beauty. But, then, some aspects of nature have a beauty that is beyond the differences shaped by racial, national, or individual tastes, customs, and fashions. A flaming sunset, the arc of a rainbow, an exquisite blossom, the colorful fire of precious stones—these are universally acclaimed as beautiful north and south, east and west, by the primitive and the sophisticated alike. Hummingbirds—tiny, graceful, and, above all, brilliantly colored—fit easily into this category. Appreciation of the beauty of color and pattern is widespread. It is more instinctive than appreciation of many other kinds of beauty—for example, that of shape or form—and less often subject to the influence of customs, fashions, and traditions as developed by individual cultures and civilizations. The appeal of color is direct and immediate.

While it is therefore not surprising that all observers single out the hummingbirds' colors above their other attributes, it is remarkable that they go to such pains to stress that these colors are unique, conjuring up images such as the rainbow, jewels, and precious metals in an attempt to achieve some adequate description. What, then, is so unusual about the colors of these little birds?

As we have already seen, iridescent and metallic colors in animals always arouse more attention and admiration than even bright "flat" pigment colors. The peacock's iridescent feathers brought it fame in distant ages; the glittering plumage of the quetzal made it the sacred bird of

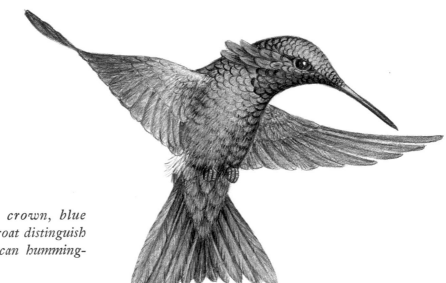

Iridescent green crown, blue breast, and red throat distinguish this South American humming-bird.

ancient Indian tribes; and the iridescent feathers displayed by many birds of paradise contributed to the fame of this fascinating group. The hummingbirds' colors are, however, unique even among other iridescent animal colors.

Collectively, hummingbirds are the smallest members of their class, although a few species are larger than some birds of other families, and one, appropriately named the giant hummingbird, is approximately the size of a thrush. The majority average a body length of not more than three to four inches, although quite a few are considerably longer by virtue of long, elegant tail plumes. The smallest member of the clan, which fully deserves its popular name of bee hummingbird, is only two and a half inches long, and weighs no more than a dime. The bill, which is included in the size, is generally quite long, sometimes taking up one-third —and in one extreme case more than one-half of the combined bill and body length. Also, their wings are long and slender, letting them appear streamlined.

The hummingbirds' flight is unequaled in all of birddom, for not only can they hover, like miniature helicopters, but they can also fly straight

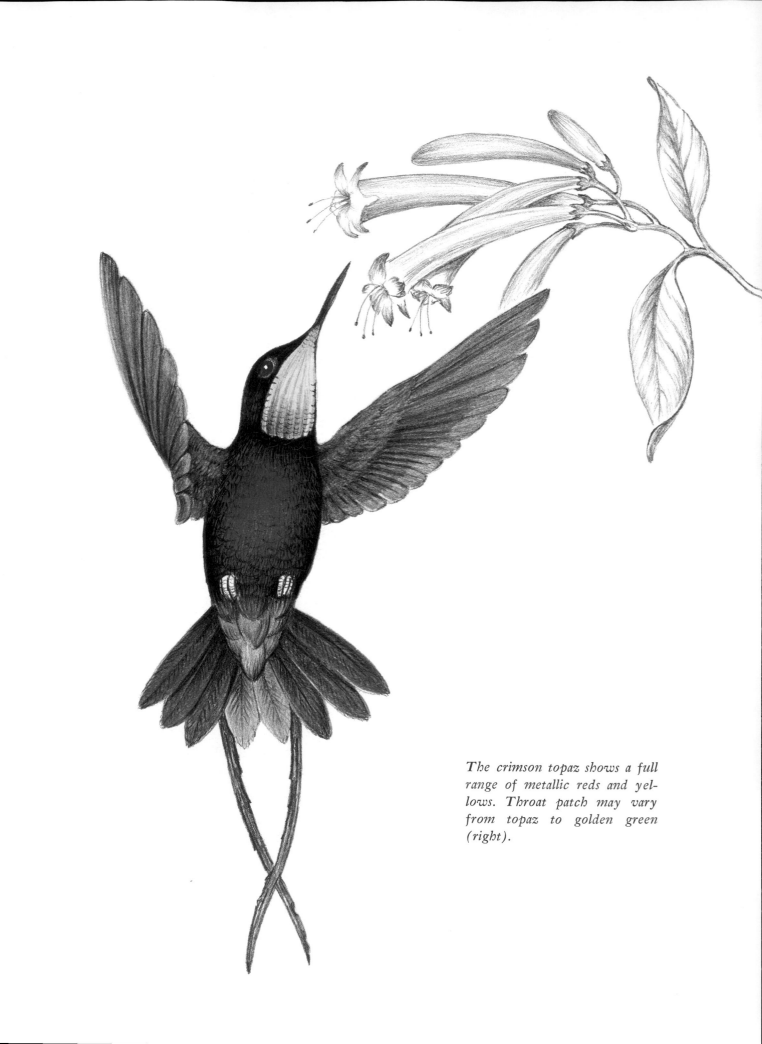

The crimson topaz shows a full range of metallic reds and yellows. Throat patch may vary from topaz to golden green (right).

up, down, sideways, and even backward. Their wings move so fast—one species was clocked at eighty strokes per second—that they appear as a blur to the eye. Before the advent of high-speed cameras, their flight mechanics by necessity had to remain a matter of speculation, but even though earlier observers had no way of ascertaining how hummingbirds move their wings, they advanced some shrewd guesses, most of which have proved correct according to modern research. More than a hundred years ago, the American naturalist Augustus A. Gould stated that hummingbirds, in contrast to other birds, could execute almost every kind of wing movement with the greatest ease—including those which allow

A change in position reveals hues ranging from golden green to violet in this hummingbird.

them to fly straight up, down, sideways, and in circles. Gould marvels at the "wonderful mechanism" of the wings which, in a whirring motion causing them to appear as a blur, enables the birds to hover as though suspended in midair.

A German contemporary of Gould calls them the "insects among the birds," and others also note that, in flight and wing movements, hummingbirds resemble insects rather than birds. This observation comes remarkably close to the truth. Hummingbird wings, which, unlike those of other birds, have an inflexible wrist joint but can pivot at the extremely flexible shoulder joint, do in fact move more like the wings of certain insects. Their appearance in flight is actually so similar to that of certain large moths which fly at dusk that the latter are frequently mistaken for hummingbirds. And not just by laymen: the English naturalist Henry Bates reported that it took him quite a while to learn to distinguish between hummingbirds and the large Titan moths of the Amazon region, and that, while collecting, he more than once shot down a moth when he thought he was aiming for a hummingbird. In North America, the Sphinx moth is often mistaken for the ruby-throated hummingbird, especially because both tend to visit the same kinds of flowers at dusk.

In the past few years, high-speed cameras have finally solved the puzzle of the hummingbirds' flight mechanics. By far the most extensive research in that field has been done by C. H. Greenewalt. His specialized camera equipment, patience, and fascination with the little "fragments of the rainbow" enabled him to take series of magnificent flight pictures which reveal the hummingbirds' every wing movement and position. These photographs show that they use their wings like "paddles" which they can twist almost 180 degrees at the shoulder, so that the underside is on top, and with which they can execute a number of other movements impossible for a bird with "normal" wings.

That hummingbirds are unsurpassed masters of the air is consonant with their character traits, for hummingbirds are intensely curious, fearless, and aggressive. Despite their size, they are afraid of nothing, and will attack —and usually drive off—even large animals, including predators such as hawks. They seem to enjoy fighting just for the fun of it and often engage in battles with other hummingbirds. Their fearlessness and curiosity contributed to their downfall because it made them the easy prey of man, who used to hunt them for their feathers. Millions of hummingbirds were killed every year and shipped to European fashion centers, where their tiny feathers were used as ornaments for women's hats and clothing. This cruel massacre was stopped just in time—about 1900—to prevent many of the most colorful species from being wiped out. Now there is no other animal they have to fear, and even the species decimated by the feather hunt of years ago have staged a comeback.

In view of the extraordinary plumage of many, though not all, hummingbirds, it seems surprising that their closest relatives should be a group of dull-colored, rather sooty-looking birds: the swifts. Earlier naturalists indignantly rejected the relationship; they classed swifts with swallows, whom they do indeed resemble in appearance and way of life. Like swallows, swifts have long, slender, sickle-shaped wings, tiny, widely slit beaks, and very small, weak feet. Also like swallows, they are superb fliers and live on insects they catch in flight. However, as so often in nature, things are not what they seem, and their anatomical structure shows many

similarities to that of the hummingbirds. We have to assume that some time in the gray past, a tropical species of swift started its descendants on the road of a new and specialized way of life. Having no fossils of any hummingbird ancestor showing an intermediate stage of this evolution, zoologists can do no more than speculate that, a very long time ago, some New World swifts began to pursue insects right into the flowers in which they sought refuge. Did these swifts then develop a taste for the sweet nectar which they first took only accidentally along with the captured insects? And did this start the development of specialized adaptations— long, slender bills and tubular tongues enabling the birds to probe even deep-throated flowers and suck their nectar? It is a tenable theory, but why and how and when, as in most specific instances of evolutionary development, remain a mystery. Nor do we have any idea of how and when the ancestors of hummingbirds began to evolve the complex submicroscopic feather structure necessary to produce the glittering interference colors of today's birds. Although Darwin's theory of evolution has been proven in broad, general terms, the origin of any *single* species is by no means clear. We do not have an explanation of the origin of ordinary feathers; much more puzzling are those feathers whose minute structures, in accordance with the physical laws governing light waves, produce the optical phenomenon of interference and allow certain pure spectral colors to become visible. When we look at a hummingbird flashing its brilliant hues, we are beholding a tiny if impressive example of the countless unanswered questions of the evolutionary process of which we, too, are a product.

We know today that no chemical substance, no pigment, is required for the hummingbirds' colors; that, in fact, no pigment, but only "reinforced" light, can produce such colors. The Indians who were the first humans to observe and admire the tiny birds did not know this, and yet, remarkably enough, heavenly sources of light such as the sun and the stars figured prominently in the names they gave to hummingbirds, names which are both poetic and appropriate. The same can hardly be said of the common names given to the family by the various Europeans. The

usually so romantic French fell down badly with *oiseaux-mouches*—fly-like birds—and the Spanish did little better with *pica flor*—peck a flower. The English *hummingbird*, which refers to the sound made by the wings in flight, shows no great imagination. Neither does the German *Schwirr-voegel*, more or less a translation of hummingbird. Generally, though, hummingbirds are known as *Kolibris* in German. This is a Spanish-Portuguese word of somewhat uncertain origin. It is believed, though, to be a corruption of the Carib Indian word, *culubi*, which means evil spirit. If this should be correct, it is rather puzzling, for it is difficult to see why these charming little birds should be equated with demons. Most

A white-and-olive bird when seen from certain angles, the Chimborazo hill star has to change its position only slightly to reveal deep violet color of head and neck, as well as an emerald green "necklace."

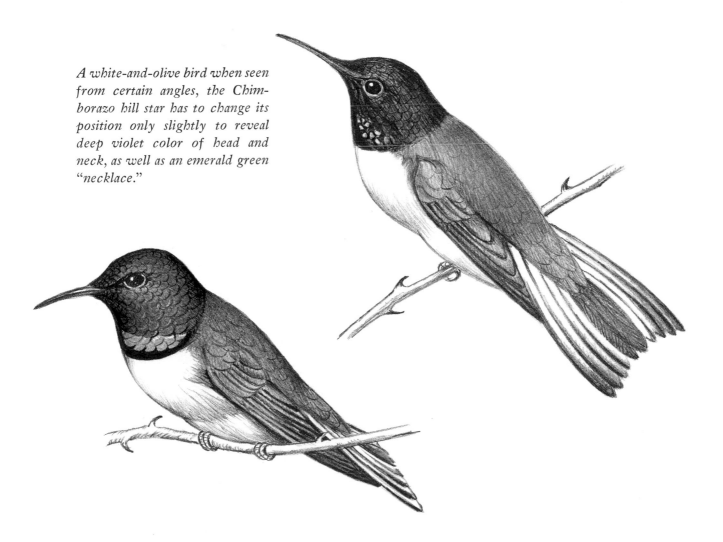

Indians not only admire them greatly, but as can be seen from names such as "rays of the sun" and "tresses of the day-star," associate them with the powers of light. The superstition may be connected with certain colors, for the beautiful butterfly *Morpho menelaus*, whose wings glitter in iridescent blues and blue-greens, is feared as an evil spirit by some Indians, who believe that it is responsible for epidemics of malaria.

It may not be a coincidence that a number of hummingbirds with blue-green iridescence, including one whose scientific name is *Colibri coruscans*, are found in the same regions as *Morpho menelaus*. However, no information seems to exist on whether these colors are considered unlucky by some Indian tribes, or whether the superstition is based on other factors.

The names of the individual hummingbird species, both common and scientific, are a great deal more colorful and descriptive than their family names. We have the blue-chinned sapphire, the crimson topaz, the ruby and topaz hummingbird, the Ecuadorian rainbow, the Chimborazo hillstar, and the Sappho comet. Even the scientific names make generous use of precious stones, gold, the sun, and the stars.

Actually, comparing hummingbirds to jewels is not at all farfetched. Jewels are small; they have to be seen up close to be appreciated; they are enhanced by the right setting and background. All this applies equally to hummingbirds. Not only are they themselves tiny; the brilliantly iridescent areas are usually small and often limited to the head and neck. The colors can be seen only from a relatively short distance; because they are completely dependent on the right light angle, they disappear when the observer moves too far away. The brilliant areas are often sharply sep-

arated from the rest of the body by black bands or collars; in some cases, the angle which lets the iridescent feathers gleam most brightly at the same time causes the rest of the plumage to appear dark like a velvet background.

Even the iridescent colors of other birds are less intense than the brightest of the hummingbird colors, which seem to have a luminescence of their own, almost as though they are lighted up from inside. It is this primarily that makes any attempt at reproduction by painting, photography, or printing so frustrating, more so than with some of the weaker, more opalescent interference colors. Certain mother-of-pearl hues, although structural, can be reproduced quite well, as can those structural blues that are caused by light scattering and not by interference. Consider the plumage of birds like the peacock and the quetzal: the brightest pigments prove woefully inadequate. The microscope quickly reveals the reason for this inadequacy: like the leaves of some kind of jeweled fairy-tale fern, the barbules of a peacock feather sprout from the barb shaft, gleaming in three-dimensional hues of gold, emerald, and sapphire. An enlarged section of even the brightest and glossiest color print, on the other hand, shows just an arrangement of rather lifeless, "flat" dots and dabs of pigment. Any attempt to capture the colors of the most brilliant hummingbird feathers with the help of pigments is an even more hopeless undertaking because of the near-luminous quality they possess.

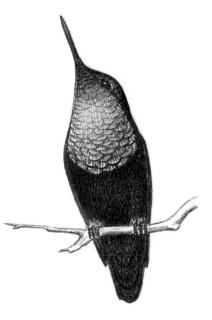

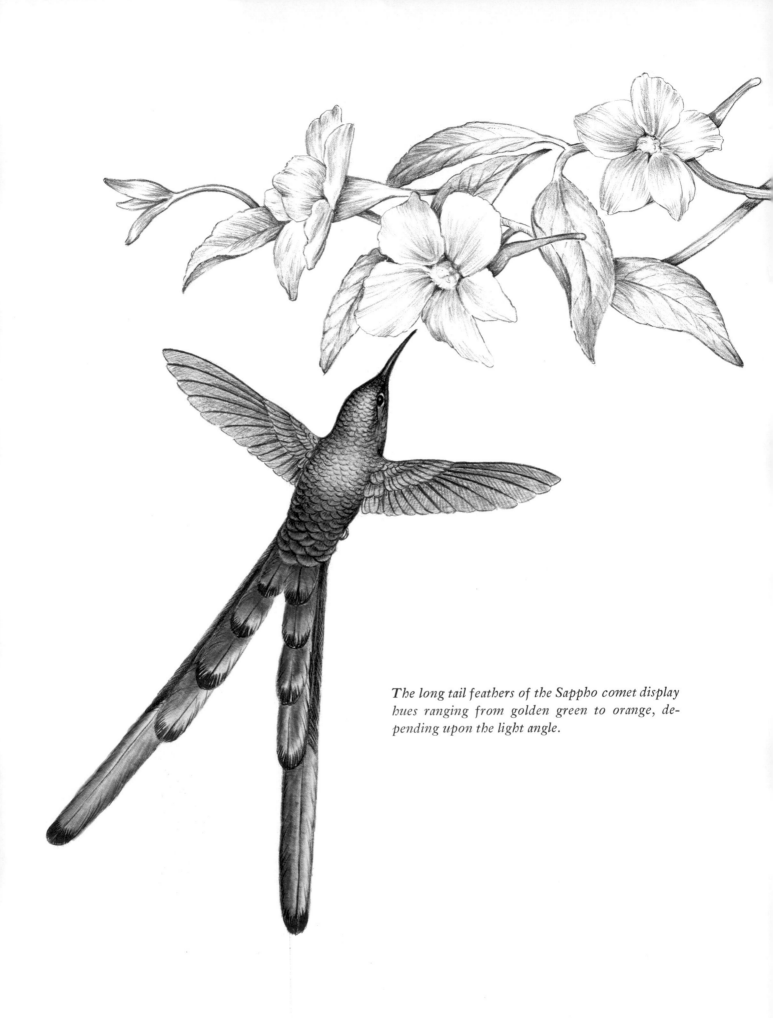

The long tail feathers of the Sappho comet display hues ranging from golden green to orange, depending upon the light angle.

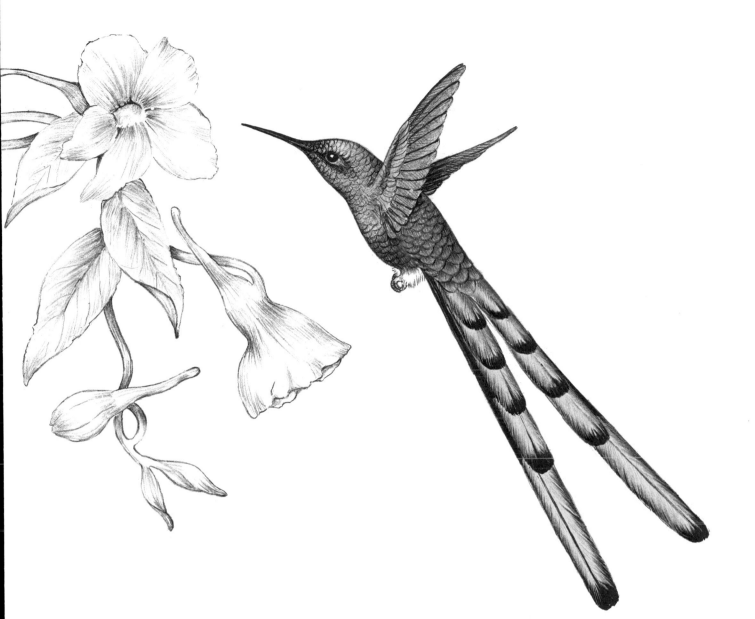

Thoroughly disappointed with the results of reproducing humming-bird colors and other brilliant iridescent hues, ornithologists have come up with suggestions on how to improve the quality of reproduction. Among these suggestions was one that called for different metallic inks super-imposed on conventional colors. This probably would produce some very good effects if it were done with great care and subtlety, but it would create problems and increase costs to a point where the price of such a book would be astronomical.

Even metallic inks, however, would not solve the problem entirely. We have to resign ourselves to the fact that these intense, pure spectral colors cannot be duplicated by any means now known, although it is possible that tomorrow something will be found which allows a much better reproduction. Even then, one additional difficulty would remain. Iridescent colors—especially those of hummingbirds—are "alive," that is, they vary with a slight movement of the bird or a shift of position by the observer. In a flash, a crown or throat patch may change from fiery orange-red to gold, and then to gold-green. A further shift, and the color may disappear; the observer who was just looking at a gleaming feathered jewel now sees nothing but a dark, dull-colored small bird. These changes are so sudden that it seems as though a switch has been turned on and off. The iridescence of such birds as the quetzal and the peacock is quite different. We recall that, although peacock feather colors range from bronze (red-green) through green to blue-green with a change of the light angle, they do not disappear; the feather never turns dark. This relative constancy is the result of the limited angle which the space-lattice structure of the feather imposes on incident and reflected light. The structures of the hummingbird feather, as we shall soon see, are of an entirely different type, and do not limit the angle at which the light can reach them. Elimination of all color at certain angles is one result of this peculiarity.

As an example, let us take a hummingbird whose scientific name is *Eugenes fulgens*, which means "the glittering well-born." This little fellow measures about four and a half inches, and more than an inch of this is taken up by the bill. The over-all body color is a dull dark green which has a golden-green or bronze sheen when the light is right. Crown and throat, though, are different. They may look almost black from certain angles, but with a slight shift of light angle, these areas burst into startling brilliance, the throat turning bright emerald green, the crown deep violet blending into purple. At the angle at which these colors are most brilliant, the rest of the body looks almost black, providing the perfect contrast to the gleaming colors of head and throat.

Another instance of such sudden change is the Ecuadorian rainbow.

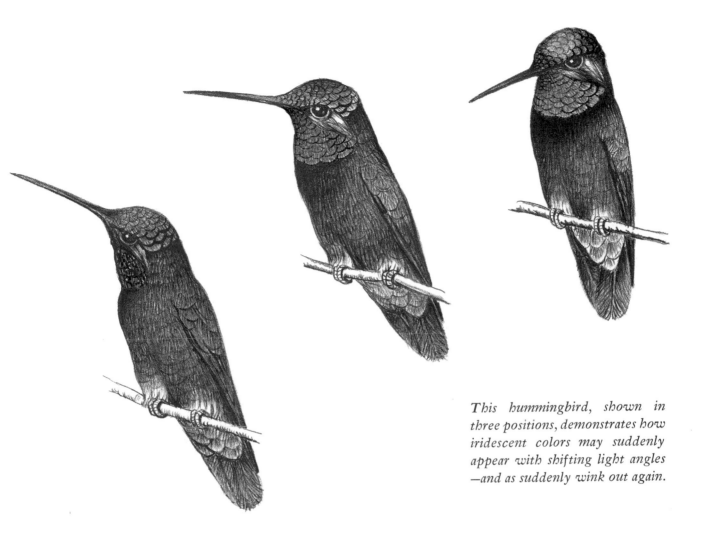

This hummingbird, shown in three positions, demonstrates how iridescent colors may suddenly appear with shifting light angles —and as suddenly wink out again.

This bird is dull bronze all over when seen from certain angles, but does indeed turn into a "fragment of a rainbow" with a slight shift of the observer's position or the angle of light. In the right light, this bird reveals a glittering golden crown, an emerald throat, and a bright green-golden breast.

Apart from the fact that all iridescent colors appear flat and lifeless in reproduction, regardless of whether by photograph or by painting, illustrations showing hummingbirds in just one position cannot possibly do justice to the peculiar life and motion these colors possess because of their extreme fluidity. This problem poses a challenge to the artist or photogra-

pher who would like to capture on paper at least some of the unusual and elusive qualities. The limitations set by pigments and paper have to be accepted, but within these limitations ways and means can be explored to achieve the maximum effect.

One way is to show the birds in different positions and from different angles. Not only the change in hue, but also the complete disappearance of color—and its startling reappearance—can be demonstrated in this manner. The method of illustration is also important, for some techniques are easier to reproduce than others. Last, but not least, the quality of the paper, the inks that are used, and other technical details count heavily in achieving good results. If all these efforts are combined, it is possible to get at least a semblance of the beauty that nature creates with unfailing excellence.

When we examine more closely those feathers which show the most brilliant iridescence, we see that they look quite different from the rest of the bird's plumage. Graded in size, smallest near the bill, and getting larger toward the body, they are arranged very much like shingles on a roof, with half-moon-shaped tips overlapping the next row. The edges are clean-cut and sharply defined, without any tapering. Unlike other contour feathers, they have a rather hard and solid appearance. If one of them is removed, it immediately becomes obvious that the "hard" part, which is also the iridescent part, does not extend all the way down to the base of the feather but takes up only a relatively small part of the broadened top. That is the only visible part in the "shingle" arrangement. The

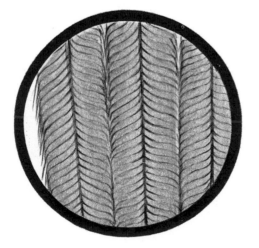

A small portion of irides-
cent hummingbird feath-
er, enlarged several times.

approximately two-thirds of the feather that are hidden by the overlap is different in color and texture: dull brown, lighter near the shaft, it is soft and rather loose. The individual barbs have a rather downy appearance. Thus, unlike the peacock train feather, the iridescent hummingbird feather is only partially modified: only the exposed top portion contains the special structures which produce the colors.

Under a magnifying glass, we see that this feather tip appears almost black, or rather, very dark brown, from certain angles, but lights up as it is moved. The microscope reveals much more, for now the arrangement of the individual barbules can be seen. They sit close to each other, are flattened, and look somewhat like the slats of a venetian blind. The tip of each barbule is bent sharply forward and joins the next one to form a sharp edge which runs parallel to the feather shaft. The flattened part of the barbule produces the color which, if light is directed onto it from the correct angle, gleams in metallic brilliance under the microscope.

The limitations of the optical microscope, which exclude objects smaller than one full wavelength of light, prevent us from studying the actual structure that creates the colors. As in the case of the peacock feather, the electronic microscope has to be employed to reveal the secrets of the minute structure of the iridescent hummingbird feathers.

Photographs taken of cuts through such feathers with the help of the electronic microscope show a picture which differs sharply from that of the peacock feather structure. The only thing they have in common is that, in both cases, layers of melanin particles are involved. But whereas in the peacock feather, the rod-shaped particles served to form a space lattice, refracting light rays into the depth of the structure, in the hummingbird feather they form thin films, or platelets, through which the light must pass.

Seen from above, a layer of these particles looks much like a mosaic of elliptical platelets. They are flat and consist of a thin melanin shell in which many small air spaces are enclosed. One layer is packed tightly upon the next: eight to ten layers seem to be the rule. Each platelet consists actually of three layers of thin films: first melanin, then air, and then

melanin again. A transverse cut through one of these platelets exposes the three layers; the platelet looks somewhat like a piece of chocolate candy with a light-colored filling.

Light waves striking these platelets are slowed down, for melanin, with a refractive index of 2.2 is more than twice as dense as air. That means, of course, that the light entering the platelets has to change its pace, which in turn means a phase difference between this light and the part which is reflected at the upper surface. The average refractive index of inhomogenous films such as the air-filled melanin platelets is determined by their individual thickness—in this case, by both the thickness of the shell and the air spaces in between. Physicists have calculated that the average refractive index of the hummingbird platelets varies, depending on the air spaces, from about 1.5 to 1.85.

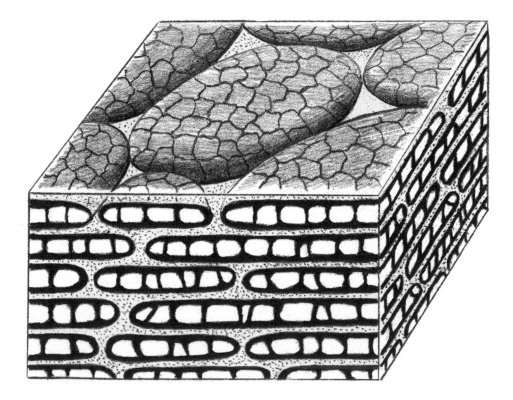

Diagram of color-producing hummingbird feather structure. Air-filled oval platelets are stacked in evenly spaced layers, separated by layers of keratin.

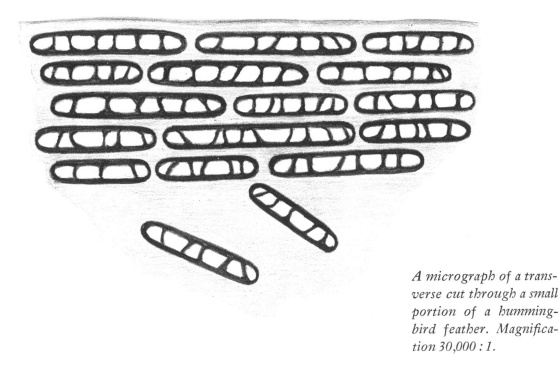

A micrograph of a transverse cut through a small portion of a hummingbird feather. Magnification 30,000 : 1.

To intensify a color, a platelet would have to have the thickness of about half a wavelength. This means a phase difference of one full wavelength by the time the light reaches the rays that are reflected from the upper surface at the point of greatest optical density, and accordingly, reinforcement of that particular color. Because we have a medium that is much denser than air, the theoretical thickness has to be divided by the refractive index of the platelet. Standard units used for measuring light waves include the *micron* (one-thousandth of a millimeter, indicated by the symbol μ) and the *millimicron* (one-millionth of a millimeter, indicated by the symbol mμ). Assuming that the wavelength or red light lies between 0.6 and 0.7 microns—which is the same as 600 and 700 millimicrons, respectively—half a wavelength, divided by the "red" platelet's refractive index of 1.85, is found to be 0.18 microns. This figure coincides exactly with the actual thickness of the platelets that produce the red color. For other colors, the thickness of both the melanin shell and

the air "filling" varies, although theoretically it would be possible to get different colors through a decrease or increase of the air spaces alone.

The fact that the platelets are arranged in several layers increases the purity of the reflected color, for in this way even neighboring wavelengths are absorbed and eliminated. Considering the number of the layers, it becomes clear that the light ultimately reflected is completely monochromatic and of great purity.

As mentioned earlier, the interference structure of the hummingbird feather does not limit incident, incoming light to certain angles as in the case of the peacock feather's space lattice. Thus, the distance the light has to travel within the platelet—and accordingly, the phase difference—is subject to considerable variation. If this phase difference coincides with the full wavelength of any one color—or a multiple thereof—that particular color will be reflected; otherwise, the waves cancel each other out, and darkness results. This is the reason why the iridescent hummingbird colors wink out so suddenly when the angle of light is changed beyond a certain point. Monochromatic light is always reflected only from a certain angle; even a slight shift lets either another color appear or eliminates all color. Thus, when the iridescence changes from red to orange, and then to gold and gold-green, it means that shorter-wave light is being reflected as the phase difference decreases with the shift of angle. Many colors, however, have only a relatively limited range: the emerald green which is so often found may show an increase in the blue or yellow components with the appropriate change of angle but will always remain basically green, winking out completely when the light angle is shifted beyond a certain point.

Despite the fact that any one species is generally limited to a few basic iridescent colors, the hummingbird family as a whole displays practically every color and shade of the spectrum. There is magenta, ruby, and fire red; orange, bronze, and gold; green, blue-green, blue, and violet—there is no brilliant hue that is not represented. No other group of birds has so wide a range of iridescent coloring.

And so they are truly "fragments of the rainbow," feathered jewels that

can turn detached scientists into poets. Their luminous colors represent the realization of what generations of artists have sought to achieve, and to which entire new methods of painting were devised. The schools of divisionism and pointilism, to name only two, sought to separate each color into its component hues, and then set them side by side on the canvas, in an attempt to create a greater purity, luminosity, and a sense of vibration. Interference colors, and those of hummingbirds particularly, have all these qualities and more, and this is probably to a great extent the secret of their esthetic appeal.

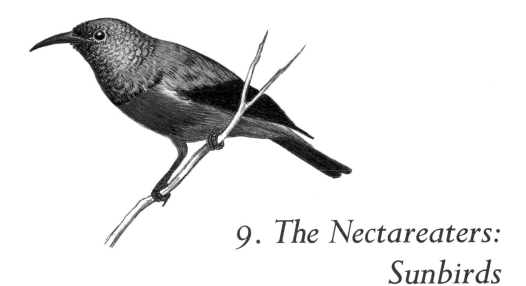

9. The Nectareaters: Sunbirds

Hummingbirds are a Western Hemisphere exclusive. None of the more than 350 species are found outside of the Americas. However, the Old World also has its group of small birds endowed with beautiful, bright, glittering colors. Because they resemble hummingbirds in their size, appearance, and way of life, comparisons between the two groups have frequently been made, and the term "hummingbirds of the Old World" is occasionally used to describe the Afro-Asian group. This is misleading, however, for the two families are in no way related despite certain superficial similarities.

Bronze and golden-green hues change into golden and orange tints in this African sunbird as light angles are shifted.

The sunbirds, whose scientific name is Nectariniidae, or nectar birds, belong to the large and worldwide order of songbirds. This does not mean, however, that they have beautiful voices: they do not. Classification is based on certain anatomical features. Sunbirds are generally quite small, averaging less than six inches. None of them are as minute as the smallest hummingbird species. Like hummingbirds, their food consists largely of flower nectar, although—again like hummingbirds—insects are also frequently eaten. Their colors are bright, with large areas of metallic and iridescent hues. The iridescence is not as intense as that displayed by the hummingbirds, however.

Apart from the zoological differences between sunbirds and humming-birds that are important to the zoologist, the two groups differ in various points of appearance and behavior that are obvious even to the layman.

Although sunbirds have iridescent colors, they also frequently display bright pigment colors. Among hummingbirds, the bright colors are always structural; no species of hummingbird has bright red or yellow pigment colors in its feathers, yet such combinations are found in many sunbirds.

Hummingbirds have tiny, weak feet which render them incapable of walking on the ground. Sunbirds, on the other hand, have normal legs like those of other small songbirds, and can hop quite well.

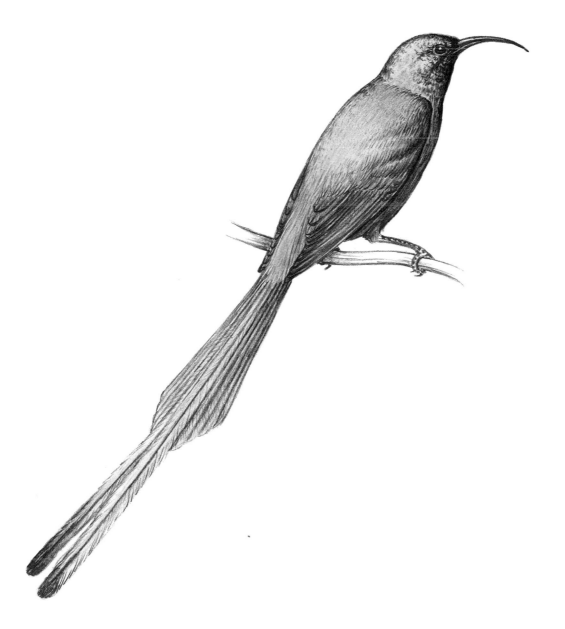

Although sunbirds fly fast and well, they can in no way match the aerial acrobatics so typical of the hummingbirds. No sunbird can ever be seen to fly straight up or down or sideways. And where hummingbirds always feed on the wing, sunbirds usually prefer to come down when they feed. They like to perch beside the flowers and insert their long, strongly curved bills into the blossom; or, if they are unable to reach the bottom, they peck a hole at the base of the flower and sip the nectar through that hole.

The majority of the more than one hundred species of sunbirds are found in Africa. The rest are distributed from Asia Minor to India and Malaysia. Wherever they occur, these little birds are a source of admiration and delight. Their graceful ways, their attractive coloring, and their association with flowers and blossoms make them welcome guests.

The iridescence of the sunbirds is of a different type than that of hummingbirds. Although it is not quite as intense, it often covers a larger area, and frequently has the "molten-metal" look we met in the Impeyan pheasant. One very handsome species, a medium-sized bird with long tail plumes, is basically black. This black, however, has a magnificent iridescence that gleams from orange and bronze hues on the head to green, blue, and violet shades on the back and tail. With every turn and shift of position, different color tones appear, so that there is a constant play of colors.

Another very beautiful species from Sumatra has a throat where deep red mingles with violet tones. The head is emerald green, shifting into gold when the light changes, and the back is bright green with a play into dark blue toward the tail. The golden-winged sunbird from Africa has an over-all gold-to-bronze coloring; yet another African species combines a glittering gold-green back with a bright red underside. The latter is a pigment color.

It was only natural that these beautiful birds should arouse much attention and admiration among naturalists, and also that the origin of their structural colors should be among those selected for examination by electron microscope, for the colors are so varied and so widely represented within the group that there had been a good deal of speculation about the

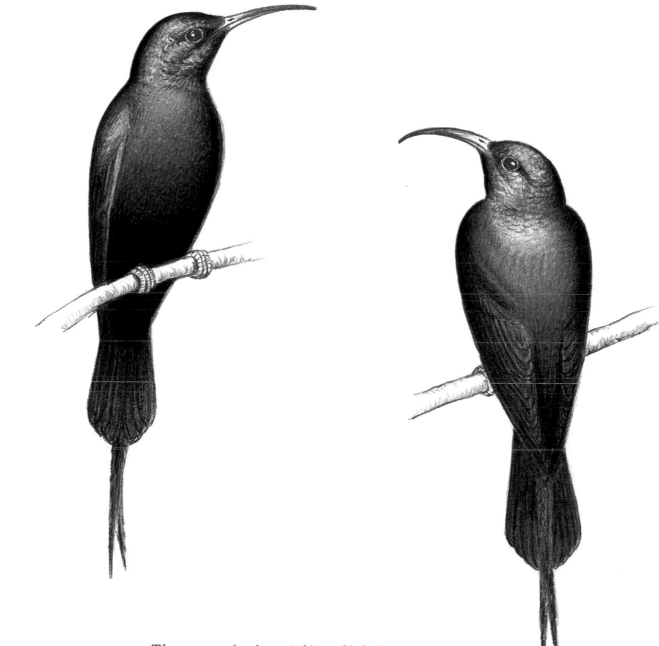

The structural colors of this sunbird disappear at certain angles, leaving the bird looking quite black. Unlike many of its relatives, this species does not have any bright pigment colors.

exact nature of the structures that caused them. Although they were, of course, known to be interference colors, modern research had already revealed the existence of a number of different interference-producing structures. Sunbirds were to prove that the possibilities for varying the typical "thin-film" structures in feathers are apparently unlimited.

We have seen that different submicroscopic structures exist in iridescent peacock, hummingbird, and Trogon feathers, and that not even all the species of Trogons have the same type of structure. Sunbirds added a fourth variant to the space lattice of the peacock, the hollow tubes of the Trogons, and the "air mattresses" of the hummingbirds.

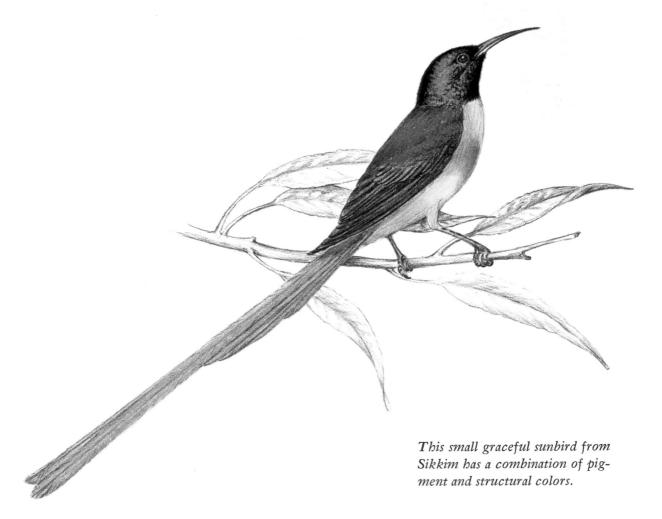

This small graceful sunbird from Sikkim has a combination of pigment and structural colors.

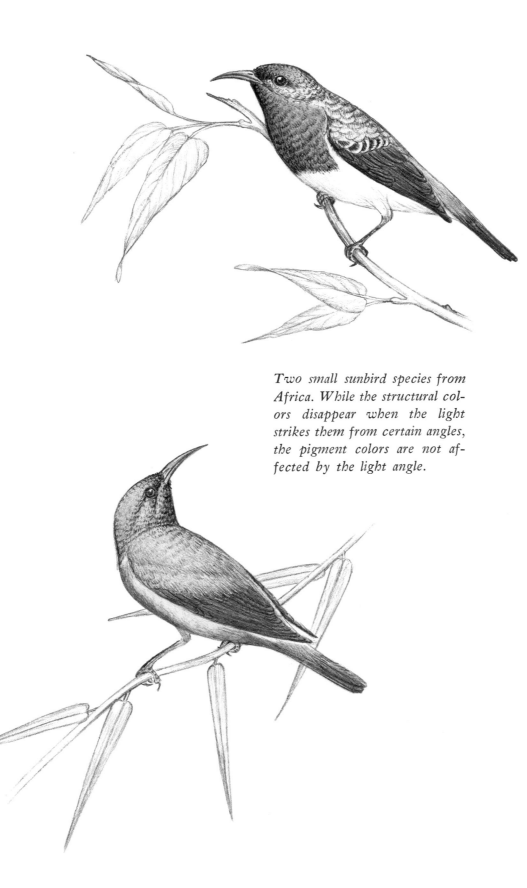

Two small sunbird species from Africa. While the structural colors disappear when the light strikes them from certain angles, the pigment colors are not affected by the light angle.

A cross section of a sunbird feather barbule shows the alternating layers of melanin platelets and keratin.

Iridescent feathers of two different species of sunbirds were used for the examination. As with the other feathers, transverse as well as longitudinal cuts through the barbules were made. The barbules, which are completely modified for their role of color production, are flattened and not as curved as those of the peacock and the Trogons. Under the optical microscope, the segments of the barbule can be seen, and it can be observed that different segments reflect different colors.

A micrograph of a transverse cut through a barbule at a magnification of 3,500 shows the by now familiar layers of dark dots in the outer zones, as well as the few irregularly spaced particles in the center of the barbule. The dots in this case are not round, but long and thin. A magnification of 30,000 reveals that they are closely spaced, sticklike particles whose ends almost touch. The actual shape of these particles is revealed by a look at a micrograph which was taken after the top layer of the barbule was peeled off, exposing the structures. The particles now could be photographed from above; they appear as long, flattened platelets packed so tightly that the sides as well as the ends barely miss touching each other.

In contrast to the air-filled, oval melanin particles of the hummingbird and quetzal feathers, the platelets of the sunbirds are long, thin, and consist of solid melanin. They vary in thickness and are arranged in rows

with layers of keratin spaced between. The distance between the rows of platelets—in other words, the thickness of the keratin layers—also varies considerably in barbules displaying different colors. Here, as in all the other iridescent feathers, the regular rows and layers are found only in the outer zones of the barbules; toward the center, the rows become more irregular and finally disintegrate.

Because the thickness of both the melanin platelets and the keratin layers may vary in the same barbule, not just one but several different wavelengths are brought to interfere at the same time. This produces delicate and beautiful mixed colors and causes the extreme mobility of the feathers' color play. A sunbird from the Congo region, for example, displays a gleaming copper color on the upper tail coverts. This hue is, as Fig. 7 shows, a result of a mixture of red and yellow-green interference colors. The micrograph from which this diagram was made enlarged the platelets 50,000 times. The difference in the thickness of the keratin layers can be clearly distinguished. The outer layers reflect a red; the other, differently

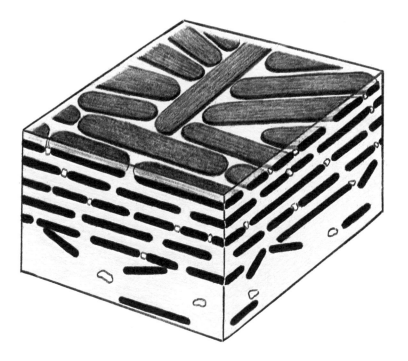

A diagram showing the structure that produces the iridescent colors in the sunbird feathers. Solid, thin melanin platelets, interspersed with layers of keratin, with practically no air spaces at all, here serve as the interference-creating "thin films."

Bronze and golden-green hues change into pinkish and mauve tints in this African sunbird as light angles are shifted.

spaced layers reflect a yellow-green hue. When the eye mixes these two colors, a copper hue is produced. A similar arrangement is found in a barbule that reflects green-gold overtones. Here the first few layers reflect the green, and the deeper-lying structures reflect the yellow-green. Because yellow-green is reflected most strongly in near-vertical light, it disappears as soon as the light strikes the feather from an oblique angle.

Generally speaking, the thicker platelets—or two thin platelets set so closely together that they form a single unit—cause the longer wavelengths at the red-yellow end of the spectrum to be reflected. As the platelets get thinner, or the distance between the rows decreases, the colors change toward the shortwave, blue side of the spectrum. The most inten-

sive color can always be seen when the light strikes the platelets from a more or less vertical angle, because then the light can reach the lower depths of the structure, and more light gets reflected. As the angle becomes more oblique, only the upper levels reflect light, the rest is absorbed, and the color becomes weaker. Thus, a color whose basic tone is bright green is less brilliant when it gets a bluish cast in light slanted at an oblique angle.

All the sunbirds that were examined showed a similar interference-producing structure. In this group, we do not find the variations of structure that distinguish the different Trogon species. So far, the sunbirds seem to have the simplest structure of all feathers examined. It produces interference colors in the classic manner of "thin films." The space lattice

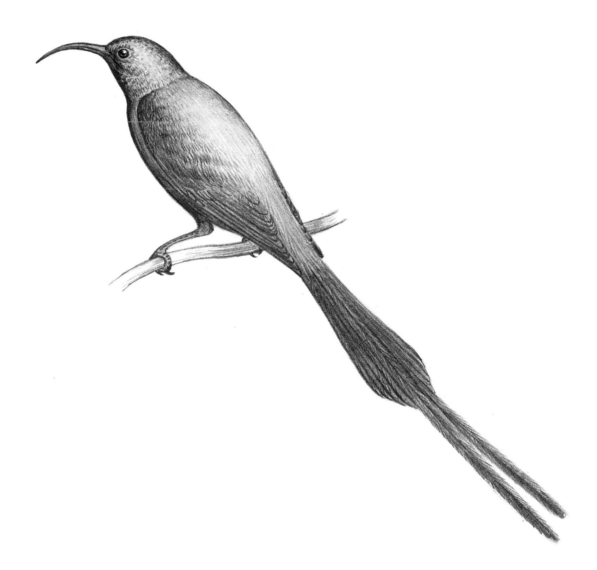

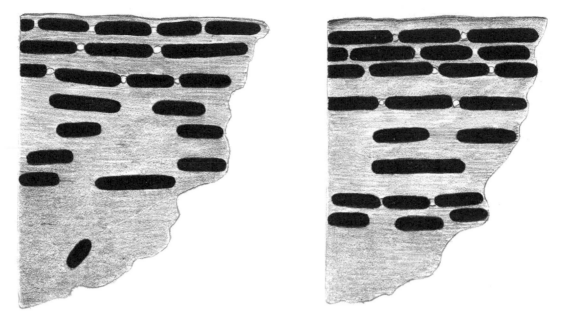

Cross section through two different color zones of sunbird barbules. Blue (right) has much thinner keratin layers betwen platelets. (From an electron micrograph, magnification 50,000 : 1)

of the peacock, the hollow tubes of many Trogons, and the "air-mattress" arrangement of hummingbirds and others, with their optically inhomogenous medium of air, melanin, and keratin, represent structures of a much more complex nature.

When we compare the various iridescent feathers that have been examined with the electron microscope, what strikes us as perhaps most astonishing about them is the fact that so many different interference structures are found in these feathers. On the other hand, it is almost as amazing that nearly identical structural arrangements have been achieved in unrelated birds through different evolutionary processes. Also, it is quite evident from these studies that the structures cannot possibly be the result of coincidental changes in the feather. The extremely complicated precision arrangement of these structures, which are distributed only in those parts of the feather normally visible on the living bird, and their incredibly minute margin of error, can under no circumstances be considered to be

the result of coincidental mutations. Rather, it must be assumed that a still unknown force working toward a definite end has produced them. It will be most interesting to see whether further advances in biological research and discovery will in the future be able to shed more light on these mysteries.

10. The Madagascan Marvel:
Urania Moths

N O PAINTING or reproduction can give more than a fractional impression of the play of colors, for they shift, blend, and then change again with every minute variation of the angle of light falling upon them." With these words, entomologist Alexander B. Klots attempts to convey some conception of what he calls the "almost three-dimensional colors" of certain moth species.

Of course, "three-dimensional" in this context is just a figure of speech; colors, having no body, cannot have three dimensions. By now, however, we are familiar with the searching for words, the invoking of symbols in an attempt to do justice to the incredibly pure iridescent hues that are

displayed by certain animals. Regardless of whether they apply to birds or insects or other creatures, ordinary descriptive terms such as scarlet or magenta red, chrome yellow, indigo blue, and the like, sound as flat as these pigments are compared to the glittering hues of really intense interference colors. Verbal descriptions of these colors fall as short of imparting any true concept of their beauty as do all pictorial reproductions. Through sophisticated photography, modern nature illustration has attained great heights; virtually any color, tone, and shade can be reproduced with great fidelity. The only exceptions are the iridescent colors.

As discussed earlier, insects are one of the animal groups in which structural colors are widespread. Of all the various insect groups, none has more beautiful and varied patterns, colors, and color combinations than the huge order of the Lepidoptera. This group includes both the moths and their more advanced relatives, the butterflies. The majority of the Lepidoptera—almost seventy of the fewer than eighty families—are moths, which are generally smaller, less attractive, and, in their larval stage, more destructive than butterflies. There are, however, many large, handsomely colored species.

Throughout the ages, the Lepidoptera have been the most admired of all insects. The ancient Greeks borrowed the wings of butterflies for their concept of Psyche, the lovely maiden which personified the human soul. The complex development of these insects, which has to go through a larval and pupal stage before the winged adult finally emerges, was a source of wonder to ancient peoples. The stages of the butterfly's metamorphosis were considered as symbolic of man's life, with the earthbound, greedy caterpillar representing man's life on earth, the motionless pupa his death, and the winged, airborne, nectar-sipping adult the soul of man and his life after death.

Apart from all such fancies, the Lepidoptera are very interesting crea-

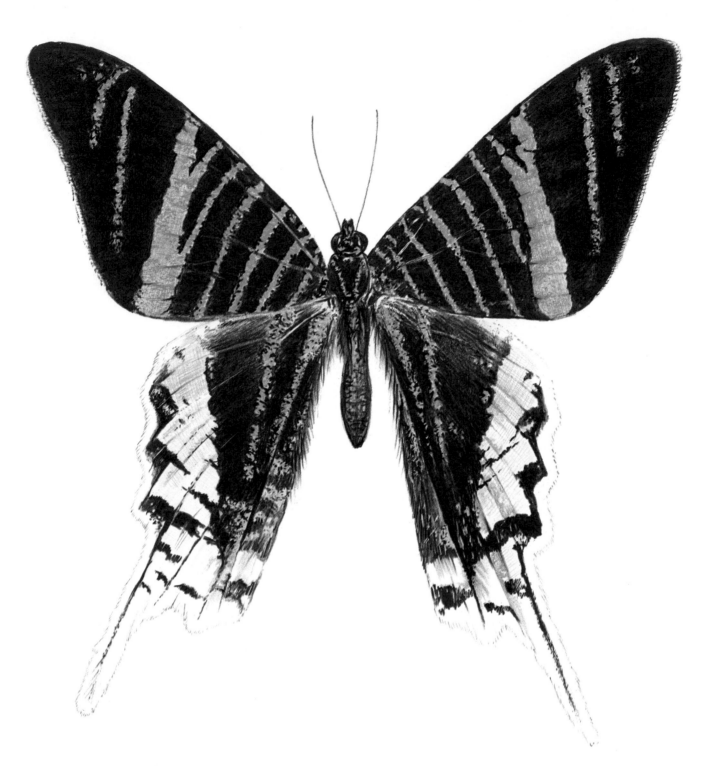

Two South American species of Uraniids. Although they are similar, pattern and colors of the hind wings are distinctive. Enlarged 3 times.

tures. With all the widespread—and often unfounded and unjustified—antipathy against insects, the person is rarely found who does not like butterflies. Amateur lepidopterists number in the hundreds of thousands, and any large and handsomely colored butterfly visiting flowers in

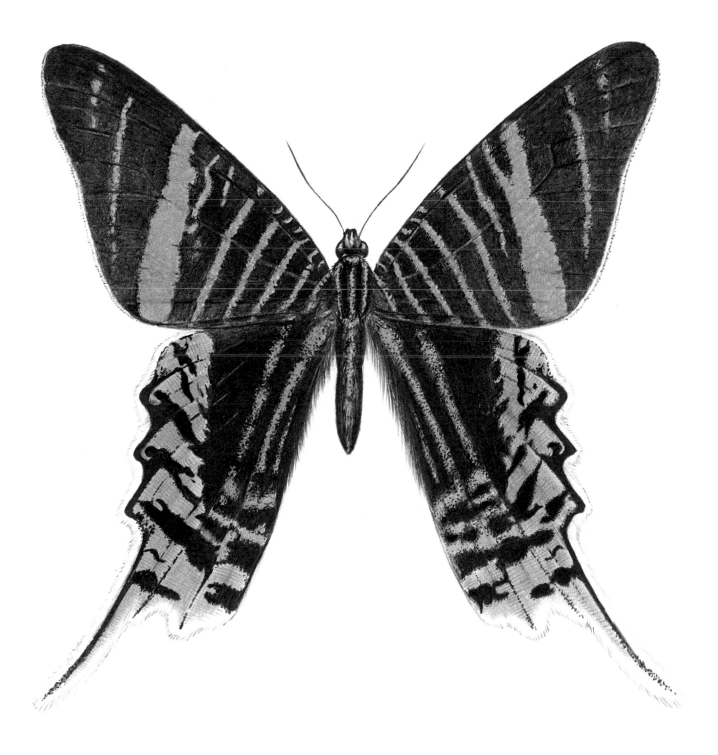

a garden will invariably draw exclamations of delight. Moths have not fared as well, for a number of unrelated reasons. One is that most moths are rather small and drab-looking. Another reason is the common but erroneous idea that any moth flying around lights at night is a clothes moth, which will immediately attack and eat anything from a cashmere sweater to a mink coat. The third—and only really valid reason—is that many moths are extremely destructive in the larval stage. Caterpillars of such species as the codling moth, a pest of apple and other fruit trees; the clothes moth, which destroys woolen fabrics, rugs, and many types of animal products; and many others that feed on vegetables and fruit cause millions of dollars of damage each year, despite control programs.

Large and handsome moths are relatively rare in the temperate regions, and because the term "moth" is most often associated with a smaller insect, the large moths such as the beautiful Cecropia or the magnificent pale green Luna moths are often mistakenly called butterflies. Moths with brilliant iridescent colors are rarely found in the cooler zones, although many smaller moths have attractive silver and golden colors that are structural; these insects go unnoticed mainly because they are too small to be eye-catching and reveal their often exquisite coloring only under the magnifying glass.

The largest and the most beautiful moths are found in the tropics of the Old and New Worlds. Certain moth species can compete with the most beautiful butterflies in both pattern and color combinations.

No other moth family has so many members with brilliant iridescent colors as the Uraniids. It is not a very large family, and many of its species are relatively undistinguished insects. But those that have the iridescent colors are outstanding, and a few are truly magnificent creatures.

Those who know enough about the difference between moths and butterflies to know that moths usually have heavier bodies and narrower wings than their more advanced relatives, and also fly at dusk, would hardly recognize these Uraniids as being moths. They neither look like moths nor behave like them, for they are slender-bodied, large-winged, day-flying insects with wings resembling those of the swallowtail butter-

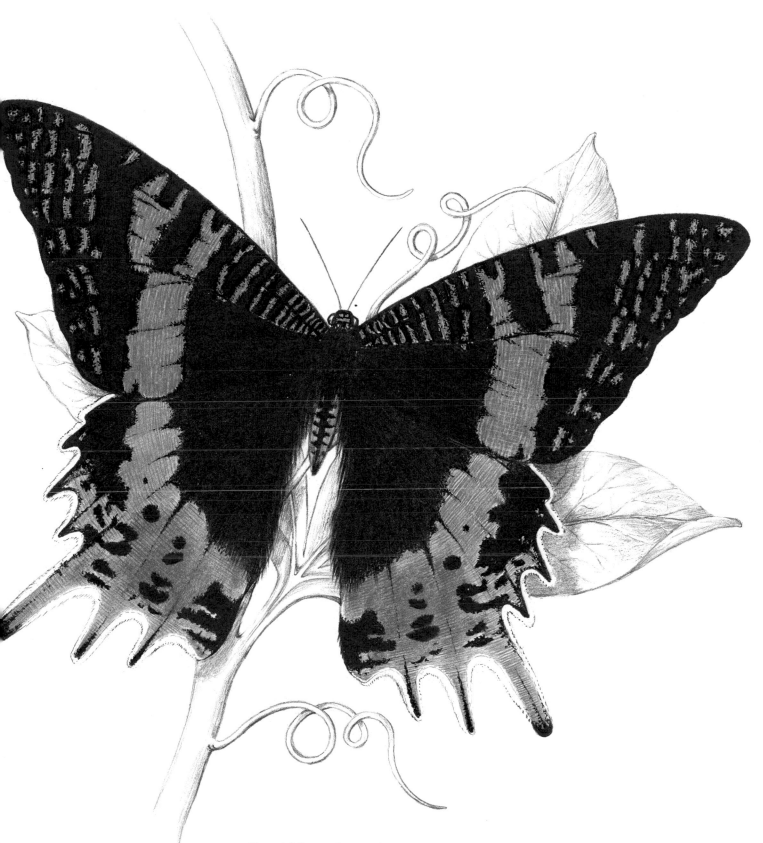

Chrysiridia madagascariensis, *enlarged about 3 times. Many naturalists claim this to be the most beautiful moth in the world.*

Hind wing of Chrysiridia madagascariensis, *enlarged 6 times. The overlapping rows of multicolored scales are clearly visible.*

flies, and their wings glitter in multihued iridescent patterns.

These colorful Urania moths are found in both the Old and New World tropics. The coloring varies considerably with the species. Those found in the Indo-Australian region generally have rather quiet, pale, satiny-looking hues that shift from green to blue or to yellow-green as the light angle changes.

Much more brilliant is the iridescence of certain South American species, whose wings display a bright gold-green that shifts into an equally bright sapphire blue. *Cherubina chlorippe*, for example, is a grand creature, shaped like a swallowtail, with long white tails on the hind wings. Its black forewings are crossed by one wide and several narrow bands of gleaming, gold-shot green, which assumes a bluish cast in certain positions. The hindwings, which are also dark, have white fringes and a broad band of color ranging from pale blue to green and gold. This moth is a creature of the tropical forests, where it flies among the treetops.

Without doubt, the most stunning of all the Urania moths is a Madagascan species. *Chrysiridia madagascariensis* also has the size and shape of a swallowtail. Like those of *Cherubina*, its black forewings are crossed by one very wide and several narrow broken bands of glittering gold-green. The tailed, deeply scalloped hindwings are a rich dark chocolate brown, with white fringes and large areas of the glowing, multicolored iridescence whose incredible brilliance and shifting rainbow hues caused the enraptured remarks by entomologist Klots quoted at the beginning of this chapter. Here blue shifts into gold-green, and into gold, copper, bright red and purplish hues of the greatest purity and intensity with every change of light angle. To have seen a specimen of this moth is to know the frustration that results from trying to describe—or to illustrate—the beauty of these colors. If well protected from dust and damage, the wings will glitter with all their natural fire years after the death of the insect. Because of this, the Madagascan moths are much in demand for use in jewelry and other ornaments, and each year thousands are bred and shipped abroad for that purpose.

The iridescent colors of insects posed just as intriguing a problem as

that of iridescent feathers and were eagerly examined by naturalists as soon as the introduction of the electron microscope permitted the study of submicroscopic structures.

In the Lepidoptera, the color-producing structures are situated in the scales which cover both sides of the wings. These scales are fastened to the wing membrane by short pedicels. In pigmented scales, the hollow interior of the scale is filled with pigment which gives the scale its color. Those scales that have structural colors may also contain some melanin, but this serves only as a background. The colors of these scales are produced exclusively by often complex submicroscopic scale structures.

The scales of both the Urania moths and the Morpho butterflies (which will be described in the next chapter) were among the first to be examined, because of the brilliant iridescence displayed by these insects.

Even with a normal microscope, some of the secrets of this iridescence are revealed. A magnification of 100 : 1, for example, shows the scales of *Chrysiridia madagascariensis* to be strongly convex, multicolored, and marked by longitudinal striations. The latter, as we soon shall see, are ridges rising vertically from the body of the scale. Enlarged photographs of the scale taken with the help of transmitted rather than reflected light

Scales of Chrysiridia madagascariensis, *enlarged 430 times.*

show the scale body to become thicker toward that part farthest away from the pedicel. At a greater magnification, the scale appears to be criss-crossed by a system of dark lines. According to the theory of interference colors, precision structures capable of eliminating certain wavelengths and reinforcing others have to be present. The multicolored hues of the

Small portion of a Urania scale. The dots are the rods supporting the lamellae which make up the scale lumen. (From an electron micrograph, magnification 1,200 : 1)

Urania scales seem to indicate that the submicroscopic structures are varied enough in different parts of the scale to reflect different components of the spectrum. In view of the minuteness of the scales, fifteen of which would fit side by side into the space of a millimeter, this is quite an achievement. The revelations of the electron micrograph are therefore especially interesting.

Making transverse cuts through scales less than one-fifteenth of a milli-meter in width, and with a thickness measuring only a fraction of this width is not an exercise for the impatient. Without going into details, it will suffice here to say that the cuts were made after embedding the scales in plexiglass. Scales from both the Madagascan and another species were prepared in this way.

The micrograph shows interesting details of the scale structure and solves the riddle of the multicolored nature of these scales. Instead of a top and bottom lamella enclosing the more or less hollow lumen, or scale

Cross sections through scales of two different Uraniids show longitudinal ridges as well as the "thin film" structure of the lumen. (From an electron micrograph, magnification 12,000 : 1)

body, the Urania scales consist of a number of extremely thin lamellae held apart by tiny vertical rods. The ridges that rise from the top lamella at evenly spaced distances can be clearly seen. The gradual thickening of the scale from the pedicel outward, which was noticeable on the photograph taken with the help of transmitted light, is explained by the fact that the number of lamellae varies from one part of the scale to another.

Some rather intricate mathematical calculations have shown that two lamellae have to be counted as one in order for pure colors to be reinforced and reflected. This means that a minimum of four lamellae have to be present to produce interference. An increase in the number of the lamellae, and a variation in the distance of the air spaces between, plus the convex shape of the scale are features which combine to permit a single scale to reflect different wavelengths at the same time, thereby giving the scale its multicolored appearance.

A scale lumen consisting of several lamellae held apart by small vertical rods, and thus creating conditions suitable for light interference, is typical

of iridescent scales found in a number of different moths and butterflies. Although these structures are by no means as complex as those of certain other Lepidoptera scales, they are responsible for producing some magnificent color effects. *Chrysiridia madagascariensis*, for one, does not have to fear comparison with any other member of its group.

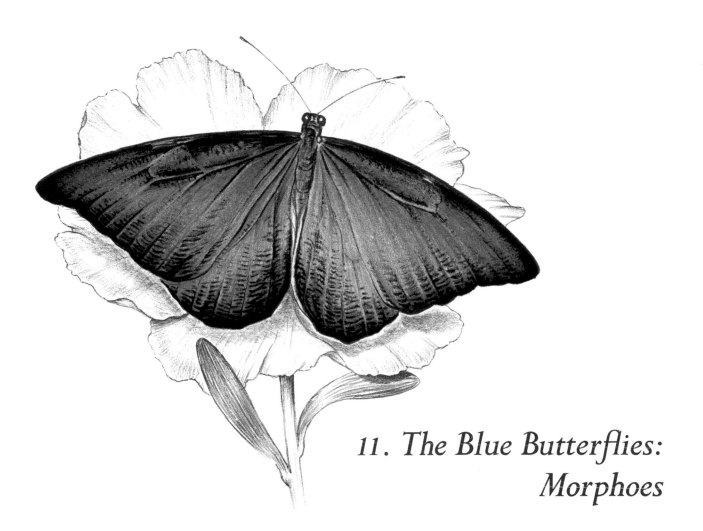

11. The Blue Butterflies: Morphoes

THE MULTICOLORED hues of some of the Urania moths are so magnificent that it would seem difficult to find any butterfly that could match their beauty. However, some of the large, almost solidly iridescent blue species must be counted among the most stunning and exquisite examples of structural colors in the entire animal world. Not surprisingly, such butterflies have always been eagerly sought by collectors, and much of the butterfly jewelry that is turned out is made of the glittering blue wings of these insects.

The Morpho family, a relatively small group of medium to large-sized butterflies, is found exclusively in the tropical regions of Central and especially South America. A great many of its members are endowed with glittering iridescent or opalescent blue hues of great depth and purity.

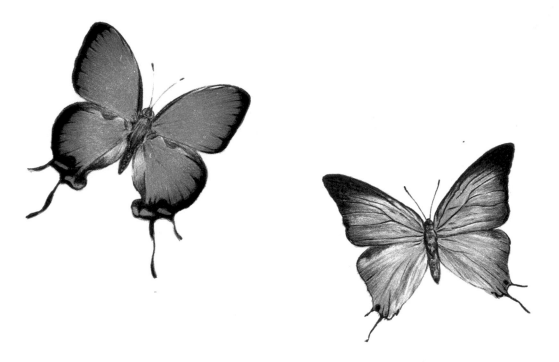

Although small, these two South American butterflies have strong pure structural colors.

There are, of course, members of other families—such as the worldwide groups of swallowtails, hairstreaks, and blues—that also have much iridescent blue coloring. However, these insects are either quite small, which makes their beauty less eye-catching; or else, in some cases, the iridescent colors cover only relatively small parts of the wing area.

Among insects, as among birds, the colors from the shortwave end of the spectrum are almost exclusively structural. This does not mean, of course, that there are no structural reds, yellows, and oranges found

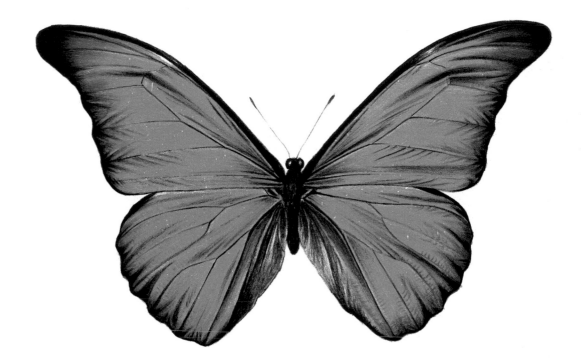

This Morpho has hues that shift from blue to a deep violet.

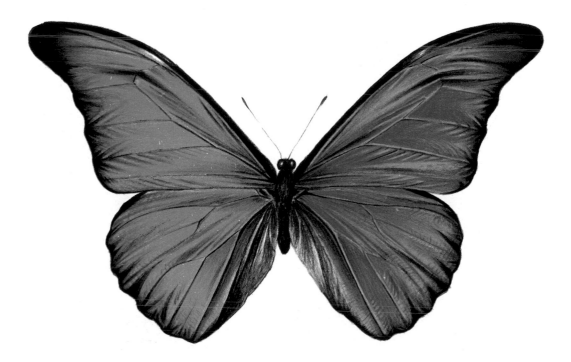

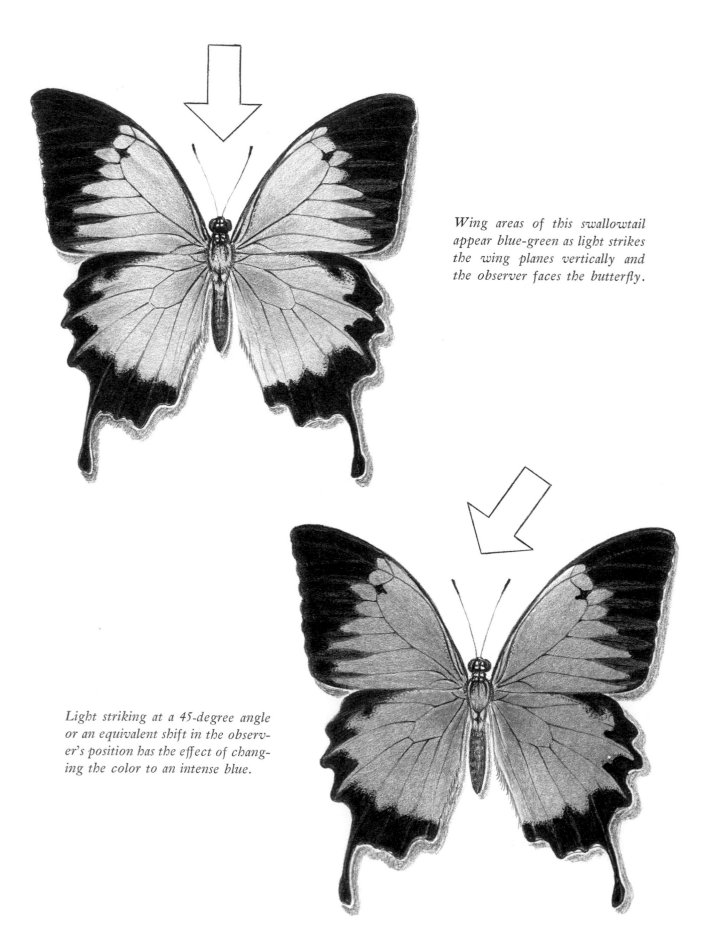

Wing areas of this swallowtail appear blue-green as light strikes the wing planes vertically and the observer faces the butterfly.

Light striking at a 45-degree angle or an equivalent shift in the observer's position has the effect of changing the color to an intense blue.

among insects. On the contrary, as we just have seen from the example of *Chrysiridia madagascariensis*, many insects do have magnificent red, gold, copper, bronze, and silver hues that are purely structural and not based on pigmentation. However, the majority of physical animal colors are in the green-blue-violet range, and virtually none of these colors found among insects is a pigment color.

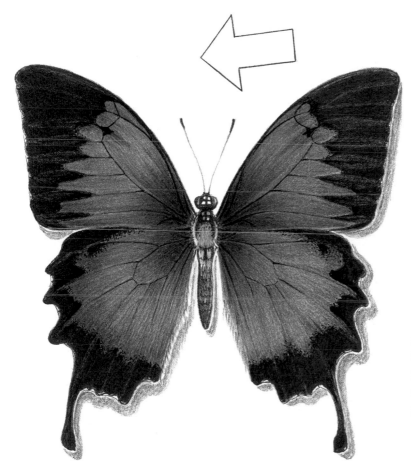

An even more oblique angle of light incidence causes the color to move further toward the shortwave end of the spectrum, with violet and even purple tones appearing.

Changing the light angle turns the colors of this tropical swallowtail from a blue-green into a blue and, finally, into a deep violet.

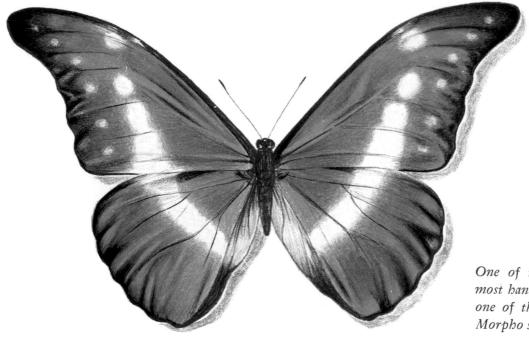

One of the largest and most handsome, and also one of the rarest, of all Morpho species.

In proportion to its size, a butterfly of the large Morpho species is much more generously endowed with iridescence than any bird. Some of the largest, which measure five inches or more across the outspread wings, are practically a solid sheet of glittering blue, with the exception only of the small body and a narrow wing border, both of which are dark brown. The colors of the·wings may be so intense and brilliant that they look as though they give off blue sparks even from a considerable distance. Entomologist Klots, who observed South American Morphoes from a low-flying plane, describes them as "soaring like jewels over the top of the forest canopy, the flashing blue of their wings plainly visible from several hundred feet above." Other naturalists also have commented on the fact that this intense blue, combined with the Morphoes' slow, deliberate wingbeat, makes them easy to spot even from a distance. A century ago, the famous English naturalist Bates wrote of one of the large Morphoes: "Sailing along, it moves its wings only occasionally, and when it does, the

blue upper sides of their wings gleam in the sun so that the insect is visible from a quarter mile."

For interference colors, such visibility from a distance is unusual. There are several reasons for the long-distance visibility of the Morphoes' blue. One is the large size of the color area, as well as the fact that the color is all on one plane. Even the smaller Morpho species have a wing expanse of about four inches, while the larger kinds measure between five and six inches. A specimen of *Morpho menelaus*, for instance, measures five and a half inches across, and thus has a wing area of approximately fifteen square inches. Almost this entire area is blue, and when the wings are fully spread, all of it is on the same horizontal plane. This means that light striking the wings is evenly reflected from every part. As the butterfly flies in the sunlight, this large mass of blue is naturally visible from quite some distance, and most especially from above, because from that vantagepoint the observer sees the reflected near-vertical light which always produces the strongest interference colors.

The slow, deliberate wing movements of the Morphoes make it easy to appreciate the colors while the insect is in flight. This, of course, is exactly the opposite of what happens when hummingbirds are observed in their natural environment. They fly about so much, and move so quickly on the wing that, even at a short distance, their gleaming colors are invisible except for an occasional flash. The beauty of their hues can be appreciated only when the birds come to rest on a branch; even then, however, the observer has to be fairly close. Not only do the iridescent colors constitute a relatively small area: the rounded body contours also permit only certain portions of these colors to be visible from any one angle and position. Thus an iridescent crown may gleam brightly while most of a normally also iridescent throat appears dark, and vice versa. Seen from a distance of more than a few yards, the glittering feathers lose their effect very much as small precious stones would lose theirs.

Among the various species of the Morpho family, the entire range of shades from the palest moonbeam-blue opalescence to a deep and intense violet-blue is represented. Some of these colors glitter with a metallic

This Morpho normally is a glittering green-blue. Color of brown borders is caused by pigmentation.

A more oblique angle brings out deep blue and violet tones in the wings.

At an extremely oblique angle, the blue color all but disappears except for raised vein areas, and any portion of the wing catching light at a more vertical angle. The rest of the wings appear dull purplish-brown.

luster; others look like smooth, silky satin; and still others glow with a subdued pearly sheen.

The full wonder of these colors becomes apparent only when and if light is directed onto the wings from different angles. Normally, a five-inch *Morpho rhetenor*, for instance, shows an intense electric blue on both fore- and hindwings, with the exception only of the dark brown tips of the forewings, and a russet border along the inside of the hindwings. If a mounted specimen is slowly moved and turned in the light, the blue changes. At one point, it takes on a greenish hue; at a different angle, it turns into a deep purple-toned violet the likes of which cannot be found on any color chart. If the light is directed so that it strikes the wings from a very oblique angle, the blue almost disappears, and the wings take on a dull brownish hue. Only the raised veins, whose scales are positioned at

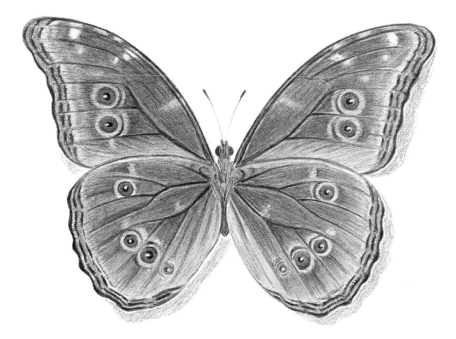

Underside of the Morpho shows "normal" brown pigment coloration and cryptic pattern. Females generally have a lot of brown and little blue on the upper wing sides as well.

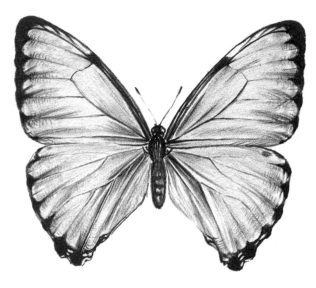

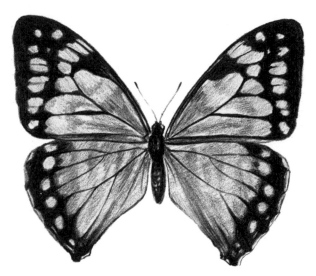

*One of the smaller Mor-
pho species. The female
lacks the color structure
and thus appears brown.*

angles differing from those of the wing membranes, retain a gleam of
bright blue. A flick of the wrist, changing the light to a more vertical
angle, restores the brilliant blue color of the entire wing area. This dis-
appearance of all blue color and the appearance of brown pigmentation
holds true for all the very glittering Morpho species; the ones with the
softer, more pearlescent blue hues appear dusted with white at certain
angles, for reasons which we shall explore later.

A surprise is in store for the unsuspecting layman who takes a look at
the underside of the wings. All the blue Morphoes are brown below and
have intricate patterns which may include eyespots as well as light and
dark scrawls, bands, borders, and blotches. The change from wings spread
to wings folded is startling; it is easy to see how, against the mottled back-
ground growth of the Morphoes' native jungle, or when the butterflies
are seen from below in flight, they all but vanish with only the cryptic
dark undersides of the wings visible.

Many butterflies, of course, have different patterns on the upper and lower wing surfaces. Quite often, the pattern below is just a paler, duller version of that above. In many cases, however, the two sides are so radically different that nothing prepares the layman who sees the butterfly from above, with its wings spread, for what it looks like when the wings are folded over its back. One of the most striking instances of such difference in color and design, in which the resting insect is camouflaged by the pattern of the lower surfaces of its wings, is the Indian leaf butterfly. The upper sides of the wings are marked with broad bands of dark brown, bright orange, and blue. The lower surfaces are grayish brown and resemble a dead, dry leaf down to all details such as midrib, vein markings, and decay spots. Not surprisingly, the butterfly which alights on a bush and clasps its wings over its back simply disappears from sight. Even experienced collectors can easily miss these insects while looking directly at them.

Although cryptic coloration among Morphoes is not carried to such lengths, and does not resemble any specific object, the difference between the bright, glittering blue upper wing surfaces and the brown undersides is quite startling. However, a simple experiment will show that the difference is not really fundamental and that the blue color is, in the truest sense of the word, superficial, that is, a result of surface structures only.

We have already seen that the wings of some of the most glittering and intense blue Morpho species lose most of their color and turn brownish when the light strikes them at a certain angle. If one of these same butterflies is held up against a strong light, and the light has to pass *through* the wings in order to reach the observer's eyes, we find that the blue color disappears. All we see now is a brownish butterfly. The patterns of the lower wing surfaces are clearly outlined in transmitted light. This happens regardless of which side is turned toward the light source: as long as the butterfly remains *between* the light and the observer, and light does not reach the upper wing surface from some other source, both sides of the wings will look the same. Indeed, which is which can be told only by looking at the body of the insect. This experiment proves that light has

Under the microscope, a magnification of 85 shows the arrangement of the blue scales. At right, light coming from an oblique angle eliminates the blue color.

to reach the *upper layers* of the *upper* wing surfaces and be *reflected* in order to produce the blue for which these butterflies are famous. When light is transmitted, only the partly transparent melanin present in the scales becomes visible.

The blue color can be made to disappear temporarily by other methods than manipulating the light source. If, for example, a liquid with a refractive index similar to that of chitin is poured over the wings, the blue disappears like magic, but reappears as soon as the moisture starts to evaporate and the wings become dry again. Different liquids have different effects, depending on their optical density, that is, their refractive indexes. Some turn the blue into bright green or even bronze-green. In other words, the colors move toward the long-wave end of the spectrum. In certain species, the wings will turn brown when immersed in liquids such as xylol. Clearly, these liquids temporarily alter or destroy the conditions necessary

for producing the normal interference colors. To understand exactly what happens, we have to consider the laws of interference and the submicroscopic structures as revealed by modern electronic research. Before we turn to the latter, let us first take a look at a Morpho wing through an optical microscope.

At a magnification of about 60 : 1, the visible wing portion is shown to consist of tightly packed rows of overlapping scales which look very much like shingles on a roof. The membrane to which these scales are attached is not visible except on a damaged wing.

In many species, the tops of the scales are smooth and slightly rounded on both sides; in others, the top edge is "toothed" or jagged. Even in the same species, scales from different parts of the wing may vary in size and shape.

With comparatively vertical lighting, the scales gleam in bright brilliant blue, which may change to a greenish or violet hue as the light angle is altered. Minute striations lend the scales a furry or pile-rug appearance, but this fur has a hard, brilliant, metallic quality. The striations betray the presence of numerous ridges, which, however, can be made out only with the help of very powerful magnification.

As the light angle is changed, the colors shift. It is fascinating to watch the enlarged scales take on a greenish-blue, deep blue, and violet hues according to the angle. As the angle becomes more oblique, the colors shift more and more to the extreme shortwave end of the spectrum, and become less brilliant as they do. Finally, the violet-blue starts to disappear, and brownish tones appear, and then the blue is gone altogether, and rows of dull brown scales with just a narrow edging of blue at the top of each row is all that is left. Just a flick of the wrist, however, will bring back the full magnificence of the blue color.

If a single scale is removed and placed on a smooth white surface—*not a job for the impatient*—shape and color of both the upper and lower scale surfaces can be studied. Right side up, the scale appears bright blue, somewhat darker near the pedicel, lighter toward the top. The striations run all the way from the pedicel—the tiny stem by which the scale is attached

to the wing membrane—to the top edge. By moving the turntable of the microscope, the blue-violet–brown–greenish-blue–blue cycle can be repeated with the single scale. Turned over to reveal the underside, the scale looks entirely different. Regardless of the angle from which the light strikes this side, it remains brown at all times. The striations are visible from the underside, but they look different. The brown color is, of course, due to melanin pigment in the scales.

On the lower wing surfaces, the scales appear brown on both sides and at all angles. Depending on what part of the wing they come from, they may vary a good deal in shape, size, and hue. Some are long and slender, some squat, some have rounded tops, but the majority end in four or five sharp points. These scales also have striations, but they differ from those of the blue scales. While some of the pigment scales display a faint opalescence when viewed from certain angles, this does little more than add a sheen to the brown color.

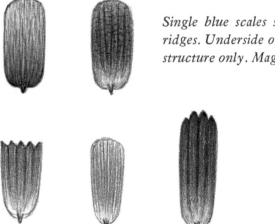

Single blue scales show texture betraying the tightly packed surface ridges. Underside of blue scale is brown: blue color results from surface structure only. Magnification 150 times.

Scales of the undersides of the wings have variety of shapes and tones of brown.

Apart from the fact that they have different shades of blue, the upper wing surfaces of all the glittering Morpho species look very much alike when viewed through the microscope. It is quite a different story, how-

ever, with those kinds that display a softer, more opalescent blue. These colors, incidentally, never turn brown regardless of the angle at which the light strikes them. Instead, as mentioned before, they take on a blue-gray

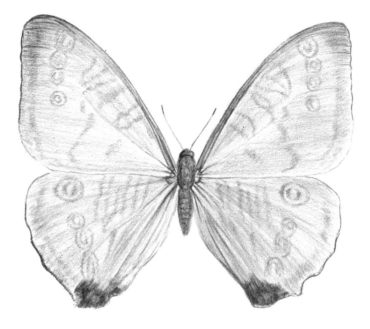

Beautiful in its own way, this small Morpho has pale opalescent hues that all but disappear in oblique light, making the butterfly look light brown.

coloring which results from the whitish overtones that appear when light reaches the wing from an oblique angle. The microscope reveals the reason for this difference.

Morpho peleides, a five-inch species with dark brown borders around both fore- and hindwings, has a silky, rather pale and muted blue color which shows a soft play of hue from green to violet. Looking at a wing through a microscope, we see what at first glance appears to be rows of very wide pale blue scales which overlap horizontally as well as vertically. On closer inspection, however, it becomes clear that these scales are trans-

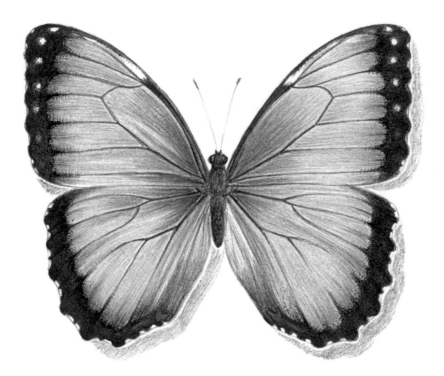

The blue of this Morpho is more muted than that of many other species.

Colors are opalescent, shifting from pale blue-green to lilac hues.

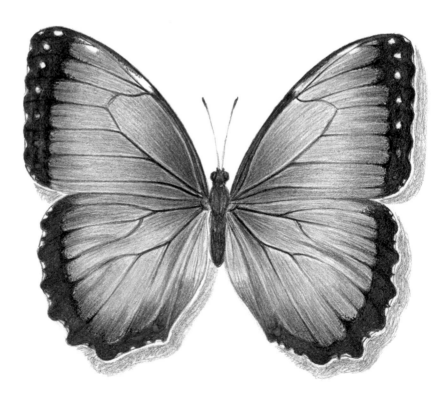

lucent and, apart from a slight opalescence, have no color of their own. Where, then, does the blue color come from? The puzzle is solved by the appearance of those portions of the wing where the blue touches the brown border. Here the glass scales are missing in some places, and the secret of the blue color's origin is revealed. The glass scales are merely the top row of a double layer of scales—the lower layers consist of the typical, bright blue Morpho scales! The glass scales, which have a different structure, permit the blue color of the underlying scales to come through in a muted tone. The effect is very much like looking at a color through a piece of frosted glass: the color appears paler because some white light is reflected by the glass. If the top row of scales were removed, these Morpho species would gleam in the same brilliant blue hues as other members of the family.

The glass scales explain not only why the blue is so much more subdued, but also why the wings never turn brown, regardless of how oblique the angle of incident light may be. At certain angles, the glass scales reflect much white light, with the result that the wings look grayish, dusted with white, in positions where a blue wing would normally appear almost brown.

Among different species of Morphoes with the softer blue hues, we find varying degrees of glass-scale arrangements. In fact, only the most glittering and metallic kinds are completely without them. Differences in the size and transparency of the glass scales—the transparency is controlled by the structure of the ridges—produce varying degrees of strength and intensity of the blue color. In some cases, the upper-layer scales are so narrow that they cover only a portion of the underlying blue scale, and so transparent that they are virtually invisible from many angles. The wider they are, the more solidly they cover the underlying rows of blue scales, the paler and more muted is the over-all color. In this way, every type of blue from the most intense and glittering to the softest, palest milky blue shades may be created just by the absence or presence of the cover scales, and the latter's degree of transparency. While minute differences in basically similar submicroscopic structures determine the *hue* of

blue—whether, for example, a species has normally a greenish- or violet-blue—the degree of *intensity* is controlled by the top row of glass scales.

Like other interference-producing structures, the minute surface structures of the Morpho scales are beyond the range of the optical microscope. Their exact shape and arrangement remained a matter of speculation until recently. However, earlier experiments with polarized light had indicated that the iridescent hues of these butterflies were the physicists' "colors of thin leaves," or films. Within the past decade, examination by electron microscope has not only confirmed these surmises but has given us photographs of the incredibly fine and complex structures which produce the breathtaking iridescent blues of the Morphoes.

Although they all involve the basic principle of "thin films," the iridescent colors of various moths and butterflies have different types of interference-producing structures. The great majority of these structures fit into one of two categories, which are named after the best-known and most striking iridescent Lepidoptera, the Urania moths and the Morpho butterflies. A third kind, called the mosaic type, is rare and therefore less important. Research has concentrated mostly on the first two types.

We have already seen the micrographs of Urania scales, with their layers of thin lamellae held apart by tiny rods. At a magnification of 2,500 : 1, a portion of the Morpho scale reveals a body that consists only of one upper and one lower lamella, with space in between. On the upper lamella, rows of tightly packed and curiously shaped vertical ridges can be distinguished. A cross section of the scale at a magnification of 12,000 shows these ridges to look very much like tiny Christmas trees with seven or eight branches sticking out on each side of a thick "trunk." In some Morpho species, the ridges stand upright at a 90-degree angle to the upper scale lamella; in others, they are slanted so that the angle is only about 60 degrees.

The fundamental difference between the Urania and Morpho scale structure is the fact that the color-producing "thin films" are located in different parts of the scale. While the lumen of the Urania scales has been converted into thin films which cause interference, the Morpho

scales have this structure in the "branches" of the scale ridges. No blue light is reflected from the body of the scale.

Although the color-producing structures of the Morpho scales are much more complex than those found in the Uraniids, both kinds result in the same optical phenomenon, because they are basically similar. In each case, thin layers of chitin, separated by "layers" of air, and spaced at equal distances, provide the right conditions for light interference by creating an optically inhomogenous medium. The resulting color is determined by the thickness of the layers, their spacing, and the angle of light.

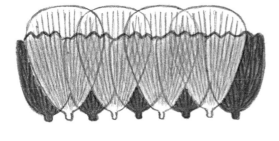

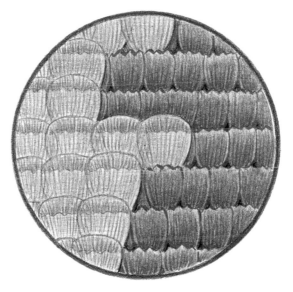

Diagram and greatly enlarged Morpho wing portion showing position and size of glass scales covering the iridescent blue scales.

As we have seen, Morphoes have a limited color range. The basic blue hues can shift somewhat to "left" and "right"—toward the short- or long-wave end of the spectrum—but cannot go beyond a certain point. The reasons for these limitations are to be found in the peculiarities of the ridge structures. Beyond a certain angle, interference is no longer possible. All that can then be seen is the underlying brown pigment—or the white light reflected from the glass scales.

Scales of Morphoes show a "Christmas tree" arrangement in cross section. The thin lamellae form an inhomogenous medium with the air spaces that separate them. (From an electron micrograph, magnification 25,000 : 1)

As mentioned earlier, the color of the Morphoes' wings can be made to change or disappear temporarily by pouring certain liquids over the wings. When this is done, what actually happens is that an optically and chemically inhomogenous medium is turned into a chemically still inhomogenous, but optically now more or less homogenous medium. The chemical composition of the medium is irrelevant in so far as interference is concerned; the only important quality in this case is the refractive index. If the liquid with which the wings are moistened has more or less the same density as chitin—the substance of which the scales are made—the air spaces between the branches of the ridges are filled with a substance optically similar to that of the scale. Interference conditions are changed, and the colors change along with them. Theoretically, it would be possible to make the scale absolutely homogenous by adding a liquid with exactly the same refractive index. Liquids and solids, however, affect light differently, and each medium has a slightly different refractive index for the various colors. It is somewhat larger for the shortwave, and smaller for the longer wavelengths. It is, therefore, in practice not feasible to create an absolutely homogenous medium which would eliminate *all* in-

terference color. It is interesting, though, to see the colors change on the wet wing, and then return to their original hue as the liquid evaporates.

To appreciate fully the wonders of the submicroscopic structures we are dealing with, and the incredible accuracy with which the branches of the ridges have to be arranged, we have to consider the minuteness of the sizes involved. Each Morpho scale—of which about fifteen fit side by side into the space of a millimeter—packs dozens of the longitudinal "Christmas tree" ridges. With approximately 1,000 ridges per millimeter, we now can play the numbers game a little further. Each ridge has about fifteen "branches"—the little chitinous lamellae sticking out from both sides of the center part. That gives us 15,000 of these lamellae, arranged to form layers with interspersed air spaces, per each millimeter of Morpho wing. Figured per inch of the wing surface, we get approximately 360,000 chitinous layers. Having noted before that many Morphoes have wings more or less solidly covered with blue, it is easy to see that many millions of these precision structures are needed for each individual butterfly to display the glittering colors we admire. All of these lamellae have the

Diagram demonstrating how an optically and chemically inhomogenous medium (left) can be changed to one that, while still chemically inhomogenous, is now optically homogenous.

This diagram shows the ridges on a Morpho scale with the color-producing "branches" extending on both sides.

thickness of only a fraction of a light wave, and each one is separated from the next one by an equally minute air space!

The wavelength of white light is considered to be 55 millionths of a centimeter. In comparison, gold, the most malleable metal known to man, has been hammered into sheets 1/250,000 of an inch thick, or approximately 1/100,000 of a centimeter. This seems an incredible achievement, and one that hardly can be improved. But the chitinous plates of a Morpho ridge, with a thickness of only about 7 millionths of a centimeter, are thinner by one-third, and, in addition, are arranged in precise and evenly spaced layers, and in numbers that stagger the imagination. No machine man ever invented or is likely to invent can come close to reproducing the Morpho structures in precision and minuteness.

The most awesome thought concerning these structures, however, is that each tiny pinhead Morpho egg contains the master plan for their construction. The egg has the blueprint, not only for the spectacular and incredibly complex metamorphosis of the caterpillar into pupa and butterfly, not only for the insect's final shape, size, vital organs, and functions, but also for the hundreds of thousands of scales that cover both sides of the wings, for the intricate patterns of the lower wing surface, and for the tens of millions of submicroscopic structures arranged to optical per-

fection to produce—just color! Each time we are faced with such exam-
ples of what nature's creative forces can and do accomplish—almost
playfully, it seems, and reaching far beyond the requirements of func-
tional necessity to the realm of "pure beauty"—we see our own limitations
sharply outlined.

12. The Gold Bugs: Iridescent Beetles

ANYONE who gets a chance to see a live specimen of a South American gold chafer will readily understand that such an insect could easily have inspired Edgar Allan Poe's famous short story, "The Gold Bug." While the beetle remains motionless, it is difficult to believe that this glittering object is indeed a living, breathing creature made of organic matter, so much does it look like a precious gem crafted of burnished metal by the happy whim of a master goldsmith.

Only when the insect starts to move its six golden legs, and slowly walks away, can there be no doubt that no human artist produced this jewel. Even so, the gold looks so metallic that it is sometimes difficult to convince people who see these beetles for the first time that they are "real," that is, that the colors are produced by nature in the living animal, and were not painted or sprayed on later. Many of these metallic beetles far surpass anything that can be fashioned from precious minerals, both

in depth and purity of hue and brilliance of color. Not only the gold and silver hues found frequently in this group, but also the gleaming green, blue, violet, and red shades are so vivid in their flash and play of color that gems appear pallid compared to them. The comparison is, of course, invariably made, for these beetles, small, compact, and frequently solidly iridescent, are the most jewel-like of all insects.

There can be no doubt that, if the only criterion applied were beauty and the brilliance and intensity of color, some of the metallic beetles would get the prize if they were exhibited side by side with objects made of gold and precious stones.

The splendor of these living jewels was not lost on the natives of those regions where they occur. Practically all of them are exotic, and are found in the tropical zones of both the Old and New Worlds. South America, Malaysia, the Indo-Australian region all have their generous share of brilliantly metallic beetles, and the natives of these parts have traditionally used them to make various ornaments, often for their ceremonial robes and regalia.

In view of this, it seems rather strange that so very few people in other parts of the world are aware of these beautiful creatures. Birds and butter-flies are widely known; many people are familiar with iridescent birds such as the peacocks or hummingbirds; and quite a few know at least some of the iridescent butterflies. Rare, however, is the layman who is ac-quainted with the beauty of the iridescent beetles. This may in part be due to the fact that, with only a few exceptions, of which butterflies and honeybees are the prime examples, any small creature with six or more legs is a "bug" to most people, and as such is feared and disliked. Thus, cockroaches, flies, mosquitoes, ants, spiders, and centipedes may be lumped together under that name, although none of them is a bug in the true sense of the word, and spiders and centipedes are not even insects. True bugs are only one of the roughly two dozen orders that make up the in-sect class. The greatest number of attractively colored and patterned in-sects are found in just two of these orders: the Lepidoptera, which include the moths and butterflies; and the Coleoptera, the beetles.

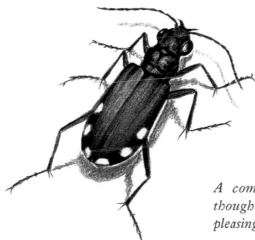

A common North American tiger beetle. Al-though not brightly iridescent, the insect has a pleasing play of green-blue-violet hues.

The other reason for the general ignorance of the six-legged gems is the fact that actual specimens of the most beautiful kinds are not easy to

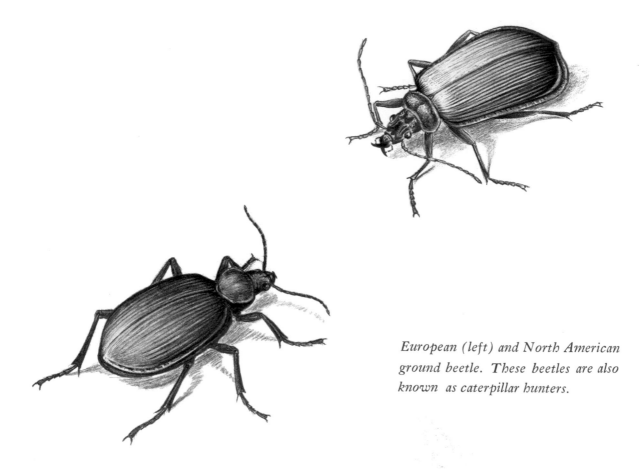

European (left) and North American ground beetle. These beetles are also known as caterpillar hunters.

come by, and photographs and paintings—neither of which are common —are usually only a weak semblance of the incredibly pure and brilliant colors displayed by the originals. Illustrations also cannot, of course, convey any idea of the flashing change of hues that takes place with every shifting of light angle.

Relatively few species of beetles with handsome structural colors are found in the temperate zones. Outstanding among those that do occur in these zones are the tiger beetles. The six-spotted tiger beetle of North America has emerald-green elytra shading into blue and violet along the edges. A much larger insect is the searcher, or caterpillar hunter. This ground beetle, which measures an inch and a quarter, is fairly common in

many parts of the United States. It is marked by golden green and blue iridescence with coppery tones on the thorax and along the edges of the elytra. Searchers are beneficial insects, because they destroy a large number of tent caterpillars and other injurious moth larvae. They secrete a fiery, burning acid that can blister the skin of a careless collector.

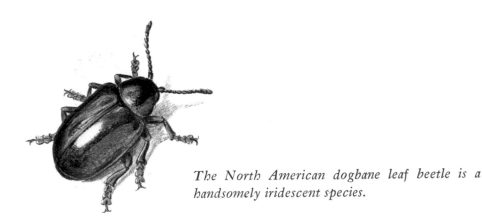

The North American dogbane leaf beetle is a handsomely iridescent species.

Although not large, the metallic-colored members of the leaf-beetle family make up in beauty what they lack in size. A handsome North American representative of this group is the dogbane leaf beetle, which displays a bright green, gold, and coppery iridescence that may even shade into crimson. Perhaps the most brilliantly metallic of all our North American species, however, is the tortoise beetle, popularly called the "gold bug." These insects are quite flat looking, owing to the expansion of the

A North American tortoise beetle, also known as the "gold bug." Unfortunately, the brilliant gold color disappears with death, leaving the beetle dull brown.

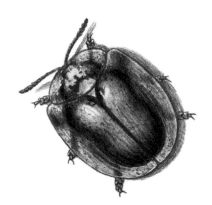

elytra around the edges, which does make them look like a turtle. When the light comes from the right angle, tortoise beetles gleam in what entomologist Ralph B. Swain calls " a glorious, glittering gold." Unfortunately, however, and in contrast to most other beetles with structural

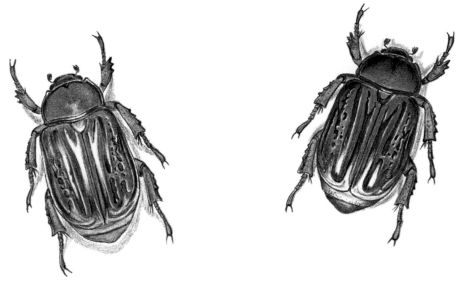

Considered one of the most beautiful of North American leaf chafers, this species is found in the American southwest.

colors, the color of the gold bug is not permanent. After the death of the insect, a slight shrinkage in the integuments of the elytra sets in. Minute as these changes are, they suffice to destroy the delicately balanced structural arrangement which alone can produce the golden color. Within hours after the beetle's death, what was a living bit of bright gold has turned into a dull, reddish-brown, ordinary-looking insect.

No less beautiful than the gold bug, and endowed with a permanent splendor, is what we may call the "silver bug." This insect, whose scientific name is *Plusiotis gloriosus*, is a leaf chafer which belongs to the scarab family. Despite the fact that so many species of this group, which include the familiar dung beetles, are dark and dull-colored insects, some of its members are among the most beautiful of the entire order. Our "silver

bug," a close relative of the destructive Japanese beetle, occurs in certain parts of the American southwest and Mexico. It is clad in a bright, light green with stripes of what entomologist Klots calls an "incredibly metallic silver" running the entire length of the elytra. The thorax is solidly green but is edged with silver. Head, legs, and undersides have the same color combination, which makes the beetle look like a green gem set in sterling silver. The green, like all interference colors, is not a flat, static color; it fluctuates from a dull bronze to an unbelievably bright emerald with every change of position or light angle. The silver seems to give off sparks when the light strikes it at certain angles, and it displays an opalescent shimmer in oblique light under the microscope. The color combination of this beetle is so striking that we can easily understand the delight experienced by Dr. Klots and his colleagues upon seeing *Plusiotis gloriosus* for the first time during a collecting trip in the southwestern states.

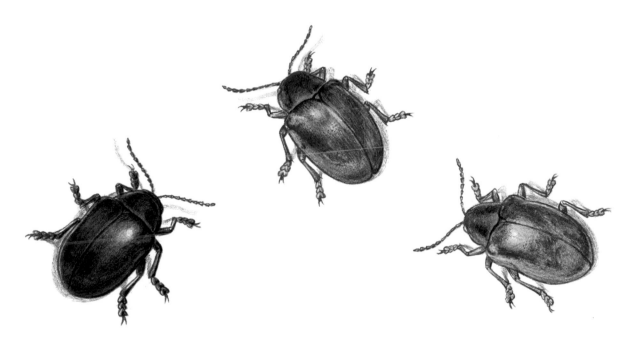

Closely related species of South American leaf beetles, displaying every color and hue of the spectrum.

For the most magnificent of all the metallic and iridescent beetles, we have to turn to the tropics. For every beetle with bright structural colors found in the temperate zones, there are dozens that occur in the tropical and subtropical parts of the world, many of them large and showy, and with the most exotic shapes and patterns. Among these beetles, which belong to a number of different groups, every conceivable iridescent and metallic color, hue, and shade may be found. Many are bright gold and emerald green; others have blue, violet, red, bronze, copper, gold, or

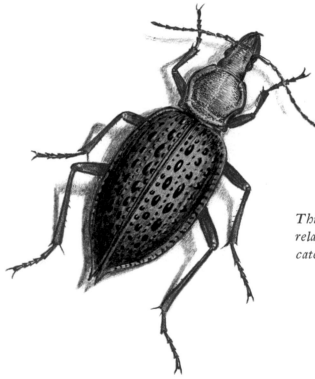

This Chinese ground beetle is a relative of the North American caterpillar hunter.

silver metallic colorations. Some have a much wider range of iridescence than others. Instead of having a single predominant color, they flash a different hue every time the light angle shifts, so that all the colors of the spectrum appear in rapid succession. So much do these beetles look like the result of an artist's conception of jeweled beauty that it is easy to

imagine they are the product of the labor of some gifted goldsmith.

The majority of strongly iridescent beetles are found among the members of five families: scarabs, metallic wood-boring, ground and tiger beetles, and weevils. A few other families also have some members with bright structural colors but cannot compete with these four groups.

For example, there is *Coptolabrus coelestris*, a Chinese relative of the North American caterpillar hunter. More than two inches long, slender, with a narrow, elongated head and long legs, this beetle has a streamlined shape and magnificent coloring and pattern. The head is bright green with a golden cast; the thorax, whose upper surface has a raised edge, glitters in bronze-green and rich copper tones. The elytra, whose basic color is a deep but not strongly metallic green, bear longitudinal rows of bead-like, purplish elevations that are graded in size. The rim of the elytra glitters in gold, bronze, and copper tones. Although the over-all effect of this beetle is not as intensely metallic as some other species, its exquisiteness and relatively large size make its inclusion in the list of the most beautiful beetles mandatory.

From the large family of scarab beetles, which include the leaf and flowers chafers, Dr. Klots picks his favorite, a native of Sumatra. *Hetorrhina dohrni*, the "burning ember" beetle, is barely an inch long. However, its coloring makes it, in Klots's opinion, "one of the most beautiful of all living things." The beetle has a pattern of black and broad green-gold areas which "glow like a burning ember with deep orange-red, a living color that changes with every tiny shift of the light or angle of view." Not only the upper parts, but also the entire underside of *Hetorrhina* gleam in these green-gold hues, while the legs may shade into deep blue and violet when seen from certain angles.

Under the microscope, these shifting, changing hues become even more intriguing. Bordering the black bands on the beetle's elytra, we find a narrow area that always remains either bright green or changes to blue-green as the light angle shifts. This area never turns orange. The more we move toward the center of the green areas, the more we find the green liable to change into the fiery orange that gives the color its "burning-

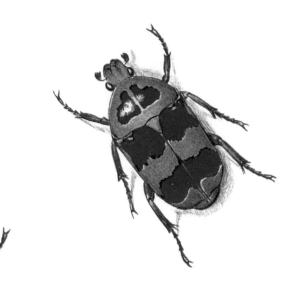

The "burning ember" beetle, a member of the scarab family, has colors which shift from golden green to bright orange.

ember" effect. By slowly moving the light source, we can watch the brilliant green areas turning, first golden-green, then bright gold, and finally a glowing, deep orange. All these colors seem to come from below the surface, which has a high gloss.

A German entomologist picked as his favorite a species of the genus *Stigmodera*. This beetle is a member of a family called the metallic wood-boring beetles, which, as their name indicates, are outstanding because so many species have brilliant structural colors. The wing cases of *Stigmateles* are covered with iridescent scales that flash in all shades from red to blue, and have earned the beetle the nickname of wandering jewel.

Another species of the same group, the big, nearly three-inch-long *Euchroma gigantea*, has metallic green coloring with areas that shade into

coppery and crimson hues. These beetles, which have extremely tough elytra, were used by the ancient Incas as ornaments for their ceremonial regalia. The Indians collected them in great numbers and strung the wing

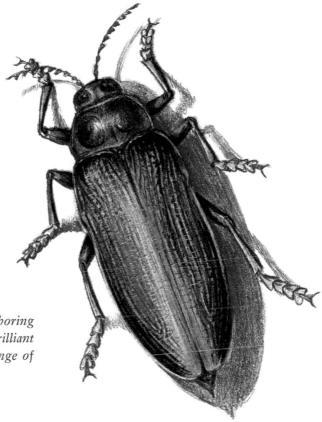

One of the largest of the metallic wood-boring beetles, Euchroma gigantea *turns from brilliant green to copper and red with every change of position.*

coverts together in overlapping rows. Even today, some natives still use these insects as ornaments.

Under the microscope, the ridges on this beetle's elytra take on the appearance of a topographical relief map, with mountain ridges rising from the valleys. But it is a strange fairyland country, for the valleys glitter in gold and green and the mountain ridges gleam in copper and ruby red.

Greatly enlarged, a portion of Euchroma's *elytra reveals a topographic design of valleys and ridges displaying greens and reds.*

The gallery of candidates for the title of "most beautiful beetle" would not be complete without including a tropical weevil. These insects, also known as elephant or snout beetles, are a large family that include some of our most destructive insect pests. The majority of weevils are rather dull brown, black, or gray beetles, but some exotic members of the group are endowed with magnificent iridescent and metallic colors. Because of the brilliant reflections of their scales, some weevils are known as diamond beetles. Others seem to be fashioned of pure gold which will turn gold-green, and then again assume a bluish cast as the light angle changes.

We have seen that examination with the electron microscope revealed the submicroscope precision structures that cause interference in butterfly scales and that three basic types of scale structures were found among the Lepidoptera: the Morpho, Urania, and mosaic type. Examination of beetle scales so far has been more superficial, and we still do not know how many different types of interference-causing structures occur among this group. The difficulty lies mainly in the fact that beetle scales are very thick, hard, strongly convex, and almost impossible to detach from the wing coverts. These scales look somewhat like buttons when seen from the side. They are attached to the elytron by a pedicel which is firmly anchored to the covert. Examinations, therefore, have been made only in

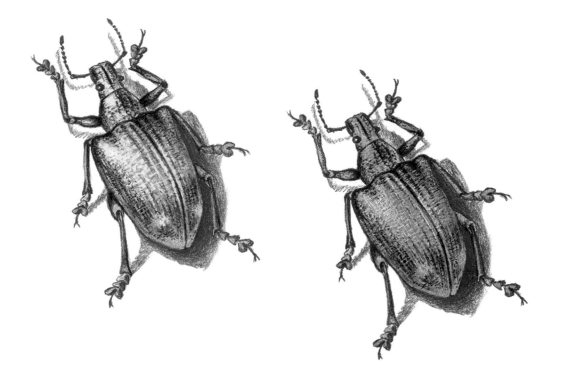

This tropical weevil is normally golden green. Oblique light brings out blue hues, but the intensity of the color is weakened.

Under the microscope, a portion of the weevil's elytra shows oval scales in gold, green, and blue.

reflected daylight and in polarized light. This research has revealed some interesting details about the scale structure of certain species.

One of the beetles selected for examination of its scales was *Pachyrrhynchus*, a tropical weevil with round patches of iridescent scales that flash in all shades from red to violet. At a magnification of 200, these scales appear as tightly packed masses of tiny colored pebbles. At an even greater magnification, we can clearly distinguish that each scale has a multicolored iridescence. The flashing hues of this "diamond beetle" are thus explained: different parts of the scales reflect different colors at the same time.

The photograph of a single scale, taken with polarized light, shows a mosaic pattern of dark and light areas. These were examined closely and were found to consist of sets of "thin films" or lamellae arranged in the scale in such a manner that they slant in different directions. Each set,

Iridescent scale of a tropical weevil. Mosaic pattern indicates lamellae slanting in different directions. (From a photograph taken in polarized light. Magnification 420 : 1)

which consists of a number of layers stacked horizontally on top of each other, thus reflects a different wavelength. While the set at the top center of the convex scale may reflect blue, the one at the very edge may simultaneously reflect red, so that the scale flashes both a red and a blue iridescence. A slight shift of light angle lets other colors appear, with the result that the color seems to be a living, moving thing.

Fig. 9 shows a schematic diagram of a beetle scale with multicolored iridescence. When we consider the minuteness of these scales, 200 of which fit on one square millimeter—which means about 1,300 on an eighth of a square inch—the mind reels at the precision arrangement neces-

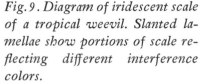

Fig. 9. Diagram of iridescent scale of a tropical weevil. Slanted lamellae show portions of scale reflecting different interference colors.

sary for fitting dozens of lamellae slanted in different directions, and with the layers of each set spaced at certain distances from each other, into a scale of such minute proportions.

Although we know that all iridescent colors are due to interference, there seems to be no doubt that the structures that produce them vary a good deal among the different beetle species. These differences become evident even when seen at a relatively low magnification with an ordinary optical microscope. Some beetles show a definite scale structure even at a magnification of about 60 times. Especially in some of the metallic wood-boring beetles, the tropical weevils, and such scarabs as the "silver bug," the masses of tightly packed scales, looking either like tiny pebbles, or rather flat, roundish platelets, can easily be distinguished. In others, however, the elytra appear as a smooth, shining surface gleaming in shifting hues. *Hetorrhina dohrni*, the "burning ember" beetle, has a clearly defined scale structure when seen in rather weak, oblique light. As soon as the light angle changes and the green-gold-orange hues come to life, however, the scales are no longer visible in that iridescent green area. Instead, the elytra take on the appearance of a rug tightly woven of glittering green and orange.

The rather weak iridescence displayed by certain species of beetles is caused by the minute ridges of the elytra. These ridges constitute a dif-

Scales of the "diamond beetle," greatly enlarged.

fraction grating. As mentioned in Chapter 4, light striking thin slits produces interference colors.

Further research will undoubtedly reveal many more details about the various structures that produce the great variety and range of hues in the exoskeleton and elytra of beetles with iridescent colors. Science is, after all, best at providing such answers as to *how* things work, and can give us invaluable insights into many details of nature's complex mechanisms. It cannot, of course, explain the whys and wherefores of life's marvels. For the miracle that invests the pinhead egg of a butterfly or beetle with the master plan, not only for the insect's complex metamorphosis, but also for

Iridescent scales of a tropical weevil, enlarged about 200 times.

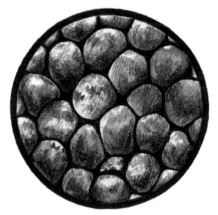

the astronomical number and the precision arrangement of submicroscopic structures necessary to create iridescent colors, science has not yet found an explanation.

Fortunately, we do not need reasons to admire beauty. The rainbow hues will continue to delight us, and their splendor is even better appreciated against the background of our knowledge of what it takes to produce the flashing, glowing colors of the living jewels.

Epilogue

EVER since the dawn of history, man has been intrigued by color. To our primitive ancestors, color appeared to have magical properties, and it played a dominant role in all the ancient civilizations that rose and flourished in various parts of the world thousands of years ago.

During the past three centuries, the science of physics has added new dimensions to the ancient esthetic and mystical qualities assigned to color by our ancestors. Beginning with Sir Isaac Newton and his contemporaries, scientists as well as philosophers explored, discussed, and argued about the various aspects of color, which is quite probably the most fascinating of all our visible phenomena. This may be due partly to the fact that color is "homeless"—or rather, according to the German physicist and philosopher Carl Friedrich von Weizsaecker—at home in a kind of no man's land bordered by physics, psychology, philosophy, and art.

Color can be all or any of a series of things: physiologically, a nerve stimulus; psychologically, an emotional sensation; physically, electronic vibrations. It also can be a chemical substance, an expression of biophysical functions; an expression of art; and an optical symbol.

From this list, which is by no means complete, it is not difficult to see why the great debate about color, which has brought forth differing—and often conflicting—theories by such famous men as Newton, Goethe, and Helmholtz, to name only a few, is still going on. Modern scientific thinking as first established in the seventeenth century has long used color as a classic example of a "subjective," or secondary, quality, as opposed to form, which was considered an "objective," or primary quality. Specific instances of these differing qualities frequently employed by scientists were the cube on one hand, representing objective form, and the green color of vegetation as the other. This quality "green," that is, light of a wavelength which we see as something we call green, was held to be subjective, and therefore not to exist objectively at all.

The separation into objective and subjective qualities, with the latter relegated to a secondary position, has permeated and influenced all scientific thinking to this day. Because of the tremendous impact of science on all aspects of our present-day life, it has helped to create a situation in which man has become separated from the rest of nature and has become merely its observer and exploiter. We unconsciously acknowledge this concept when we use expressions such as "realism and idealism" or "man and nature." Philosophically, and in direct proportion to the accelerated speed of scientific progress and achievement, this concept led to a gradual downgrading of all so-called subjective qualities, including man's intuition and inspiration, while exalting the "objective" findings of science, which were held to establish incontrovertible facts absolutely, for all time, and beyond all doubt.

The thoughtful individual may feel that something is wrong with this concept, but he may not know enough about science to argue the point and may fear exposing himself to ridicule by challenging it. To be effective, the challenge must come from scientists, and a number of outstand-

ing modern men of science are mounting just such a challenge. Dr. von Weizsaecker, for instance, who was a noted physicist before he became a professor of philosophy, frequently takes issue with what he calls the residues of scientific thinking of past centuries. In his foreword to a book on light and color, Dr. von Weizsaecker uses color to make his point. He states that the old theory of separating all phenomena according to whether they have objective or subjective qualities cannot be maintained, for any attempt to do justice to color must lead to an approach where the division into primary and secondary qualities becomes untenable. This, of course, runs contrary to popular understanding of today's science, which, among other things, still takes the stand that, in discussing color, a sharp distinction has to be made between purely physical and purely esthetic aspects. Not so, says Dr. von Weizsaecker: color in all its manifestations is *one* phenomenon, and none of its aspects can be treated as though the others did not exist.

How deeply the old position is entrenched can be seen from the uneasiness resulting almost inevitably wherever esthetic and physical qualities are discussed side by side. The two, it is felt, simply don't mix. Crawford H. Greenewalt, in his book of magnificent photographs of hummingbirds, includes an explanation, based on the most modern electronic research, of the physical, structural basis of these birds' marvelous iridescent colors. At the end, however, he wonders whether it would not have been better to omit the explanation, allowing the reader to simply enjoy beauty without trying to understand it. He goes on to say that perhaps, though, some knowledge of the physical origin of these colors will not detract from the visual pleasure we get when we look at them. Actually, one should expect that insight into the incredibly fine and minute structures that produce the iridescent colors would *enhance* our wonder and delight. Instead, we find the widespread uneasy feeling that scientific, "objective" facts must by their very nature disillusion and disenchant. This feeling affects many aspects of our life. Sometimes we encounter what amounts to a desperate attempt to save at least some of the magic and the mysteries of our world from the merciless onslaught of science.

Many people feel that science reduces all beauty and all marvels to cold facts in the process of establishing the absolute and unquestionable truth about our universe. This view is as incorrect as it is regrettable. The findings of science uncover more new mysteries and pose more new questions than they resolve. The doors unlocked for us by science should, therefore, increase, not diminish, our awe and reverence for the enigma of the universe of which we are an integral part. As for establishing the "absolute" truth: the physicist Vannevar Bush claims that science can never prove *anything* in the absolute sense, and that the concept of the universe as being some kind of mechanism which works according to a "neat set of equations" is a residue of a naïve eighteenth-century scientific belief. And so, says Dr. Bush, those "who follow science blindly come up against a barrier beyond which they cannot see," and end up where they began. If we understand science properly, he asserts, it will make us humble through the awareness of our own ignorance.

On a different level, but in a parallel concept, Dr. Adolf Portmann, zoologist at the University of Basel, and director of its Institute of Electronic Microscopy, calls for increased "knowledge of our ignorance" in the field of biology. Decrying the mechanistic, utilitarian approach to living beings and the phenomena they exhibit, Dr. Portmann states that many oddities and beauties in the animal world cannot be explained on the basis of necessity or functional purpose. In an introduction to a book on butterflies, he says that the intricate designs and multicolored hues of many butterfly species belong quite simply in what he calls "the free realm of beauty." To Portmann, as to some other outstanding modern scientists, the discoveries of science are nothing more than excellent material with which we can shape a background against which the immensity of natural mysteries may be better appreciated. "We enter," he says, "the obscure realm of the mysterious, a realm of uncharted vastness compared to which the brightly-lit region of the known and explored is but a small island in a huge stream of darkness. Light and Darkness—both belong together. The light world of the known gives enrichment and delight to him who ponders its discoveries; from the dark depths of the realm of

mysteries come forth great incentives and inspirations for new work and new exploration."

From the words of men such as Bush, Portmann, and Von Weizsaecker, the overwhelmed and confused layman today can take new heart and attain a better perspective on both the great possibilities and the strict limitations of science. He will realize that the schizophrenic condition of our present-day world can be cured; that the "objective" and "subjective" phenomena are but part of a whole; that the findings of science can never establish the absolute truth; that for every one of our world's secrets unraveled by these findings, dozens of new and even more intriguing questions arise for which there are no answers. He will, in other words, liberate himself from the stranglehold which a wrong concept of science and what science can do now has on the minds of men—and which, if unchecked, can lead to a feeling of inadequacy and despair. He will then be free to see and enjoy the marvels of our life and our world from a new and more solidly based vantagepoint.

Biographical Notes

ALTUM, BERNARD, 1824–1900. German zoologist and forestry expert.

A strong interest in animals and in what we today call conservation led Bernard Altum to a career as professor of zoology and forestry expert. As a consultant to German authorities in charge of forest and woodland, he wrote a book about pest insects. The warning by Altum almost a hundred years ago that measures to control pest insects may do more damage than the insects themselves has a prophetic ring today, amid general concern about the environment.

Altum was especially interested in birds and wrote a book about the life history of birds. In the course of his close observation, he became intrigued by the question of feather coloring. In 1854, he wrote an article on colors in feathers, with special emphasis on iridescent feathers. However, his fellow biologists largely ignored this problem, and it was not to be taken up seriously again until early in the twentieth century.

AUDUBON, JOHN JAMES, 1785–1851. American artist-naturalist.

Audubon was born in what today is Haiti as the son of a French planter and naval officer. His boyhood was spent in France in comfortable and even luxurious surroundings, supervised by a doting foster mother. Young Audubon did not care very much for school and was an indifferent pupil. However, even at an early age he showed great interest in, and talent for, drawing, especially drawings of birds.

Sent to the United States on business in the early years of the nineteenth century, Audubon married a teacher, and he then began to devote himself entirely to the study and illustration of American bird species. In this he was encouraged by his wife, and for a number of years the couple lived on what the wife earned as a teacher and on the money made by Audubon himself through drawing lessons. During these years, he collected, studied, and painted hundreds of birds, creating beautiful and painstakingly accurate reproductions. His comprehensive work *Birds of America* was first published in England, where Audubon's genius found immediate recognition.

In 1837, Audubon settled in New York City and began, this time with the help of his sons, to prepare another work on animals for publication.

At the Museum of Natural History in New York City, some of the original bird specimens collected by Audubon, one of the rifles he used for collecting, and several of his original paintings have been preserved.

BATES, HENRY WALTER, 1825–92. English naturalist, explorer and author.

A contemporary of Darwin, with whom he carried on an extensive correspondence, Bates at an early age became interested in insects, especially in butterflies. In 1848, he went to Brazil on a collection trip and spent the next seven and one half years exploring the Amazon region. During this period, he collected 14,712 species of insects, more than 8,000 of which were up to then unknown to science.

Bates is perhaps best known for his theory on mimicry, which he

developed after being struck by the resemblance of certain butterflies to other, completely unrelated species. The resemblance was so great that Bates made mistakes in classification which he found out only later, after studying the insects more closely. Because the "models" were usually poisonous or at least unpalatable insects, Bates concluded that the "mimics" gained a considerable immunity by resembling the former. This conclusion is the basis for the theory known as Batesian mimicry, a theory which has gained wide recognition among zoologists today. Darwin wrote Bates enthusiastic letters on his work in this field.

Although the bulk of his research in South America was about butterflies, later on in life Bates sold his huge butterfly collection and concentrated on the study of beetles.

BOYLE, ROBERT, 1627–91. English natural philosopher and founder of modern chemistry.

Robert Boyle, fourteenth child of Richard Boyle, the earl of Cork, was a man of varied scientific interests. He was fascinated by chemistry and tried long to transmutate metals. In that, he did not succeed, but during his experiments he advanced the science of chemistry considerably. His contributions to other branches of science are no less impressive. He is perhaps best known for his definition and explanation of interference colors, the "colors of thin films," as he called them.

Despite his scientific inclinations, Boyle was deeply interested in theology, and he studied Greek and Hebrew in order to be better equipped for studying that subject. He founded the Boyle lectures, which were designed to prove the Christian religion against what he called "notorious infidels."

BRAGG, SIR WILLIAM HENRY, 1862–1942. English physicist.

His work on radioactive phenomena and his studies of crystal structures by means of X-ray diffraction won Bragg international fame. It was during the latter studies that he was able to define the special properties

of the so-called space lattice. In recognition of his contributions to the advance of physical science, he received the Nobel Prize for physics in 1915.

In later life, Sir William, in cooperation with his son, who also became a noted scientist, developed the X-ray spectrometer. Outstanding among his publications is his book *The Universe of Light*.

BUFFON, JEAN JACQUES LECLERC, COMTE DE, 1707–88. French naturalist and author.

Buffon started out as a student of law, earning a degree in that field at the early age of nineteen in 1726. However, his interests turned to natural history in 1730, when he met a young English nobleman, Lord Kingston, and his tutor, who was an entomologist. Through this meeting, Buffon's latent interest in nature and animals became active, and he gave up his law career, devoting his time to the study of natural history. Some years later, he was appointed keeper, or curator, of the Jardin du Roi, which included a natural history museum. Buffon undertook the job of cataloguing the contents of the King's Museum, and then proceeded to put together the most comprehensive work on natural history ever attempted by one man. It was published under the title *Histoire naturelle* and comprises forty-four volumes. The original edition was beautifully illustrated.

DARWIN, CHARLES ROBERT, 1809–82. English naturalist and originator of the theory of organic evolution.

As a young man, Darwin prepared himself for the medical profession, for which, however, he was not well suited. Turning to other fields of endeavor, at the age of twenty-one, he found what for him proved to be an ideal opportunity to pursue his real interest. H.M.S. *Beagle* was being readied for a surveying expedition which was to take it well around the world. In 1831, Darwin joined the crew of the *Beagle* as a naturalist on a voyage which was to take more than five years and cover thousands of miles. Darwin kept a meticulous diary of his observations during this

trip, which turned out to be the preparation and basis for his life work. Certain places he visited during the voyage, such as the Galapagos Islands, offered ideal conditions for the observation of evolutionary patterns. Darwin thus was able to make extensive studies, laying the foundation for his concept of natural selection, later known widely under the catchword of the "survival of the fittest."

After his book *The Origin of the Species* was published in 1859, a bitter controversy began to rage about his conclusions, which were attacked from many different quarters. In the course of time, however, the general concept of evolution has been almost universally accepted, even though many unanswered questions remain on a great number of points.

It is interesting to note that Darwin's four sons all became prominent scientists in their own right.

EINSTEIN, ALBERT, 1879–1955. German-born physicist.

The world-famous author of the theory of relativity on which the entire concept of atomic energy is based began his epoch-making career in Berlin, which, at the turn of the century, was one of the great centers of scientific research.

After Hitler took power in Germany in 1933, Einstein left that country and went to the United States. He settled in Princeton, New Jersey, where he became what was probably the most famous and distinguished member of that university's faculty. During World War II, he advised President Franklin D. Roosevelt to develop the atomic bomb.

FRAUNHOFER, JOSEPH VON, 1787–1826. German astronomer, physicist, and optician.

Fraunhofer's early work was almost entirely in the field of astronomy, in which he made a name for himself when still a young man. He experimented for many years with lenses, which he often ground himself, in order to get better telescopes. His later experiments with light, which eventually led to the development of spectral analysis with the aid of the so-called Fraunhofer lines of the spectrum, brought him great fame. An-

other significant advance in the field of physical optics was his calculation of the wave lengths of different colors by employing a diffraction grating.

FRISCH, KARL VON, 1886– . German zoologist.

As a professor of zoology at various German universities, von Frisch conducted numerous experiments with animals, especially fish, designed to test their sensory capabilities—their ability to distinguish color, for example. A statement by another zoologist claiming that honeybees were color-blind induced him to devote his efforts to studying these insects. For several decades, and especially after he became professor of zoology at the University of Munich, von Frisch and his associates conducted their painstaking experiments with honeybees. This research led to some astonishing results which permitted unthought-of insights into the operation of a beehive. Among other things, von Frisch proved that honeybees can see certain colors but not red, that they can navigate because they can distinguish polarized from ordinary light, that they can see ultraviolet light, and that they have a "dance language" with which they communicate with each other.

GOETHE, JOHANN WOLFGANG VON, 1749–1832. German poet, dramatist, and author.

Best known for his great dramatic poem *Faust*, which was set to music by Charles Gounod, among others, Goethe was a towering literary figure of the Age of Enlightenment. His great fame brought visitors from all parts of the civilized world to the small Thuringian town of Weimar, where Goethe took up residence after becoming a close personal friend of Grand Duke Carl August, the ruling prince of that Grand Duchy.

Goethe was a man of many talents and always had a lively interest in various aspects of nature. He studied botany and anatomy and was intrigued by the problem of light and color to the extent that, in 1810, he wrote *Die Farbenlehre*, a theory on color. Scientifically, his ideas have proved untenable and without value, but the book is interesting from the

esthetic and psychological viewpoints. Goethe considered the so-called warm colors the plus section of the spectrum and relegated the "cold" colors to the minus section.

His writings contain many indications of his interest in natural science. Intuitively, Goethe seems to have foreseen some of the later findings of the evolutionists. In his *Faust*, for example, there is an ode to the ocean, in which the claim is made that all forms of life have come from the ocean, and that all life is supported by the ocean. Some sixty years later, Darwin set out to prove, among other things, that all life had indeed originated in the ocean.

GOULD, AUGUSTUS ADDISON, 1805–1866, American zoologist.

Although Gould specialized in the study of mollusks, about which he wrote several books and numerous articles, he also did work on a number of other zoological subjects and even one on botany.

After graduating in medicine from Harvard University in 1830, Gould devoted his time almost exclusively to the study of natural history. He became well known through his writings. Together with Louis Agassiz, he published *The Principles of Zoology*.

Gould traveled extensively in connection with his studies of animal life in general, and mollusks in particular.

HELMHOLTZ, HERMANN LUDWIG FERDINAND VON, 1821–94. German philosopher and man of science.

Helmholtz began his scientific career as a professor of physiology, first at the University of Königsberg in East Prussia, and later at the universities of Bonn and Heidelberg. In 1871, he was appointed professor of physics in Berlin.

Famed for formulating the law of conservation of energy, Helmholtz' scientific studies ranged all the way from physiology to mechanics. He did considerable work in acoustics, but his contributions to the advance of physical optics are perhaps most outstanding. Based on Thomas

Young's theories, he redefined the primaries of light as being red, green, and violet, the three main color sensations. Helmholtz also did much to clarify the physiological causes of color blindness.

HUYGENS, CHRISTIAN, 1629–95. Dutch astronomer, mathematician, and physicist.

Born at The Hague, Huygens was a contemporary and colleague of Sir Isaac Newton and worked in the same fields as the eminent English physicist. Some of his conclusions, in fact, helped Newton formulate his famous law of gravitation.

In the field of physical optics, however, the theories of the Dutch scientist differed sharply from those of his English colleague. Newton's corpuscular theory of light was challenged by Huygen's wave theory of light, published under the title *Traite de la Lumiere* in 1690. In time, Huygens' theory was destined to be accepted by most scientists in preference to Newton's concept of light.

Huygens, who also did many experiments in polarization, gained considerable fame through his work. He was finally invited by King Louis XIV of France to take up residence in that country. The invitation was too advantageous for the Dutch scientist to pass up, and so he moved to France, where he remained until his death in 1692.

MAETERLINCK, MAURICE POLYDORE MARIE BERNARD, 1862–1951. Belgian critic, dramatist, and author.

Maeterlinck's interests were so varied that he tried his hand at a number of widely different subjects. His play *The Blue Bird* was a great success, for it showed him to have a sensitive understanding of a child's world and dreams. In 1911, Maeterlinck received the Nobel Prize in literature.

Philosophy and natural history were among the chief interests of his later years, and he wrote several books, including some on insects, in which he mixed facts, fancy, and folklore. In the last years before his death, Maeterlinck adopted an increasingly pessimistic view of nature.

NEWTON, SIR ISAAC, 1642–1727. English scientist and mathematician, one
of the greatest figures in the history of science.

It is perhaps not too much of an exaggeration to say that the develop-
ment of modern physics is to a large extent based upon Newton's achieve-
ments in this field, even though the contributions of other scientists were
necessary for the fruition of many of his theories and conclusions.

The foundation of the modern science of color and spectrum re-
search is to be found in Newton's claim that "natural bodies . . . are
variously qualified to reflect one sort of light in greater plenty than
another. . . ."

When he was still in his twenties, Newton experimented with prisms,
and he ground lenses to fit his needs. In those experiments he discovered
that a beam of white light, directed onto a prism, could be refracted and
separated into its component colors.

Newton was the author of the corpuscular theory of light, which for
years was accepted by many scientists but was finally more or less dis-
carded in favor of the wave theory formulated by Newton's contem-
porary, Huygens.

All his life, Newton was plagued by the controversies which arose
from some of his conclusions; these bothered him considerably because
they often led to sharp exchanges between scientists of different schools
of thought.

PLANCK, MAX KARL ERNST LUDWIG, 1858–1947. German physicist.

The bulk of Max Planck's scientific work centered on thermody-
namics. In 1897 and for several years thereafter, he concerned himself
with the so-called black-body radiation. In 1900, he caused considerable
excitement in the scientific world by publishing his quantum theory,
which revolutionized modern physical science and influenced every as-
pect of it.

In appreciation of his contributions to physics, Planck was awarded
the Nobel Prize in 1918. When Hitler took power in Germany in 1933,

Planck deemed it his duty to remain in his native country, despite his abhorrence of the Nazi regime and the many tempting offers he received from foreign countries. He continued sharply to oppose the policies of the Hitler regime, especially their treatment of the Jews, and it was only his great fame which saved him from a dire fate. One of his sons was not so lucky: involved in the opposition against Hitler, he was executed by the Nazis in 1944.

TYNDALL, JOHN, 1820–1893. English natural philosopher and scientist.

Tyndall started out on his career as a surveyor-engineer. He attended the University of Marburg, Germany, in 1848, and received his doctorate in 1850. Later, he became professor of natural philosophy at the Royal Institute.

Tyndall's greatest contributions to science lay perhaps more in his ability to make difficult things clear and easy to understand than in his own discoveries. All the same, much of his research greatly furthered the advance of science in a number of different fields. His experiments with the opacity and transparency of gases clarified many questions on that subject.

Tyndall's greatest claim to fame, however, was his experiments establishing the reason for the blue color of certain substances, especially the sky. Proving this so-called Tyndall blue to be caused by diffraction and diffusion of light by very small particles, he cleared up a problem that had been puzzling scientists for a long time.

WALLACE, ALFRED RUSSELL, English naturalist. 1823–1913.

Best known for his joint communications with Darwin, Wallace started out as a surveyor and architect. About 1840, he became interested in botany and began to study that subject. A meeting with Henry W. Bates resulted in Wallace getting interested in insects. In 1848, Bates and Wallace joined forces in an expedition in the Amazon region, but they separated in 1850.

A few years later, Wallace made a tour of the Malay archipelago. During these travels, he began to formulate his concept of natural selec-

tion. After long reflection on how changes in a species could have come about, the idea of a "survival of the fittest" suddenly flashed to his mind.

Wallace sent a draft of his theories to Darwin in London, who was amazed to find the coincidence of two naturalists arriving separately and without previous collaboration at the identical conclusions. Darwin used Wallace's terms as headings for his own chapters on the evolutionary theory.

Wallace differed from Darwin in that he believed that man is a product not only of natural selection but of other forces operating in addition to the evolutionary process. He also did not agree with Darwin on some other points of the latter's theory on evolution.

WATERTON, CHARLES, 1782–1865. English naturalist.

Charles Waterton lived in British Guiana for a number of years and studied the wild life of that region during that time. After returning to England, he made frequent trips to South America, where the beauty of the hummingbirds especially caught his attention. In 1825, he published his *Wanderings in South America*, a sort of natural-history diary of his travels. Rather than being scientific, the book is a popular account of the wildlife of those regions.

YOUNG, THOMAS, 1773–1829. English physicist and physician.

Although he began his career as a medical man, Young soon turned to physics, and for the remainder of his life his work was devoted chiefly to the field of physical optics. In 1801, he published a detailed explanation of light interference, drawing upon the work done a century before by Robert Boyle. In later life, much of his research centered on the physiological aspects of light and color as they affect the human eye. In this work, his medical knowledge was of great advantage. He proved that color perception depends upon the presence of three different kinds of nerve fibers in the eye which respond, respectively, to red, green, and violet light waves. A defect in one of these nerve fibers results in partial color blindness.

Selected Bibliography

BOOKS

Austin, O. L. 1961. *Birds of the World.* New York: Golden Press.

Curran, C. H., and others. 1945. *Insects of the Pacific World.* New York: Macmillan.

Danesch, O. 1965. *Schmetterlinge I (Tagfalter).* Stuttgart: Chr. Belser Verlag.

Fox, D. L. 1953. *Animal Biochromes and Structural Colours.* Cambridge: At the University Press.

Fox, H. M., and Vevers, G. 1960. *The Nature of Animal Colours.* London.

Frisch, K. von. *Aus dem Leben der Bienen.* Berlin: Springer Verlag.

Greenewalt, C. H. 1960. *The Hummingbirds.* New York: The American Museum of Natural History.

Heimendahl, R. 1961. *Licht und Farbe.* Berlin: Walter de Gruyter & Co.

Klots, A. B. 1959. *Living Insects of the World.* New York: Doubleday.

Luckiesh, M. 1921. *Color and Its Applications.* New York: Van Nostrand.

Lutz, F. E. 1948. *Field Book of Insects.* New York: Putnam.

Newbigin, M. I. 1898. *Color in Nature.* London: J. Murray.

Newton, I. 1704. *Treatise on Optics*. London.

Peterson, R. T. *A Field Guide to the Birds*. 1947. Boston: Houghton Mifflin.

Portmann, A. 1948–60. *Die Tiergestalt*. Basel: Fr. Reinhardt, Verlag.

——. *Neue Wege der Biologie*. 1960. Munich.

——. *Von Voegeln und Insekten*. 1957. Basel: Fr. Reinhardt. Verlag.

Schmidt, K. P., and Inger, R. F. 1957. *Living Reptiles of the World*. New York: Doubleday.

Schroeder, C. 1925–29. *Handbuch der Entomologie*. Jena: Gustav Fischer.

Swain, R. B. 1948. *The Insect Guide*. New York: Doubleday.

Weber, H. 1954. *Grundriss der Insektenkunde*. Stuttgart: Gustav Fischer.

——. 1933. *Lehrbuch der Entomologie*. Jena: Gustav Fischer.

ARTICLES AND SCIENTIFIC PAPERS

Altum, B. 1854. "Ueber die Farben der Vogelfedern im allgemeinen, ueber das Schillern insbesondere." Naumannia, *4*, 293–304.

Anderson, T. F., and Richards, A. G. 1942. "An electron microscope study of some structural colors in insects." J. Applied Physics, *13*, 748–58.

Auber, L. Ph.D. 1957. "The structures producing 'non-iridescent' blue colour in bird feathers." Proc. Zool. Soc. London, 129, *4*, 455–86.

Crane, J. "Spectral reflectance characteristic of butterflies from Trinidad." Zoologica, New York, *39*, 85–115.

Dorst, J. 1951. "Recherches sur les structures des plumes des trochilides." Mem. Mus. Nat. (Zool.), Paris, *1*, (3), 125–260.

Durrer, H. 1962. "Schillerfarben beim Pfau (Pavo cristatus L.)." Verhandl. Naturf. Ges. Basel, *73* (1), 204–24.

Durrer, H., and Villiger, W. 1962. "Schillerfarben der Nektarvoegel (Nectariniidae). Eine elektronenmikroskopische Untersuchung." Rev. Suisse Zool., *69* (38), 801–14.

Elsaesser, Th. 1925. Die Struktur schillernder Federn." Journal f. Orn., *73*, 337–89.

Greenewalt, C. H., Brandt, W., and Friel, D. D. 1960. "The iridescent colors of hummingbird feathers." Proc. Americ. Soc., *104*, 249.

Gentil, K. 1941. "Beitraege zur Kenntnis schillernder Schmetterlingsschuppen auf Grund polarisationsoptischer Untersuchung." Z. Morph. und Oekol, Tiere *37*, 591–612.

——. "Elektronenmikroskopische Untersuchung des Feinbaus schillernder Leisten von Morpho-Schuppen." 1942. Z. Morp. und Oekol, Tiere *38*, 344–55.

Kinder, E., and Sueffert, F. 1943. "Ueber den Feinbau schillernder Schmetterlingsschuppen vom Morphotyp." Biol. Zbl., *63*, 268–88.

Lippert, W., and Gentil, K. 1952. "Elektronenmikroskopische Studien ueber micellare Strukturen bei Schmetterlingsschuppen vom Morpho-Typ." Z. wiss. Mikr., *61*, 95–100.

Onslow, H. "On a periodic structure in many insect scales and the cause of their iridescent colours." 1921. Nature, London, 108. Phil. Trans. Roy. Soc., London, B. 211.

Portmann, A. 1960. "Die Vogelfeder als morphologisches Problem." Verhandl. Naturf. Ges., Basel, *74* (1), 106–32.

Rensch, B. 1925. "Untersuchungen zur Philogenese der Schillerstruktur." Journal f. Orn., *73*, 127–47.

Sager, E. 1955. "Morphologische Analyse der Musterbildung beim Pfauenrad." Rev. suisse Zool., *62* (2), 25–127.

Schmidt, W. J. "Wie entstehen die Schillerfarben der Federn?" 1952. Natw. *39*, 313–18.

Schmidt, W. J., and Ruska, H. 1962. "Ueber das schillernde Federmelanin bei Heliangelus und Lophophorus." Z. f. Zellforsch., *57*, 1–36.

Schmidt, W. J. 1934. Polarisationsoptische Analyse des submikroskopischen Baus von Zellen und Geweben." Handbuch der biol. Arbeitmethoden, Abt. V., Teil 10, 435–665.

Sueffert, F. (1924) Morphologie und Optik der Schmetterlingsschuppen, insbesondere die Schillerfarben der Schmetterlinge. Z. Morp. und Oekol. Tiere *1*, 171–308.

Voelker, Otto. 1962. "Gefiederfarben der Voegel und Carotinoide." Nat. und Mus. *93*, (2), 39–53.

Zur Strassen, O. 1935. "Plastisch wirkende Augflecke und die 'geschlechtliche Zuchtwahl.'" Jena: Ges. f. Naturwis.

Index

Pages on which illustrations appear are shown in *italics*.

About the Making of This Book

The text was set in Janson on the Linotype by Lettick Typografic, Inc., Bridgeport, Connecticut. The display type is Perpetua. The book was printed on Hopper Offset paper in five colors on a two-color Miehle press by Rae Lithographers, Cedar Grove, New Jersey, and bound by Chas. H. Bohn & Co., Inc., New York, New York.

DESIGNED BY NANCY DALE MULDOON